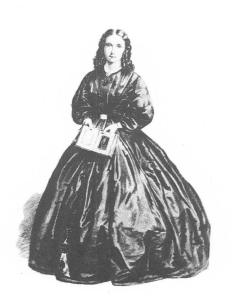

A VICTORIAN

PORTRAIT

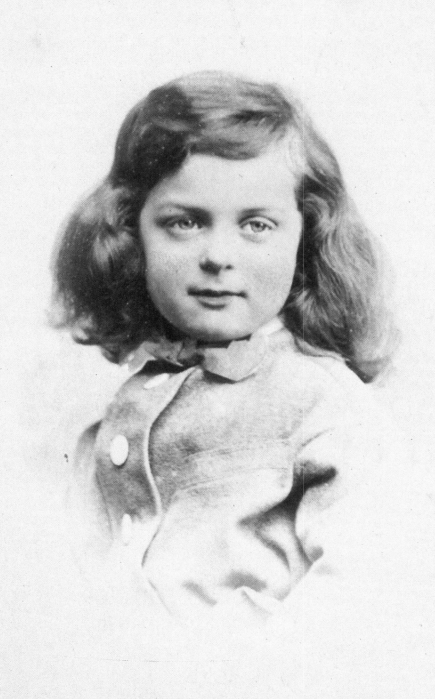

A VICTORIAN

Portrait

VICTORIAN LIFE AND VALUES AS SEEN
THROUGH THE WORK OF STUDIO PHOTOGRAPHERS

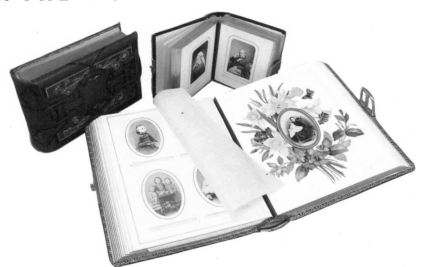

ASA BRIGGS

WITH ARCHIE MILES

CASSELL

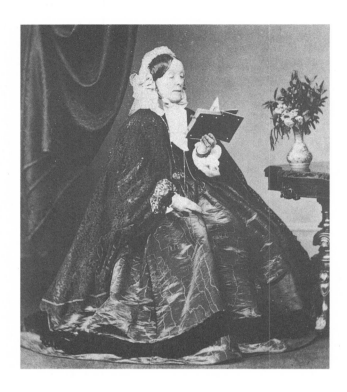

Published by
Cassell Publishers Limited
Artillery House, Artillery Row
London SWIP IRT

First impression 1989

Editor in Chief: Simon Rigge
Editor: Ruth Baldwin
Art Direction and Book Design: Bob Hook and Ivor Claydon
Production Manager: Hugh Allan
Production Controller: Rebecca Bone
Electronically composed by: Caroline Helfer and Camille Favaloro

Distributed in Australia by
Capricorn Link (Australia) Pty Ltd
PO Box 665, Lane Cove, NSW 2066

British Library Cataloguing in Publication Data
A Victorian portrait.
1. Great Britain. Photography, 1850-1900
I. Briggs, Asa, 1921-
770'.941

ISBN 0-304-31837-X
Printed and bound in Spain by Artes Graficas Toledo S.A.
D.L.TO: 1188-89

AUTHOR'S ACKNOWLEDGEMENTS

I am deeply grateful to my secretaries, Jenny Blake and Yvonne Collins,
for their help with the preparation of the text of this book for the
printer, and to Ruth Baldwin for her indispensable help as editor in
getting the text through the press in record time.

A VICTORIAN PORTRAIT – PICTURE ACKNOWLEDGEMENTS

All illustrations are from The Archie Miles Collection with the exception
of the following: 20,21,170 (bottom),190 (left) – Hulton Deutsch
Collection, London; 22-9,64 (bottom right),73,131,141 (top left),159
(bottom left, centre and right),160 (bottom) – Tom Reeves Studio,
Lewes; 32 – North of England Open Air Museum, Beamish; 34 –
Burlington Northern Railroad, Fort Worth, USA; 36,37 (top) – National
Maritime Museum, Greenwich; 42 (bottom left),50,53 (top),168 – Mary
Evans Picture Libary, London; 43 – The Welfare History Picture Library,
Glasgow; 45 – The Deanery, Christ Church College, Oxford; 52 – The
Salvation Army International Heritage Centre, London; 53 (bottom) –
City of Birmingham Public Libraries; 54 – Lever Brothers Limited, Port
Sunlight; 56 – Barnado Photographic Archive, London; 62 –
Metropolitan Police Museum, London; 103,161 (bottom) – Dale Family
Collection, London; 174 – Pitt Rivers Museum, Oxford; 183 – the private
collection of Lord Briggs; 197 – Richard Morris Collection, Chalfont St
Peter; 199 – The Bridgeman Art Library, London; 204 (bottom) – The
Sutcliffe Gallery, Whitby; 207-9 – John Moffat Collection, Berkhamsted.

CONTENTS

CHAPTER ONE

PORTRAIT AND PORTRAITS

The most brilliant of all essays on Victorian England is called *Portrait of an Age.* Its author, G. M. Young, writing during the early 1930s and trying to explain what the Victorians were really like, had a strong visual sense. 'Every one of us', he claimed, 'lives in a landscape of his own.'

Young described how things changed – or did not change – in the years between Queen Victoria's coronation in 1837 and her funeral in 1901, catching the light and the shade. Yet he had nothing to say in this essay about photography, the great nineteenth-century invention which changed ways both of viewing and of recording the world. Photography was a triumph of science, but could be conceived of and practised both as an art and as a trade.

There are many excellent histories of photography, and this book is not just another of them. It appears at the time of the 150th anniversary of photography, when there is far more interest in the Victorians, their achievements and their limitations, than there was when Young painted his portrait; and it draws on the work of historians who have transformed our understanding of the period since Young wrote. It is concerned with Victorian life and values as seen through the work of studio photographers, and the portraits assembled in these pages are treated as witnesses – witnesses that speak for themselves, but nevertheless require historical cross-examination. They require at least as much historical cross-examination as caricatures, the kind of caricatures of Victorian people that Young was reacting against when he wrote his essay.

That he himself might interpret them inadequately has been suggested by Bevis Hillier in his *Victorian Studio Photographs* (1976). The Victorians in their photographs, Young observed in a shorter and later essay, look 'more noble' than the moderns. Hillier disagreed, as he also disagreed with the proposition that 'there were giants on the earth in those days'. It was simply that they were 'more *extreme* in their appearance'.

It took time for the Victorians themselves to appreciate that 'the eye of the camera' is not an impartial eye whether it is dealing with people or with places. The idea that photographs present 'actuality' or reveal what is 'true' requires to be particularly critically considered within the context of the century when photographs first appear as witnesses. Alan Thomas in his fascinating historical study *The Expanding Eye* (1978), subtitled *Photography and the Nineteenth-Century Mind,* has rightly dealt in detail therefore with

A view of Princes Street, Edinburgh, by James Valentine of Dundee. Almost identical to an earlier George Washington Wilson photograph, this busy scene was photographed from a first-floor balcony. Gernsheim cites this as an early example of instantaneous photography, although clearly a degree of movement is recorded. This must have proved a highly saleable photograph as the two most prolific companies photographing Scottish views deemed the scene worthy of recording from almost identical viewpoints.

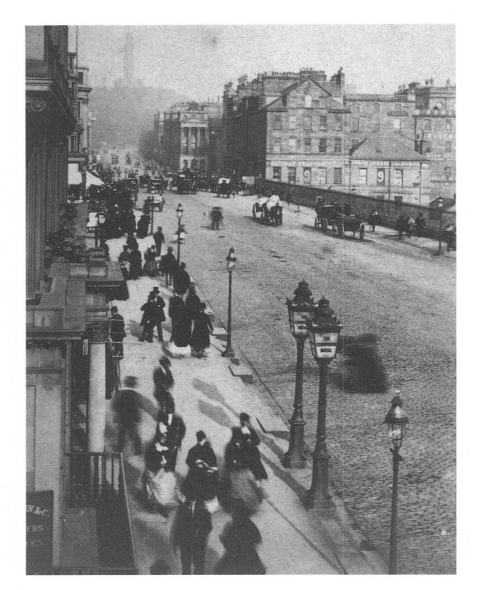

complexities in the inter-relationships between photographers and patrons and between photographers, patrons, critics and historians.

Towards the end of his *Portrait of an Age* Young quoted John Constable's remark that 'painting is a science of which pictures are the experiments', and Thomas placed the Victorian photographer very firmly at the centre of his own picture:

> For many reasons the Victorian photographer appears as a representative figure, to be associated with that period and no other: typically sunk down on one knee on drawing-room carpet, head concealed beneath black cloth as he consults the viewing-glass, hand upflung in an appeal for stillness – fixing the image, as it were, with his gesture – the photographer expresses both the scientific capacity of the age and the restricted rigidities of its vision.

'Restrictive rigidities' is a powerful phrase. The history of photography is not just the history of techniques or arts: it is part of social history; it fixes images, and the Victorians were conscious image makers. They were conscious too that photography was one of the wonders of their age. Lady Eastlake, wife of the President of the Royal Academy, was particularly shrewd when she recognized in 1855 that the invention of photography was 'neither the province of art, nor description, but of a new form of communication between man and man'.

Most Victorians concentrated either on the art and techniques – some seeing photography as a 'foe-to-graphic art' – or on the underlying science. Thus, in a characteristic late Victorian assessment of the scientific triumphs of the reign, the biologist Wallace devoted one whole chapter of his book *The Wonderful Century: Its Successes and Failures* to the scientific invention of photography, 'a totally new departure'. *The Wonderful Century* appeared in 1898, one year after Queen Victoria's Diamond Jubilee.

As a scientist, Wallace was familiar with the story of the development of pre-Victorian science that led back through optics to the *camera obscura* – photography had its pre-history – but he had curiously little to say about the details of the development of photo-

Punch, founded in 1841, never failed to find fun in photography. It focused both on the photographers and on their subjects, identifying set types rather than individual likenesses. In this John Leech cartoon from 1862 *Punch* depicts two members from the 'lower reaches of society' stepping into a studio to have their photographs taken. Studio details typical of the period are the glass roof and the photo finisher-cum-artist busy in the corner of a clearly cramped premises.

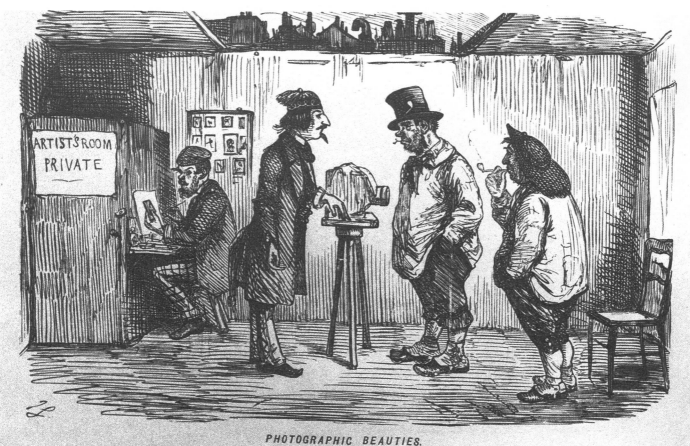

PHOTOGRAPHIC BEAUTIES.

"I SAY, MISTER, HERE'S ME AND MY MATE WANTS OUR FOTERGRUFFS TOOK; AND MIND, WE WANTS 'EM 'ANSOM, COS THEY'RE TO GIVE TO TWO LADIES."

graphy, a continuing process, throughout what in retrospect were 'formative' Victorian years. In recent times, however, the story has been told frequently in close detail. It has been of particular interest to collectors both of photographs and of cameras – and there are large numbers of them – but at the same time, given the development of social history, it has increasingly appealed to historians. Since the 1950s they have become more concerned with visual (and oral) as distinct from documentary history. They now treat photographs (and films) as necessary evidence.

Like the history of almost any Victorian invention, the history of photography has many twists and turns, culminating, according to the standard accounts, in the invention of the box camera and the motion picture. There, they explain, is the way into the twentieth century. But there is also general agreement that the year 1839 was a landmark, the first important date in a long sequence of inventions, some far better known than others. It was in that year that not one but two practical versions of photography – and the word 'practical' is significant – were announced to the world, neither of them at that point in the story described as 'photography'.

Louis Daguerre, a Frenchman with no scientific training, following in the footsteps of Nicéphore Niépce, introduced in Paris what was proudly proclaimed amid much fuss as 'a new art in the midst of an old civilization'. The daguerreotype, an image produced on a silver plate or a silver-covered copper plate, was named after him. On this side of the Channel, William Henry Fox Talbot, a gentleman artist with considerable scientific knowledge, announced his 'calotype' (from the Greek word for beautiful). His process involved sensitizing paper with solutions of nitrate of silver and iodide of potassium and fixing an image with other chemicals.

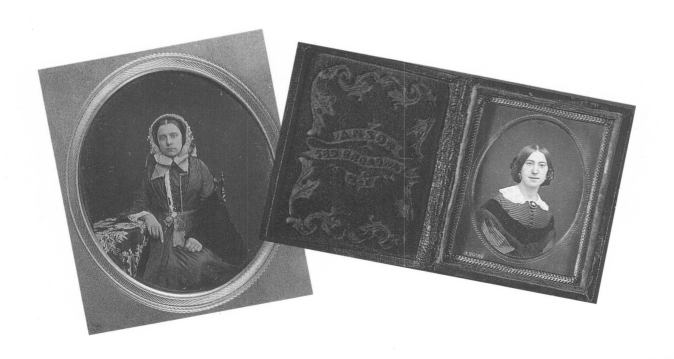

Fox Talbot, who thought of his process as 'photogenic drawing', was to write in his manual, *The Pencil of Nature* (1844), the first photographically illustrated book, that 'when a group of persons has been artistically arranged, and trained by patience to maintain an absolute immobility for a few seconds of time, very delightful pictures are easily obtained'. The language is more revealing than any photograph – 'artistically arranged'; 'absolute immobility'. And Fox Talbot, educated at Harrow and Cambridge and a former Member of Parliament, revealed much about himself also when he went on to frame the question:'What would not be the value to the English Nobility of such a record of their ancestors?'

Queen Victoria was both an early patron of photography and an early subject – the first calotype portrait of her, posed with the Prince of Wales, was taken in 1844 or 1845. Yet it was not for the nobility but for the larger and increasingly prosperous middle classes that the first photographic portraits were to be produced in large numbers.

Most of the early business – and it was soon thought of as a business – went not to calotype portraitists, but to daguerreotypists. Indeed, if the studio photographer is a representative figure of the Victorian period, as Thomas claims, the daguerreotype seems one of the most representative of early Victorian things. For the Japanese-German novelist Sadakichi Hartmann, coiner of the phrase 'the Valiant Knights of Daguerre' (1902), it was difficult to resist the temptation to take a forgotten daguerreotype from its case. 'The image of some gentleman with a stick or some lady in a bonnet and puffed sleeves appears like a ghost-like vision.' Daguerreotypes were 'shining sorceries'.

On 23 March 1841 the first public photographic studio in Europe was opened on the roof of the Royal Polytechnic Institution by the daguerreotypist Richard Beard, a coal merchant and part-time inventor and speculator, who had acquired English patent rights from Daguerre in 1840. He was soon making what was then the large sum of £150 a day. Queen Victoria bought her first daguerreotypes in 1840, but it was Beard's great rival, Antoine Claudet – they fought a bitter patent war – who in 1853, three years after Beard had gone bankrupt, became 'photographer-in-ordinary' to the Queen, a memorable title.

There were so many improvements during the 1840s both in calotype and in daguerreotype photography – the word 'photography' was still not used – that the early achievements of Daguerre and Fox Talbot could already be seen as only the beginnings.

The year 1851, the year of the Great Exhibition in the Crystal Palace, was the next outstanding date in a continuing sequence of inventions relating to the technological advancements in photography. It was then that Frederick Scott Archer, a sculptor and

Cartes-de-visite designed especially as introductory items for photograph albums. These were sold by studios, stationers, booksellers and fancy-goods repositories.

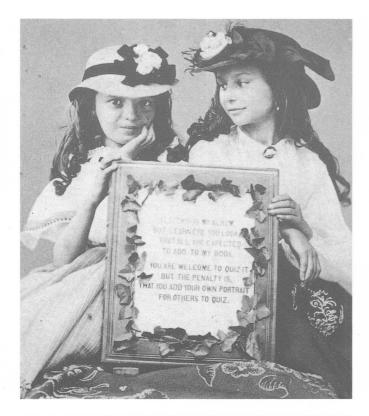

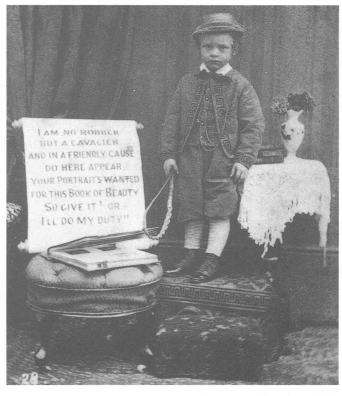

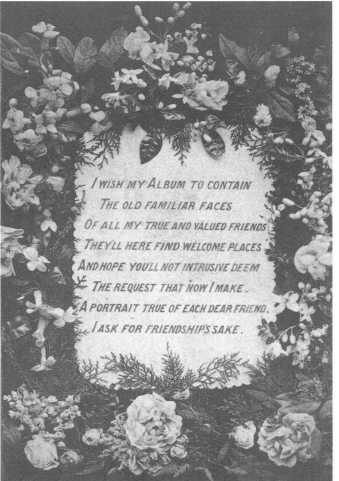

I WISH MY ALBUM TO CONTAIN
THE OLD FAMILIAR FACES
OF ALL MY TRUE AND VALUED FRIENDS
THEY'LL HERE FIND WELCOME PLACES
AND HOPE YOU'LL NOT INTRUSIVE DEEM
THE REQUEST THAT NOW I MAKE
A PORTRAIT TRUE OF EACH DEAR FRIEND
I ASK FOR FRIENDSHIP'S SAKE.

HAIL TO THE PHOTOGRAPHIC ART!
WHICH SUCH PURE PLEASURE CAN
IMPART:
DEPICTING ON THE ALBUM'S PAGE,
FROM BABYHOOD TO HOARY AGE,
THE FORMS WHICH OUR BEST LOVE
ENGAGE.

HAIL SCIENCE, HAIL INVENTIVE
MIND!
WITH HAPPY SKILL ALL THUS COM-
BIN'D,
TO FURNISH FORTH A PURE DELIGHT,
AIDING THE MEM'RY THROUGH THE
SIGHT,
AND BRINGING CHERISH'D FORMS
TO LIGHT.

The *carte-de-visite* shown here (actual size 2½ x 4 inches) was the first type of photograph that could be marketed at a price that large numbers of people could afford. Its popularity soared from 1859 to a peak during the mid-1860s, but it was the mainstay of many studios until the end of the century. The pioneer was Disdéri whose popularity declined with the fall of Napoleon III's Second Empire in 1870.

calotype photographer, who was to die penniless in 1857, devised wet plates. Using collodion, a recently discovered material produced by dissolving gun cotton in ether mixed with potassium iodide, he coated glass plates, subsequently sensitizing them by plunging them into silver nitrate. The plates were exposed immediately while still wet and straight after exposure were developed, fixed and washed.

Wet plate photography was a messy, unpatented process, but it reduced exposure times to a few seconds and allowed, as did Fox Talbot's calotype process, for the making of multiple copies. By contrast daguerreotypes, much improved after 1839, were unique pictures. It was wet plate photography, itself greatly improved after

Opposite: The cabinet portrait (actual size 4 x 6½ inches) to some degree eclipsed the *carte-de-visite*. Its larger size offered greater versatility in relation both to composition and to quality, and in some respects it offered a foretaste of the ubiquitous picture postcard of the Edwardian era.

Cabinet Portrait. *1878*

CHANÇELLOR, Photo. REGISTERED LOWER SACKVILLE S?. DUBLIN

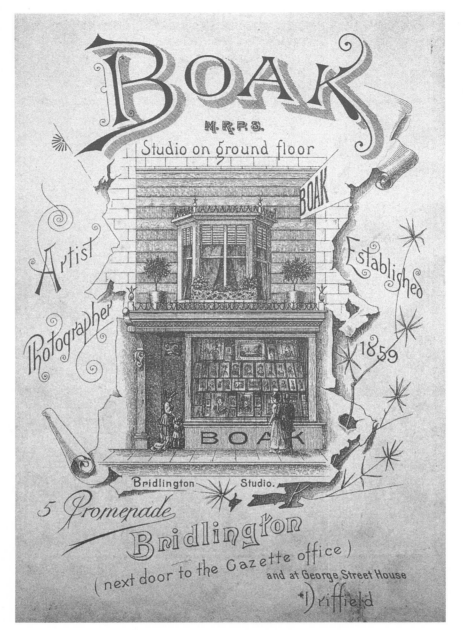

The design used by Mr Boak, *c.* 1885, on the reverse of his cabinet portraits was not one of the standard patterns offered by the photographic wholesalers. It was specially created by a local artist to replicate the actual studio frontage. Customers can be seen entering the studio and photographs are displayed in the windows of the studio shop. The design is very non-photographic.

1851, and the invention of albumen printing paper that made possible the great mid-Victorian expansion of photography through the *carte-de-visite*. J. Towler in his book *The Silver Sunbeam* (1864) described daguerreotypes, calotypes, ambrotypes, tintypes, platinotypes and albumen paper prints, but by then both daguerreotype and calotype processes were virtually obsolete. Between 1861 and 1867, it has been estimated, between 300 and 400 million such *cartes-de-visites*, as they were called at the time, were marketed each year.

During the mid-Victorian years the word photography, derived from the Greek words *photos* (light) and *graphics* (drawing), entered the English and other languages. It is said to have been devised by the astronomer Sir John Herschel, who had himself contributed to

the events of the birth year of photography, 1839, by explaining to Fox Talbot how 'hypo' (hyposulphite of soda) was an ideal material for fixing a photographic image, a point immediately appreciated not by Fox Talbot but by Daguerre. Herschel also took a picture of his own in 1839, now preserved in London's Science Museum, by laboriously precipitating silver chloride on to a glass plate. Later in the century, he is said to have coined the word 'snapshot'.

Snapshots and all that came with them as photography was 'democratized' have been the subject of many specialized histories; and it was a genuine revolution when, in 1888, George Eastman added a genuine new word, 'Kodak', to the English and other languages. At the same time he promised to 'furnish anybody, man, woman or child, who has sufficient intelligence to point a box straight and press a button...with an instrument which altogether removes from the practice of photography the necessity for exceptional facilities, or, in fact, any special knowledge. It can be employed without preliminary study or a darkroom and without chemicals.'

Meanwhile, in 1873, the first gelatin dry plates had come on to the market and by 1888, ten years after Charles Bennett had improved the dry plate process, the older wet collodion process had become obsolete. It was no longer necessary even for a professional photographer to carry a dark tent and a chest of chemicals when photographing outside his studio, and inside the studio photo-

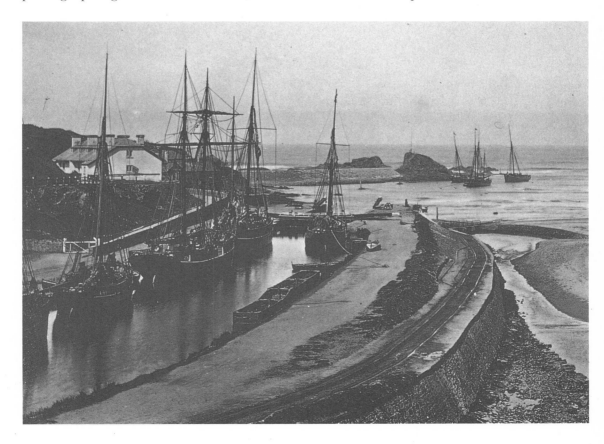

A peaceful view of the quayside at Bude in Cornwall. Photographs of local landmarks and views were the stock in trade of many studio photographers long before the age of the picture postcard and could be bought in many sizes, most commonly between that of the *carte-de-visite* and 10 x 8 inches. They were usually unmounted, so that they could be pasted into family travel albums.

Electric light, widely introduced during the 1880s, changed the operational rhythms of a studio. Once reliant on reasonably strong daylight, photographers could now offer sittings on overcast days and evenings. The French photographer Nadar used electricity in his studio as early as 1860.

graphy was speeded up. In 1888 the first reliable exposure meter, the Actinograph, was marketed.

There are no snapshots in this book which, while it concerns the whole of Queen Victoria's reign, concentrates on studio portraits. The photographers who took them did not all enjoy 'exceptional' facilities, but they all depended on a cluster of human skills in order to earn their living. In addition to studio portraits there are many 'outside' photographs, also taken by professional photographers, who began to 'collect places' – urban and rural – as well as people during the 1850s and 1860s. Topographical *cartes-de-visite* preceded postcards. There were always two sides to the work of the photographer – studio/outdoor – as there always have been two sides to twentieth-century television. There were photographers' vans a century before television vans. And street-corner photographers were numerous enough to be 'a public nuisance'.

'Cartomania', the noun derived from *carte-de-visite*, was only one version of 'photomania' – another was 'stereomania' – but while it lasted it had a big enough social impact for it too to have been described by the distinguished American historian of photography, William C. Darrah, as 'a photographic revolution'. In his scholarly book *Cartes-de-Visite* (1981), he quotes a comment of the 1860s: 'Card portraits, as everybody knows, have become the social currency, the "greenbacks of civilization" ' – a remark which could also have been made about 'golden sovereign' Britain.

As in the case of most Victorian inventions, there have been many claims and counter-claims as to who first introduced *cartes-de-visite*, but there can be no argument about the central role of another Frenchman, André Disdéri, whose *cartes* constitute a rich visual archive in themselves. It was he who introduced the name, the method of producing the product and the actual format of the *carte-de-visite* in 1854. Albumen silver prints pasted on to a card

A typical example of a decorated album page, *c.* 1880. These delightful chromolitho leaves were usually printed in Germany. Not all chromolithography, a nineteenth-century invention, was as attractive.

allowed you to collect 'living celebrities' as well as family portraits. However, the *carte* did not really take off until 1859 with the publication of Disdéri's photographs of Napoleon III.

By the end of the 1860s cartomania was international. Again Queen Victoria played her part. J. E. Mayall, an American daguerreotypist, published a set of royal portraits in 1860 and a second and a third series in 1861 and 1862. Followed by other series of portraits, they made their way round the world. Mayall became court photographer with the enthusiastic blessing of the Queen, who was one of the earliest collectors of photographs of all kinds. Indeed, in 1860 one of her ladies-in-waiting, the Hon. Eleanor Stanley, reported a remark that 'the Queen could be bought and sold for a photograph'. Victoria went on to patronize photographers even after she had gone into mourning on her husband Prince Albert's death in 1861. She was consoled by the fact that when Albert had gone she still had his photographs. She also kept family albums – no fewer than 110 of them.

Some of the portraits assembled in this book, like the pictures in her albums, have artistic claims to be set alongside painters' portraits, including the miniatures and silhouettes that were popular on the eve of the development of photography, and the last chapter of this book deals with 'inspiration' in photography. Yet most of the chapters relate less to art than to life and to the experiences – and values – of the Victorians. We continue in the late twentieth century not only to fall back upon (or attack) those values but to depend in many aspects of life on a Victorian infrastructure, much of it hidden. We are often unaware of the extent of our debts – and burdens – and we are even more unaware of the nature of Victorian experiences. Historians, with the help for the first time of photographers, have to try to uncover them.

They were contrasting experiences – and the Victorians themselves were conscious of the contrasts – and the values were clashing values. There was never one immutable or indisputable code which commanded universal assent. Moreover, there were significant shifts in values during the reign, with critics of traditions, conventions and institutions prominent in every phase of it. There was doubt as well as faith, nonconformity as well as conformity, pessimism as well as optimism. Above all, there was no ultimate sense of permanence.

Every chapter in this book, which illustrates attitudes and values, includes positives and negatives – 'work' and 'idleness', for example, 'success' and 'failure'. Even the idea of progress always had its critics.

For G.M.Young the very diversity of historical approaches adds to the appeal of history as a subject. Towards the end of his *Portrait* he wrote that 'to impose an Interpretation of History on history is

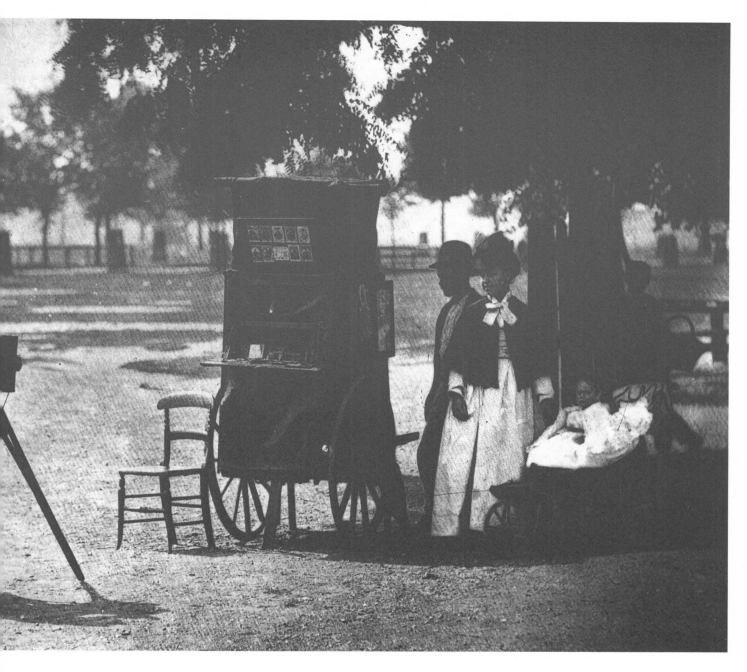

to fall into the error, or to commit the presumption, of saying that...if we were sufficiently enlightened, we should see all chairs as Van Gogh saw them.' And certainly, *pace* Bevis Hillier, he would have objected if he had thought that all future historians would see the Victorians individually or *en masse* just as he did.

Each photograph in this book has its own history. The captions which accompany them – are as essential reading, therefore, as the text of the chapters. Sometimes the very titles of the photographs speak for themselves. Oscar Rejlander's famous photograph 'The Two Ways of Life' was sub-titled 'Industry and Dissipation'; another series of photographs with abstract titles included the title 'Truth'.

An itinerant portrait photographer offers his services on Clapham Common (*c.* 1873). His barrow provided instant processing facilities, so that a portrait, often of dubious quality and permanence, could be photographed and finished in a few minutes.

The Reeves Studio, established in Lewes in 1858, although enlarged somewhat during the 1930s, is a remarkable example of continuity. It retains its original glasshouse design, and Tom Reeves still photographs his customers in a setting which is quintessentially Victorian. The glass wall faces east, while the skylight is angled slightly to receive the soft north light. The continuity might have been broken when, during the devastating gale of 1987, a falling tree, close to the studio, missed this delicate structure by inches. Lewes is my own home town and I have known Tom Reeves since he was a boy.

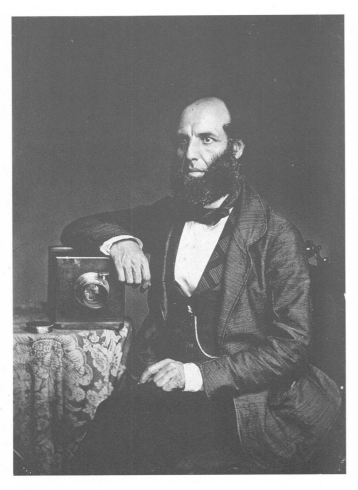

Above: Edward Reeves, jeweller, watchmaker and photographer, and founder of the studio at 159 High Street, Lewes. This half-plate tinted ambrotype shows Edward Reeves with one of his first wet-plate cameras, and dates from the late 1850s. It was when Reeves lost his entire stock of watches and clocks in a burglary that he turned to photography.

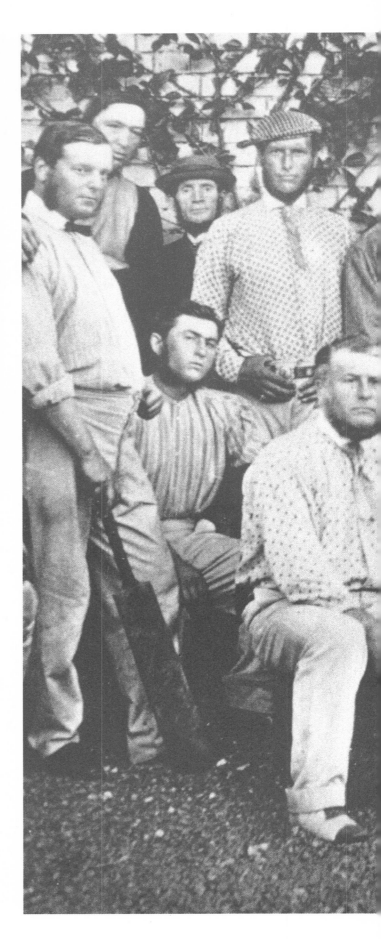

Right: A seemingly informal group of cricketers posed in the garden of Edward Reeves's studio. It is interesting to note the variety of garb worn for the game.

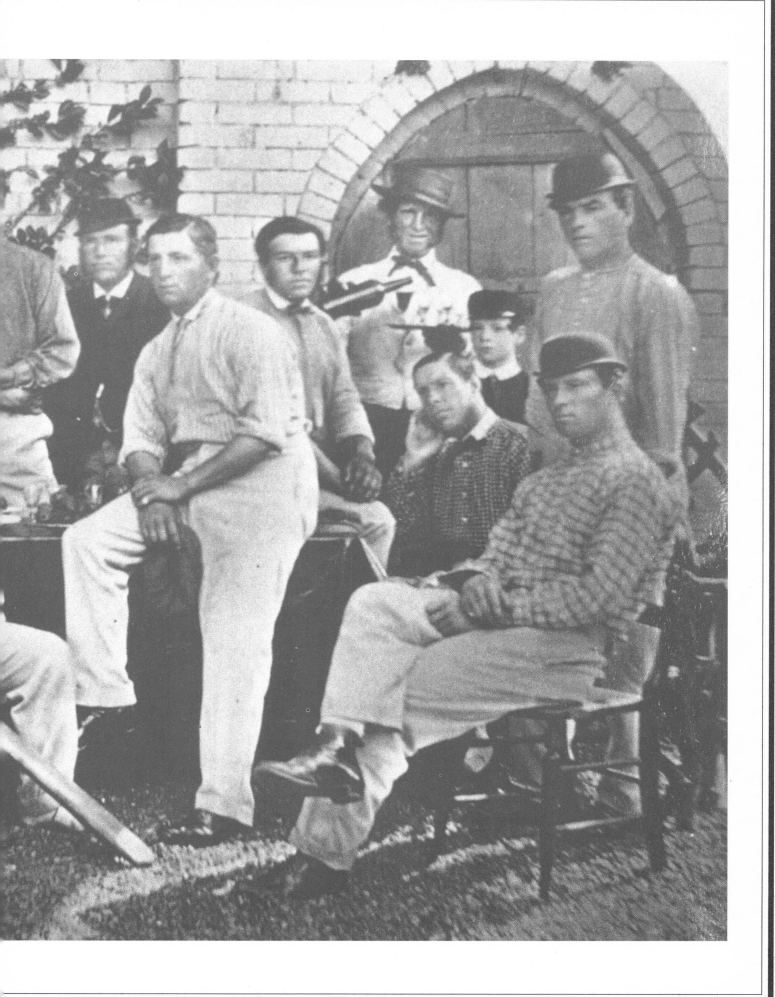

Right: A chime of six little bells attached to a handle which Edward made to charm his youngest sitters. Bell ringing was a favourite Victorian pastime which has survived in Lewes and elsewhere (Tom Reeves himself is a bell ringer).

Below right: Balanced precariously on top of the camera in this photograph is a little high-wire man used also to distract awkward children.

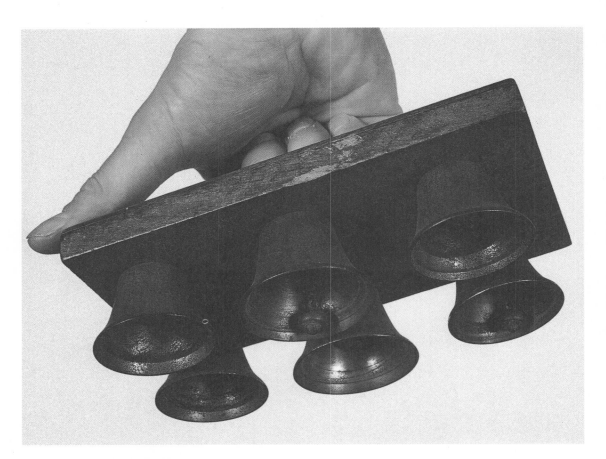

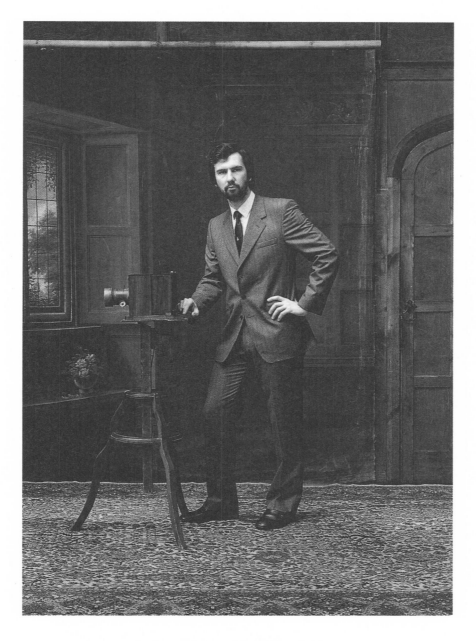

Edward Reeves's great grandson Tom poses
in Victorian fashion in the studio with one of
the family's early quarter-plate wet-plate
cameras by W. W. Rouch of London.

This page: Examples of Edward Reeves's early work from the 1860s. The reproductions reveal the whole image from these quarter-plate glass negatives. Such contact prints would have a *carte-de-visite*-sized image cut from them. Numbers and titles would be scratched in the original margin for filing.

Opposite: Scratched down the edge of this negative of a Sussex villager who found his way to the Reeves Studio are words that had amused Edward. The villager had announced himself thus: 'I am a *young* man from...' The Victorians treasured the contrasts between young and old as much as between rural and urban. The contrasts between rich and poor often alarmed them.

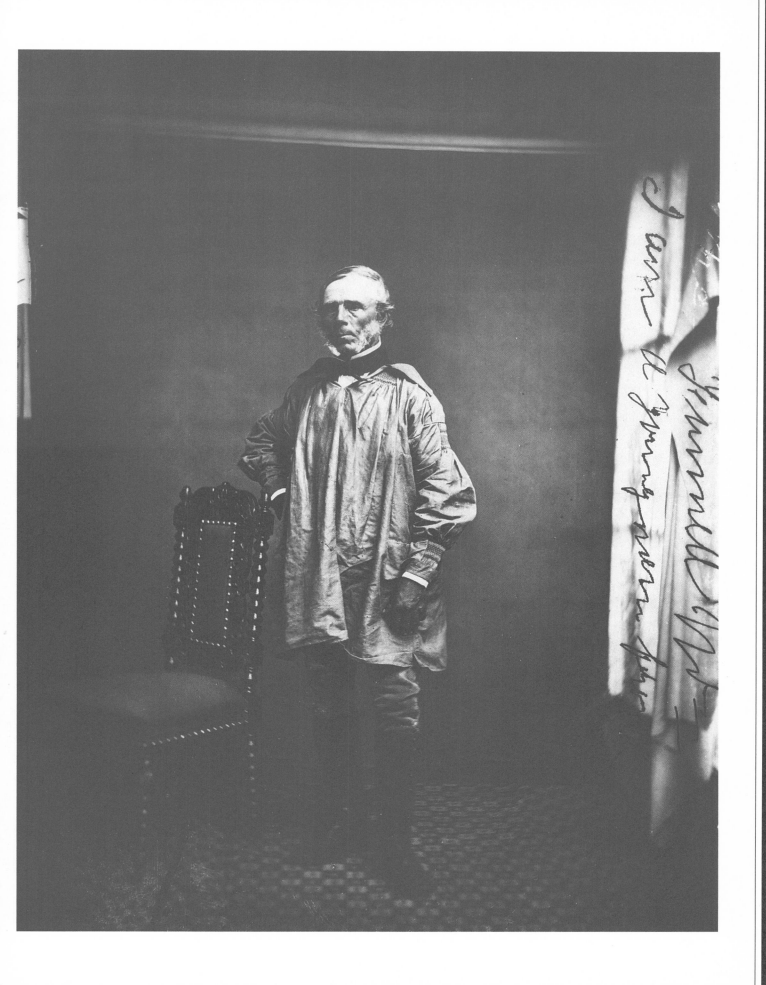

CHAPTER TWO
PROGRESS

There were many signs of tension and conflict during the early Victorian years, but by 1851, the year of the Great Exhibition, there seemed to be far more signs of progress. Indeed, progress became one of the fashionable words of the nineteenth century. The Exhibition itself, recorded in photographs as well as in paintings and prints, seemed to make progress visible. The objects on display from all parts of the world included large numbers of materials and machines from Britain, 'the workshop of the world', far ahead, it seemed, of all her competitors. These for the novelist W.M.Thackeray, the subject of a striking *carte-de-visite,* were 'the trophies of her bloodless war'.

A note of confidence, even of complacency, was struck in an equally assured manner in 1851 by statisticians and by popular poets, so that we can set alongside the statistical tables of material progress presented in G.R. Porter's great work, *Progress of the Nation,* which went through many editions, the sonnets of the popular poet Martin Tupper. Both proclaim the same message. It is significant that the first edition of Porter appeared in 1836, one year before Queen Victoria came to the throne. The foundation of Britain's commercial and industrial prosperity had already been laid.

As he collected statistics of coal and cotton, iron and railways, ships and foreign trade – all that had made Britain 'the workshop of the world' – it seemed 'almost a duty' for Porter 'to inquire into the progress of circumstances which has given pre-eminence to one's own nation'; while for Tupper, writing of 'the world's wonderhouse', the Crystal Palace, it seemed that in twenty years the fortunes of 'common humble multitudinous man' had advanced more rapidly than ever before in history:

> Our flag of progress flaming in the van!
> This double decade of the world's short span
> Is richer than two centuries of old:
> Richer in helps, advantages and pleasures,
> In all things richer – even down to gold.

There was more of moralizing here than there was poetry, but there could be genuine poetry in the response to some of the great inventions of the period, particularly the railways, which for Thackeray represented the beginning of a new era. Life before railways, he claimed, was like life before Noah's Flood.

The great Victorian historian Lord Macaulay was supremely

confident when, earlier in the century, he took a longer look at the future of his country. 'The history of England is emphatically the history of progress,' he claimed. Nor had he many doubts when he projected progress into the future. In the year 1930, he prophesied, a far larger and richer population would be 'better fed, clad, and lodged' than it had been in 1830, and would live longer and healthier in bigger cities. There would be machines 'constructed on principles yet undiscovered...in every house'.

The year 1851 was a special vantage point from which to look backwards and forwards. Yet during the fifty years that followed, the economy did not advance evenly. For some historians looking back, there even seem to have been signs of a decline in 'the industrial

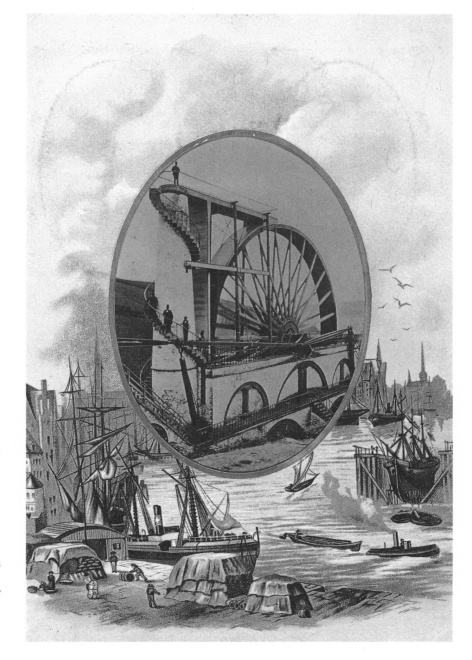

The 'Great Wheel' of Laxey, on the east coast of the Isle of Man, was built in 1854 to pump water out of local lead mines. Given the endearing name of 'The Lady Isabella' by local inhabitants, it has survived the local mines to become an island tourist attraction. Water power continued to be used in the age of steam.

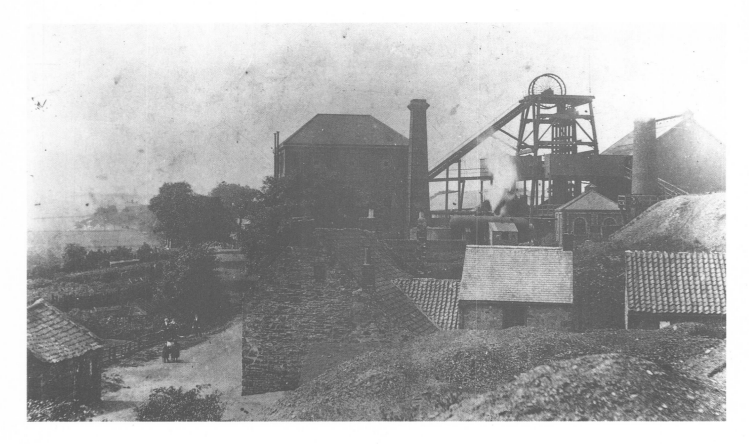

Steam power was first employed for pumping purposes in mines. This is a general view of Twizell Colliery.

spirit': technology ceased to excite the imagination.

There is room for continuing argument on such matters as there is about the statistics. Production levels continued to rise, but profit margins were reduced during the 1880s and 1890s when there was talk of a 'great depression'. The term has rightly been questioned, and in the middle of the period the scientist T. H. Huxley, Darwin's great supporter, could write as confidently as any of his predecessors that 'the most obvious and the most distinctive feature of the History of Civilization during the last fifty years is the wonderful increase of industrial production by the application of machinery, the improvement of all technical processes and the invention of new ones, accompanied by an ever more remarkable development of old and new means of locomotion and intercommunciation'. His essay in which this passage appears is called 'The Progress of Science'.

One new point was as clear to Huxley as it was to inventors and to economists: Britain's earlier industrial revolution, resting on enterprise and invention, had not been unique. Some economists had foreseen this. As early as 1848, when continental Europe was torn by political revolution, John Stuart Mill, economist and philosopher of liberalism, had written that 'most of the other nations of the world, including some yet not founded', would successfully 'enter upon the same career' as Britain had already done.

Industrial revolutions in Germany and the United States dur-

ing the last decades of the nineteenth century enabled those countries to forge ahead in the production of steel and its alloys, in the use of electricity and in the application of science to industry at a time when Britain seemed already to be suffering from its early lead in the age of iron – and textiles. There were repercussions also on international trade. From 1875 to 1895, while the value of British exports stood still – volume rose substantially in a period of falling prices – the value of German exports rose by 30 per cent and volume correspondingly more. British coal production remained greater throughout Queen Victoria's reign than that of Germany or of the United States, but fears had long been expressed about British dependence, particularly in the export trade, on a diminishing national asset.

Not much of this story is captured in photographs, which recorded war – and travel – more effectively than trade. As the report of the Royal Commission on Historical Monuments put it, for every photograph of a textile mill there must be hundreds of 'ruins'. Yet a sequence of photographs of locomotives produced in the Crewe works by the London and North Western Railway from 1865 onwards tells something of one part of the story, and great engineers like Isambard Kingdom Brunel appeared among the *cartes-de-visite* celebrities. There are some photographs, too, of working people, although there are more of the workers in old pursuits, like David Octavius Hill's fisher folk, than there are of workers in industry.

It is difficult from photographs to capture the sense – obvious enough in the history of photography itself – that, as Mill put it, progress was a law of development. In 1848 he wrote:

> Whatever may be the other changes which the economy of society is destined to undergo there is one actively in progress, concerning which there can be no dispute. In the leading countries of the world, and in all others as they come within the influence of those leading countries...with little interruption from year to year and from generation to generation [we can trace] a progress in wealth, an advancement of what is called national prosperity. All the nations which we are accustomed to call civilized increase gradually in production and in population.

Malthus would have treated the increase in population as a threat – and would have felt that his warnings were useful if he had seen some of the mid-Victorian photographs of very large families – and Marx, while impressed by the new productive potential, would have focused attention on the respective shares of employers and employed in the fruits of industry and on the inherent class conflict that in his view would inevitably lead to revolution. (Engels's study of Manchester in the 1840s might have been illustrated by photo-

Fascinated by photography but sceptical of claims made for it – and for Victorian progress – John Ruskin, prominent critic, author, artist, social reformer and an enthusiastic amateur photographer, is seen here in one of a series of portraits by Elliott & Fry (*c*. 1870). Ruskin was one of the most photographed men of eminence of his time. 'Learn to use your own two eyes as God made them' was his advice to his own generation.

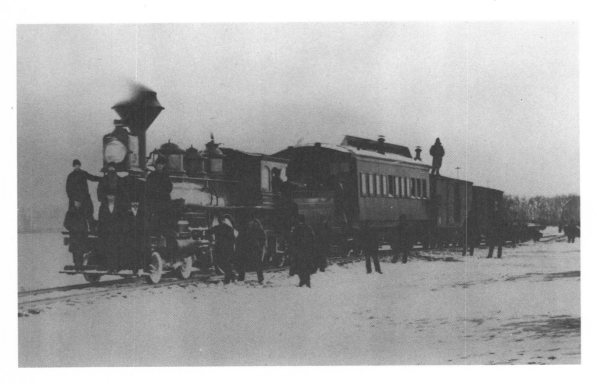

The railway was a symbol of progress, but it was also an instrument of disaster. It opened up the American continent, although the geography and economics of railway development were always controversial. This photograph shows the first train over the Missouri River, on tracks laid on ice, in March 1879.

graphs.) In the same year in which Mill wrote, a year of revolutions, the formidable Scot Thomas Carlyle, Victorian prophet, argued on very different lines from Marx that revolution was imminent. It did not come, and that added to mid-Victorian complacency. Yet there were always observers, even in 1851 itself, who thought that things were getting worse. Occasionally the camera exposed them. Some late Victorian photographs tell us more about poverty than they do about wealth. The photographers who took them were, as Gail Buckland has written in *Reality Recorded* (1974), 'eye witnesses to the state and condition of society'.

Neither John Ruskin, who tried to teach his contemporaries how to look at Nature, Art and Society, nor, writing later in the nineteenth century, William Morris, a maker of things as well as a critic of them, thought much of the century in which they were living. They contrasted it with the Middle Ages and, in the case of Morris, who tried to teach his contemporaries how to act as well as how to look, with a 'utopia' set in the future.

Other observers, less politically motivated, discerned 'a solid layer of savagery beneath the surface of society', an observation of the painter G. F. Watts. (Some photographs bear this out.) According to the anthropologist J. G. Frazer, author of *The Golden Bough*, 'we seem to move on a thin crust which may at any moment be rent by the subterranean forces slumbering below.' This aspect of Victorian England, emphasised by Walter Bagehot, for Young the most Victorian of Victorians, is often ignored a century later.

Not all poets were as confident as Tupper. Indeed, there was a predominant note of pessimism in late Victorian poetry. The out-

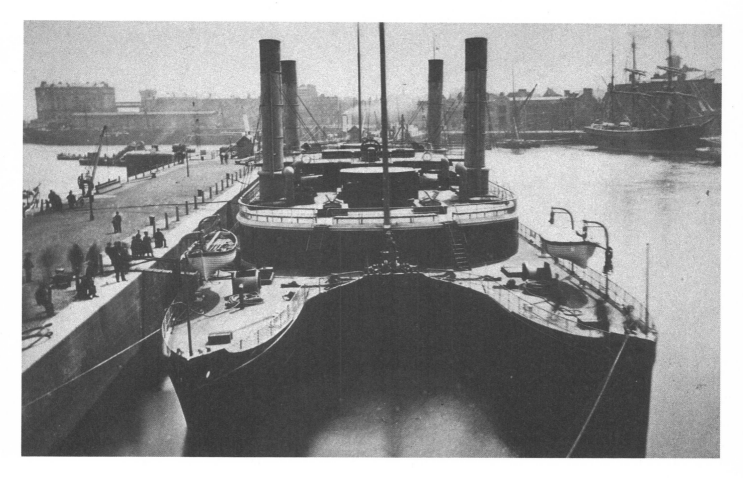

standing poet of Victorian England, Alfred Lord Tennyson, who spanned early, middle and late Victorian years, changed his mind as the reign progressed. It is revealing to compare his poem 'Locksley Hall', published in 1842, with his 'Locksley Hall Sixty Years After', published in 1886. In 'Locksley Hall' he put his faith in science – 'Science moves but slowly slowly, creeping on from point to point' – and while he did not seek to minimize the problems of a 'hungry people' (and there still was a 'hungry people' in 1842, a year of deep depression), he showed confidence in the future:

> For I doubt not thro' the ages one increasing purpose runs,
> And the thoughts of men are widen'd with the process of the
> suns.

By contrast, in 'Locksley Hall Sixty Years After' he feared the growing power of ordinary people, 'Demos', and found no comfort in scientific evolution:

> Gone the cry of 'Forward, Forward', lost within the growing
> gloom;
> Lost, or only heard in silence from the silence of a tomb.
> Half the marvels of my morning, triumphs over time and
> space,

The *Calais-Douvres*, a twin-hulled cross-Channel packet steamer of exceptional power, consumed huge quantities of coal in each crossing. In one season, making a round voyage each day, she carried 50,000 people. She was withdrawn from service in 1887 to become a hospital ship.

> Staled by frequence, shrunk by usage into commonest
> commonplace.

There was despair in his question:

> Where was age so cramm'd with menace? madness? written,
> spoken lies?

It was not only poets who peered into the abyss and asked such haunting questions. Tennyson was impressed by science in the early and middle years of the reign at a time when there were religious leaders who were hostile to the conclusions that scientists were reaching about the age of the earth and the processes of human evolution. And before Charles Darwin challenged many accepted beliefs, J. H. Newman, Anglican turned Roman Catholic, had himself challenged the liberal doctrine that 'education, railroad travelling, ventilation, drainage and the arts of life, when fully carried out, serve to make a population moral and happy'. Once again Lord Macaulay propounded the orthodoxy: 'Every improvement of the means of locomotion benefits mankind morally and intellectually as well as materially' because it 'not only facilitates the interchange of the various productions of nature and art, but tends to remove national and provincial antipathies, and to bind together all the branches of the great human family'.

It is more sensible, perhaps, to put aside the rhetoric and to consider the Victorians as people forced to take account of change whether they liked it or not. A phrase that they often used was 'an age of transition'. They were living in an old time and a new. 'All ages are ages of transition, but this is an awful moment of transition,' Tennyson claimed in a passage quoted by Hallam Tennyson in his *Alfred Lord Tennyson, A Memoir* (1897).

The literary critic Humphry House, who played as important a role in the reinterpretation of the Victorians as G. M. Young did, put it memorably when he observed that

> the Victorians themselves knew that they were peculiar; they were conscious of belonging to a *parvenu* civilization. At one moment, they are busy complimenting themselves on their brilliant achievements, at the next they are moaning about their sterility, their lack of spontaneity. In either mood they are all agog at being modern, more modern than anybody has ever been before. And in this they were right. They took the brunt of an utterly unique development of human history: the industrialization and modernization of life meant a greater change in human capabilities in the practical sphere than ever before had been possible.

Technological advancement was not always in the right direction. HMS *Captain* (*opposite above*), built by Laird of Birkenhead and launched on 29 March 1869, was the world's first sea-going turret ship. She was a twin-screw ironclad with a large spread of canvas, a combination which was to prove her undoing when she ran into a south-westerly gale off Cape Finisterre on 7 September 1870. She capsized with the loss of 472 officers and men, including her designer, Captain Cowper Coles (*above*).
Opposite below: A sad memento that vividly recalls the vulnerability of seafaring in the days of sail. This group of bedraggled survivers from HMS *Captain* was reassembled by the photographers Liddiard of Portsea to record the tragic loss for posterity. Profits from sales of these photographs contributed to a fund for relatives of the lost crew.

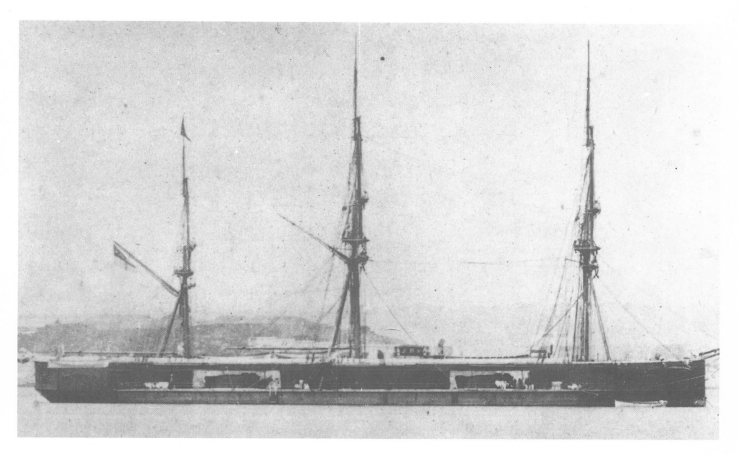

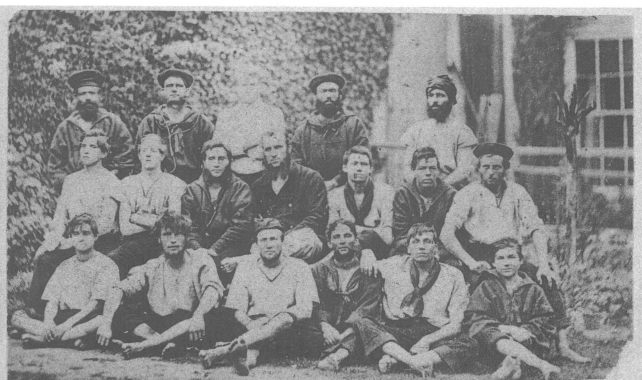

The only Survivors of H.M. late Ship "CAPTAIN," in the same Clothing they wore on landing at Finisterre.

Copyright. LIDDIARD, PHOTO., 182, QUEEN-ST., PORTSEA.

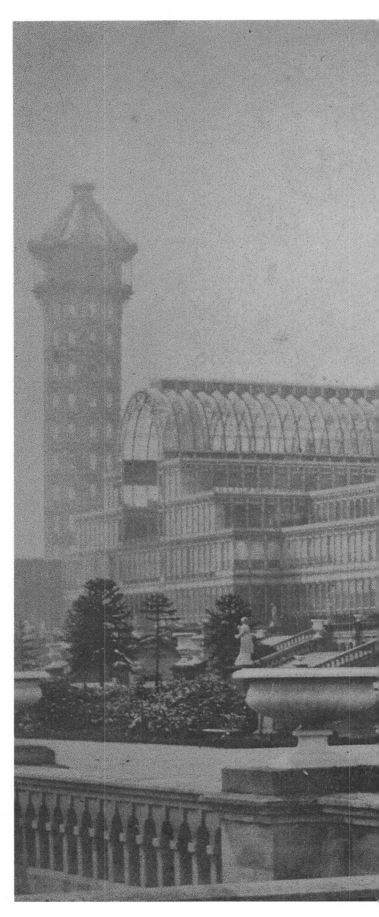

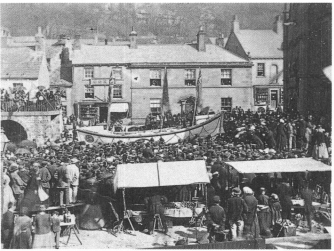

Exhibitions, both permanent and touring, were a popular feature of provincial as well as metropolitan life. They satisfied the demand for advancement and knowledge. After its removal from Hyde Park to Sydenham in 1854, visitors continued to flock to the Crystal Palace to see what was on display and to listen to music. This view of the Crystal Palace *(right)* in the mid-1860s was taken by Negretti & Zambra, who were appointed official photographers after the Palace's move; their logo is shown *far above*.

A different kind of display was that of the lifeboat *Christopher Brown (above)*, photographed on 14 April 1868 in Settle, Yorkshire, far away from the sea. The boat had been bought with local subscriptions and was being presented to the National Life Boat Institution.

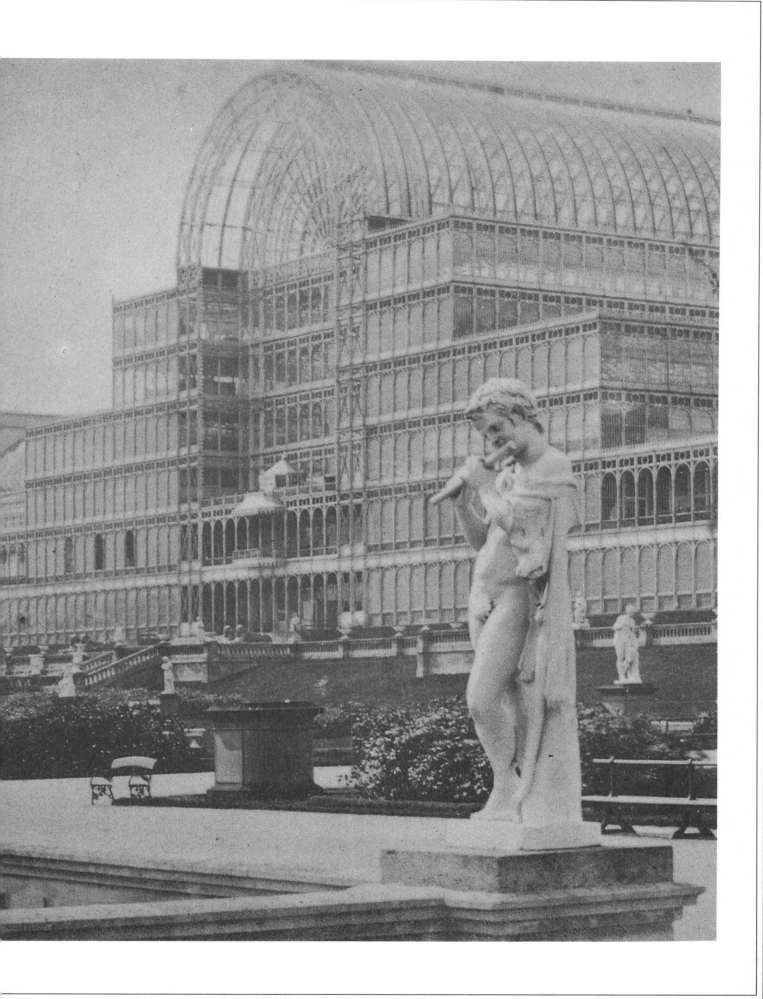

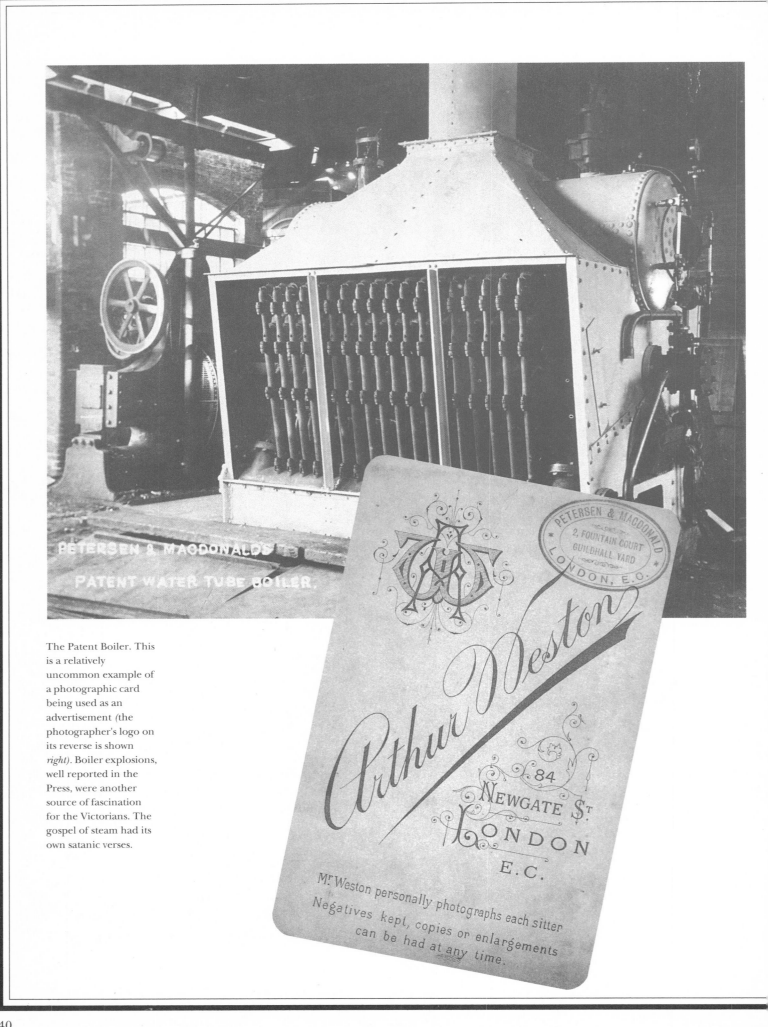

The Patent Boiler. This
is a relatively
uncommon example of
a photographic card
being used as an
advertisement *(the
photographer's logo on
its reverse is shown
right)*. Boiler explosions,
well reported in the
Press, were another
source of fascination
for the Victorians. The
gospel of steam had its
own satanic verses.

PETERSEN & MACDONALD'S
PATENT WATER TUBE BOILER.

PETERSEN & MACDONALD
2, FOUNTAIN COURT
GUILDHALL YARD
LONDON, E.C.

Arthur Weston

84
NEWGATE S⊤
LONDON
E.C.

Mr Weston personally photographs each sitter
Negatives kept, copies or enlargements
can be had at any time.

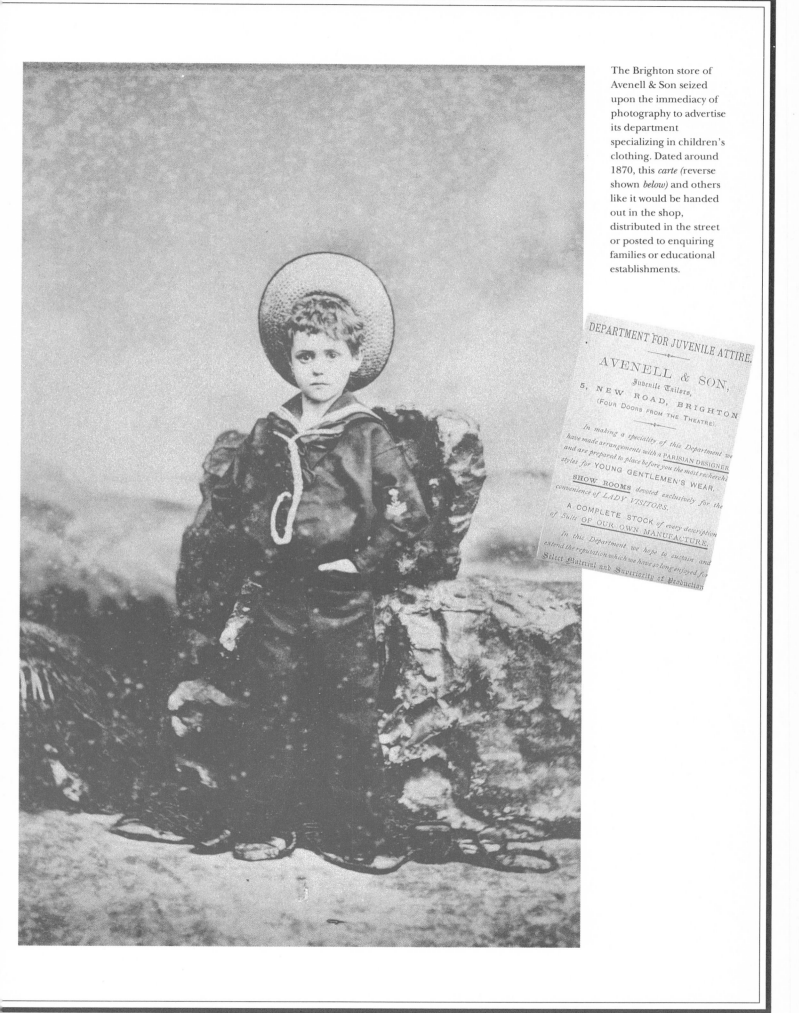

The Brighton store of Avenell & Son seized upon the immediacy of photography to advertise its department specializing in children's clothing. Dated around 1870, this *carte* (reverse shown *below)* and others like it would be handed out in the shop, distributed in the street or posted to enquiring families or educational establishments.

DEPARTMENT FOR JUVENILE ATTIRE.

AVENELL & SON,
Juvenile Tailors,
5, NEW ROAD, BRIGHTON
(FOUR DOORS FROM THE THEATRE).

In making a speciality of this Department we have made arrangements with a PARISIAN DESIGNER *and are prepared to place before you the most recherché styles for* YOUNG GENTLEMEN'S WEAR.

SHOW ROOMS *devoted exclusively for the convenience of* LADY VISITORS.

A COMPLETE STOCK *of every description of* Suits OF OUR OWN MANUFACTURE.

In this Department we hope to sustain and extend the reputation which we have so long enjoyed for Select Material and Superiority of Production.

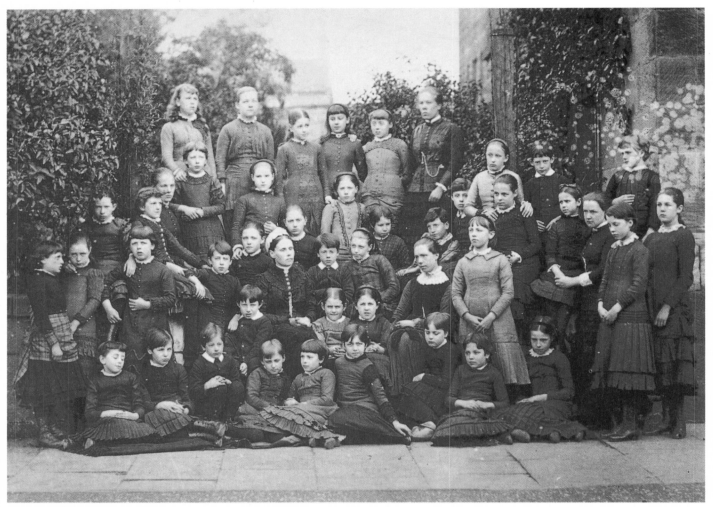

There was a huge social
– and educational –
distance between the
new Board School *(a
certificate issued by one
is shown below)* and the
public school. The two
photographs of school
groups *(above and right)*
bring out contrasts
between a village school
with a motley band of
children and a more
up-market
establishment.

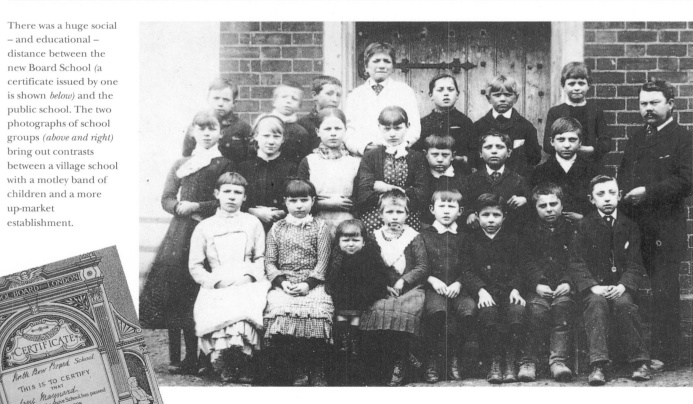

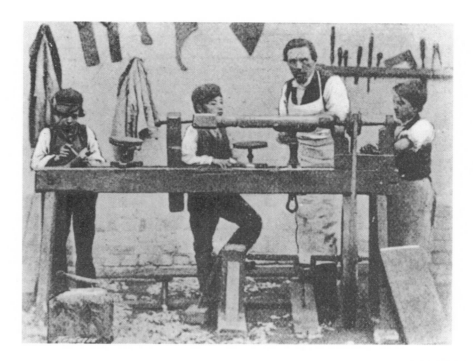

Technical education was relatively
neglected, although it had its eloquent
advocates inside and outside Parliament.
These photographs show apprentices at
Ipswich Industrial Ragged School seeking
to become upright members of society.
Apprenticeship remained the entry to the
working life of the skilled employee on
whom all progress depended.

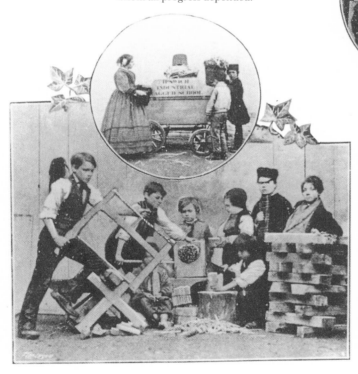

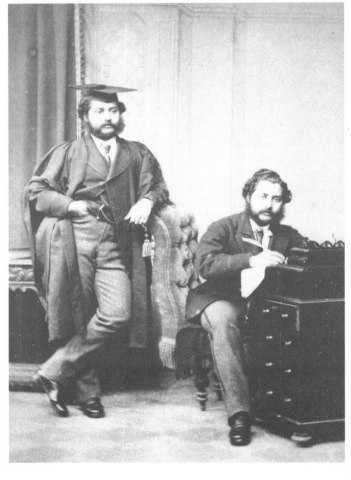

Far above: A group of undergraduates outside Trinity College, Cambridge, 1867.

Above: This portrait appears to be one of twin academics clad in gowns and mortar boards, but close inspection reveals a photographic trick that was often played. One person was photographed twice on the same plate, thus creating the illusion of twins.

Right: A visit by the Prince and Princess of Wales to Christ Church, Oxford, the college of Dean Liddell (seated right), father of Alice around whom Lewis Carroll wrote *Alice in Wonderland*. The date of 1863 would make this one of the earliest public engagements of the royal couple.

LORD H·

TH

E·

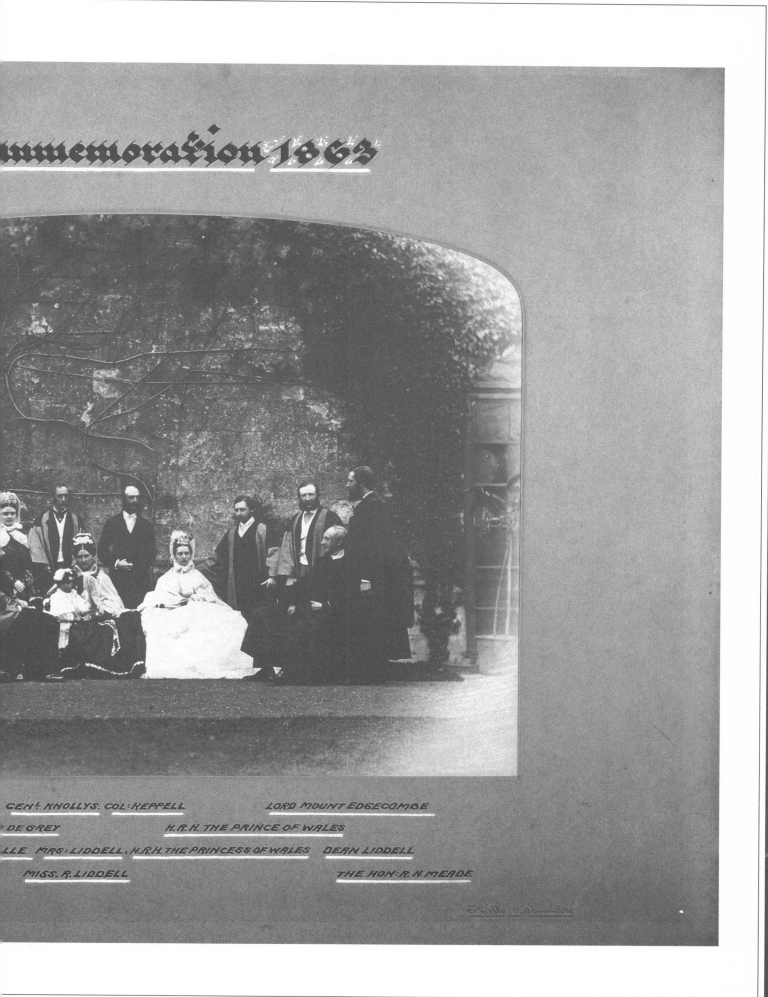

ommemoration 1863

GEN: KNOLLYS. COL: KEPPELL LORD MOUNT EDGECOMBE

DE GREY H.R.H. THE PRINCE OF WALES

LE MRS: LIDDELL. H.R.H. THE PRINCESS OF WALES DEAN LIDDELL

MISS. R. LIDDELL THE HON: R. H. MEADE

Right: Sport was a major feature of mid-Victorian and even more of late-Victorian public-school life and of college life at Oxford and Cambridge. It certainly figured more prominently than science. This photograph by Naudin of London shows the Trinity College, Cambridge, rowing eight with their cox, *c*. 1867, on the College steps. The Boat Race between Oxford and Cambridge, held on the Thames in London, was and still is a national popular event.
Below: A team of footballers from Bootham School, York, by W.Eskett, *c*.1885.

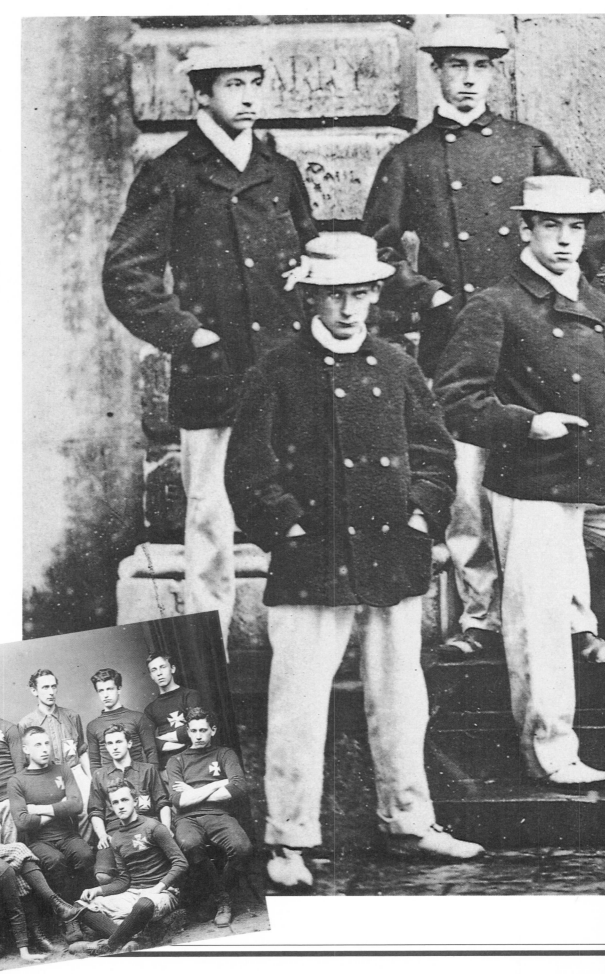

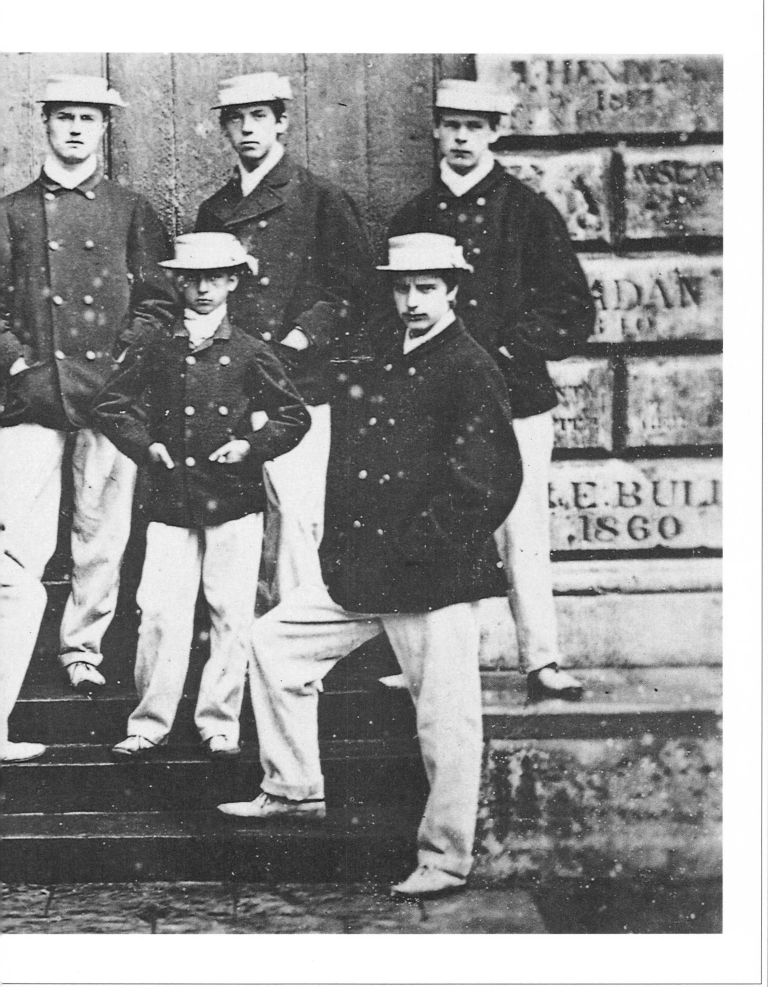

CHAPTER THREE
SELF-HELP

'National progress', wrote Samuel Smiles, 'is the sum of individual industry, energy and uprightness What we are accustomed to decry as great social evils will, for the most part, be found to be but the outgrowth of man's own perverted life; and though we may endeavour to cut them down again and extirpate them by means of law, they will only spring up again with fresh luxuriance in some other form, unless the conditions of personal life and character are radically improved.'

This association of progress with '*individual* industry, energy and uprightness' was characteristically Victorian. So, too, was the appeal to 'character'. Yet in practice not all energy was channelled into industry nor was all industry 'upright':

> Thou shalt not steal, an empty feat,
> When it's so lucrative to cheat:
> Bear not false witness, let the lie
> Have time on its own wings to fly:
> Thou shalt not covet, but tradition
> Approves all forms of competition.

These words of the poet Arthur Hugh Clough were written in 1862, three years after Samuel Smiles's *Self-Help* was published, when Britain was still the workshop of the world and when there was a feeling that the social conflicts of the early Victorian years belonged to a past that had disappeared.

By the end of the Victorian years, it was plain that social conflict had not been eliminated: there had, indeed, been a marked advance in the socialist movement after the 1880s. It was plain, too, that trade unionism, drawing on collective values very different from the individualist values of Smiles, could appeal to unskilled as well as to skilled workers, and that 'on the other side' of industry – and there were obviously two sides thoughout the century – not all industrial organization was competitive. Businessmen could band together as protectively as their employees. Indeed, they could sometimes band together with their employees against the foreigner.

Britain remained a free-trade country throughout the late Victorian years, but within the structure of industry there were many restrictive labour practices and many business groupings and associations that deliberately limited the free play of competition in

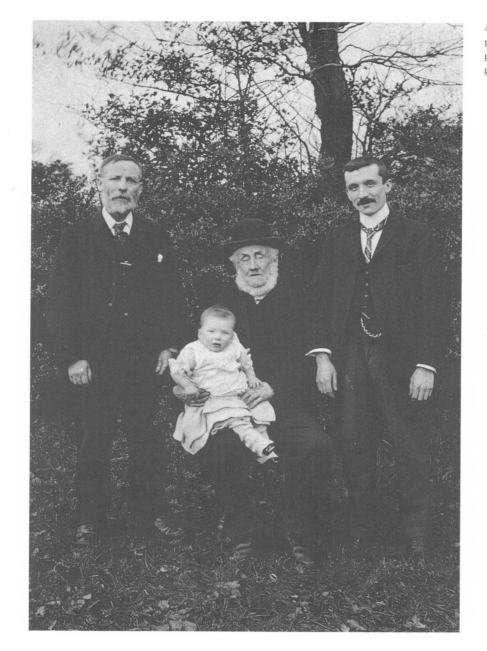

A seemingly impromptu gathering of four family generations in the garden, *c.* 1890.

order to safeguard profit margins that were falling as a result of it.

There was also an increased managerial influence in the operations of large businesses, with the kind of self-made employers whom Smiles had extolled playing a smaller part. Even when Smiles was writing, there had been less mobility than he sometimes seemed to suggest. Not everyone who believed in self-help got very far in life. At best, you needed luck as well. Moreoever, many heroes of self-help who had set up their own businesses and who seemed to be on the road to success went on to fail. Smiles himself explained that he was preaching the values of self-help so forcefully because they were not generally accepted. Nor were they 'natural'. 'Prodigality is more natural to man than thrift.... Economy is not a natural instinct but the growth of experience, example and foresight.'

Samuel Smiles, the Scots-born author of *Self-Help*, which, like his other books, extolled what have come to be called 'Victorian values'. Educated as a doctor, Smiles became an editor in Leeds and secretary of a railway company before turning to writing. Characteristically, perhaps, he did not inspire a good photograph.

At least one late Victorian socialist, Robert Blatchford, spokesman of 'Merrie England', resolutely defended Samuel Smiles against criticism, stressing rightly, for the foundation of Smiles's thought – and experience – was radical, that he had never argued that the acquisition of wealth was a proof of moral worth. 'Far better and more respectable is the good poor man', Smiles had claimed, 'than the bad rich one – better the humble silent man than the agreeable well appointed rogue.' Plainly for Smiles, as for most Victorians, everything hinged on 'character'.

His book on the subject, published in 1871 as 'a supplement to *Self-Help*', included chapters on 'home power' (everything started in the family), 'companionship and example', 'duty – truthfulness' (he was to write a book called *Duty* in 1887) and 'the discipline of experience', the title of his last chapter, which had much to say about 'the school of life'.

In a preface to a second edition of *Character*, published in 1878, Smiles replied to those of his critics who complained that he had not explained just what he meant by 'character'. 'Character means the distinctive qualities by which one person is known to another. It may mean weakness or energy', he acknowledged, 'and exhibit itself in goodness or badness. It may also mean the adventitious qualities impressed by nature or habit on a person. He stands apart by himself, and becomes known as "a regular character".' Smiles knew also that Charles Dickens, like Shakespeare, had presented a whole gallery of characters, some reputable, some disreputable, some innocent, some hypocritical, some believing in self-help, some trusting entirely to luck, some conformist, some eccentric.

Given such a possible range of character expressed in a wide range of individual characters – and Anthony Trollope had a gallery of his own – Smiles went on to stress that he was interested only in energetic, good, true and – to use a favourite Victorian word – respectable character. *Respectability* might seem superficial – and certainly it was expressed in external appearances, in clothes and in the home, well described by G. M. Young in an essay, 'The Happy Family' (1946), which picked out among 'the outer and visible signs' cleanliness (including that of the children at school), sobriety ('a pint of beer may pass, but the respectable man never enters a gin shop'), the benefit club, the family walk on a Sunday afternoon, the moralizing weekly magazine such as the *Weekly Welcome*.

These were all signs that Smiles would have recognized. Yet for him the springs of character were internal. A man was what he was because of what was in him. He was, to use a twentieth-century phrase of David Riessman's, 'inner-directed'. Independence of spirit was more important than any external appearances; and

The scientist was a favourite example of self-help. This is the naturalist Dr W. B. Carpenter, palaeontologist and zoologist, with the microscope that he perfected.

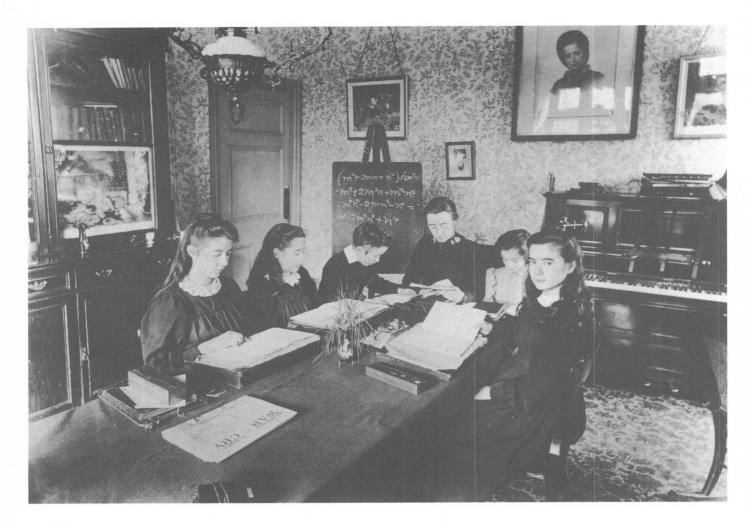

The equations on the blackboard in the image read:

$$(m^2 + 2mn + n^2) \text{ for } ?$$
$$= m^4 + 2m^3n + m^2n^2$$
$$+ m^3n - 2mn^3 - n^4 =$$
$$m^2 - 2m^2n^2 + n^4$$

Women played a
prominent part in the
pre-history and history
of the Salvation Army,
given its name in 1878.
Catherine Booth
worked closely with her
husband, who called
her the Army Mother.
She was also mother of
a large family, and is
shown here with her
daughters who learned
at an early age to make
the very most of their
experience and their
study.

there was no place for deference. Self-help meant standing on your own two feet.

Smiles was concerned with character, therefore, as 'the highest embodiment of the human being – the noblest heraldry of Man'. It was that which 'dignified' him, which 'elevated him [another favourite Victorian word] in the scale of mankind'. It was not birth that made 'gentlemen' but character. It also formed 'the conscience of society' and provided it with 'its best motive power'. It was associated with 'the exercise of many supreme qualities', including truthfulness, integrity and courage.

Smiles was happier giving examples than he was in defining terms, and he gave many examples of character in action just as he gave many examples of the triumphs of self-help. He also wrote a *Life of George Stephenson*, the railway builder – this was his first popular book – and an impressive series of volumes called *The Lives of the Engineers*. The Liberal politician W. E. Gladstone read the latter in 'little fragments', agreeing with Smiles that 'the character of our engineers is a most signal and marked expression of British character'. They enjoyed great prestige in mid-Victorian Britain where they owed nothing to Oxford or Cambridge.

Left: Smiles first delivered the contents of *Self-Help* for a Leeds evening class devoted to improvement. Such classes, like those in mechanics institutes, concentrated on 'useful knowledge'.
Below: 'Domestic economy' was one branch of 'useful knowledge' that was thought particularly appropriate for young girls.

Each of the examples of character chosen by Smiles, great or humble, might well have been the subject of Victorian photography, which, like Smiles, started with the family. Clothes were often Sunday best, doorsteps were scrubbed. Many characters were keen to reveal their selfness, or 'inscope', to use the word coined by Gerard Manley Hopkins and quoted by Bevis Hillier. 'None needed bidding "Be yourself".'

The idea of a 'pose', nonetheless, was even more important in the photographer's studio than it was in Dombey's busy counting house or in his comfortable, if always uneasy, home. The seated pose might be chosen because subjects were said to be more relaxed, but it allowed for every kind of artifice and every kind of background. For this reason alone we have to consider 'attitudes, dress, features' and poses when we look at any Victorian *carte-de-visite*. The picture can tell us as much about the photographer as about his subject.

There were some studio photographers who liked rogues and there were others who asked their clients to put on a 'fool face'. Elizabeth Heyert, in her book *The Glass-House Years, Victorian Portrait Photography, 1839-1870*, gives many examples of contrasting atti-

W.H.Lever, born in 1851, the founder of a huge soap business, was a great admirer of Smiles. This charming and relaxed photograph, *c.* 1900, reflects the paternalist side of his nature. Lever was one of the few great businessmen to become a member of the House of Lords – in 1917. The Victorian House of Lords was not a theatre of self-help. *Below right:* The model settlement of Port Sunlight, *c.* 1890, was built by Lever for his work force. One of the photographs shows Mr Waring of Vineyard Farm delivering milk to the residents. Keenly interested in architecture, Lever endowed architectural studies at Liverpool University. Sunlight was the name of his first highly successful branded product, and at the 1889 Royal Academy Exhibition he bought a painting by W. P. Frith, *The New Frock*, showing a little girl holding up a white pinafore. He used it later in an advertisement bearing the words 'So clean'. Frith was not amused.

Not all children blossomed through self-help. Many of them were exploited, and many of these were photographed. This Guy Fawkes tableau was most probably taken in one of the major London studios during the mid-1860s. A photographer's imprint is rare on such novelty cards, but they were produced in great numbers and varieties. The children were hauled off the street for a few minutes, made to pose, a couple of pennies were stuffed in their hot little hands and they were sent on their way.

tudes on the part of the studio photographers, some of whom were distinctly 'Bohemian' and some of whom were thought to be charlatans. 'The impression' sitters wished to convey, she suggests, 'had less to do with wealth than with social position and rank, and more especially with moral character'.

Photographers knew, like Samuel Smiles, that self-help went with education, one of their most lucrative subjects. You might get a Sunday School prize or a Sunday School photograph. In the absence of a free and compulsory school system for all until the last decades of the Victorian period, education was an important key to effective self-help. You had to learn to read before you could learn to live fully.

The fact that the first Board Schools, set up after the 1870 Education Act, had to spend as much time disciplining children as in educating them was a sign that 'character', like 'respectability',

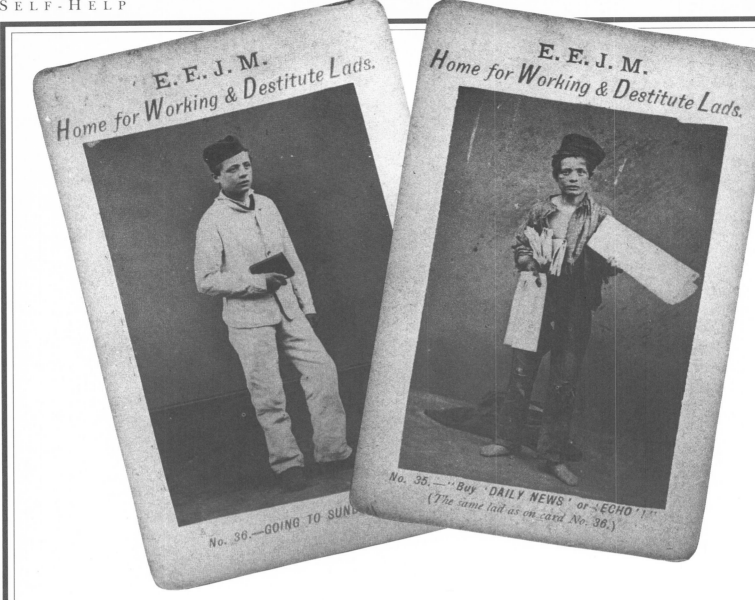

E.E.J.M.
Home for Working & Destitute Lads.

E.E.J.M.
Home for Working & Destitute Lads.

No. 35.—"Buy 'DAILY NEWS' or 'ECHO'!"
(The same lad as on card No. 36.)

No. 36.—GOING TO SUND...

had to be taught. The Act, however, was more the product of economic, social and political pressures than it was of a sum of individual demands for self-improvement. Economists, social critics and politicians alike had pointed in the decade before 1870 to the national need for a school system which would guarantee basic literacy. Permitting the development of individual talent seemed increasingly important to them, too, particularly since the Americans and the Germans had proved themselves more alert to the possibilities than British governments had been. Compulsory school attendance for all was a new principle.

Much of the legislation of the Victorian period, including the Education Act of 1870 and laws relating to public health, was introduced – often as a result of the dedicated efforts of particular individuals and groups – to deal with the limitations and problems of a society which was inspired by ideas of self-help, the promotion of market forces and the stimulus of voluntary organization. It is important to note that Smiles himself, while he believed in market forces and in voluntary organization, did not believe in *laissez-faire*, letting things be, in social matters. Indeed, he drafted one of the

Many Victorian children were deprived and philanthropists interested in their welfare tried to support them by charity. These 'before' and 'after' photographs of a Dr Barnardo's orphan are of special interest because of Dr Barnardo's keen interest in photography as propaganda.

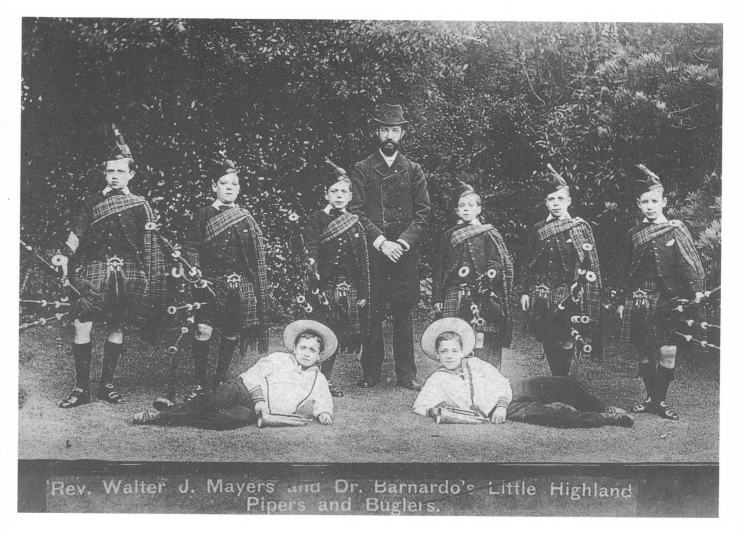

Rev. Walter J. Mayers and Dr. Barnardo's Little Highland
Pipers and Buglers.

most remarkable indictments of *laissez-faire:*

A natural extension of
Dr Barnardo's
propaganda exploits was
to form bands such as
this, who could spread
the word of the Mission
with their performances
all over the country.
Here they are
photographed in Sussex.

> When typhus or cholera breaks out, they tell us that Nobody is
> to blame. That terrible Nobody! How much he has to answer
> for. More mischief is done by Nobody than by all the world
> besides. Nobody adulterates our food. Nobody poisons us with
> bad drink....Nobody leaves towns undrained. Nobody fills jails,
> penitentiaries and convict stations. Nobody makes poachers,
> thieves and drunkards. Nobody has a theory too – a dreadful
> theory. It is embodied in the words: *laissez-faire* – let alone.
> When people are poisoned with plaster of Paris mixed with
> flour 'let alone' is the remedy...let those who can find out when
> they are cheated: *caveat emptor.* When people live in foul dwell-
> ings, let them alone, let wretchedness do its work: do not inter-
> fere with death.

As I wrote in *Victorian People,* the discovery of the malevolent
and invisible Nobody pointed to a hidden figure of evil at the heart
of the Victorian social world at a time when economists, following
in the wake of Adam Smith, were pointing to the beneficent pres-

ence of an 'invisible hand'. And legislation failed to limit hours of work, to protect life and to control 'abuses'.

By the end of the Victorian period there had been much direct legislative and administrative intervention – critics called it 'collectivist', even 'socialist' – and extirpating evil 'by means of law' was commonplace. Market forces were no longer allowed to operate without contraints, and there was an impressive administrative apparatus designed to inspect and to control. Just as significant, by 1901 there had been something of a revolt, if only as yet a minority revolt, against Victorian values.

Respectability, in particular, was attacked. For the critics it often seemed to be as much of a pose as the pose insisted upon by photographers. There was an element of cant, they claimed – and cant was a favourite Victorian word – in the claims of many 'pillars of society'. For writers like George Bernard Shaw the 'respectable poor' were to be condemned for their passivity, not praised for their virtue. As Oscar Wilde put it epigrammatically: 'The virtues of the poor may be readily admitted, and are much to be regretted. The best among the poor are never grateful. They are ungrateful, discontented, disobedient and rebellious. They are quite right to be so.'

Scamps and tramps figure among many late Victorian photographic subjects; so too do gypsies and vagabonds; so too do criminals. There were few pictures, however, of men who had just failed, including bankrupts. Whatever was appropriate then, to be photographed was not.

One collector of photographs, Arthur Munby, concentrated from the 1850s until his death on working women. 'If I had the means', he wrote in his diary in 1859, 'I would investigate...the moral and physical statistics of labouring women all over the world.' His zest was unbounded, and his photographic investigations are unique. Michael Hiley, who collected some of them in his *Victorian Working Women* (1979), rightly describes his concern as obsessive, adding, 'Lewis Carroll revealed a great deal about his own preoccupations in his remark, "I am fond of children, except boys". Arthur Munby was fond of working people, except men.'

Obsessions account for as much as conventions in the way the world is viewed – and the people within it, although in the case of Carroll, a skilled photographer, the term 'obsession', though much used, does not seem the right one. Carroll, who produced a *carte-de-visite* of Tennyson and who tried in vain to secure a photograph of G. F. Watts, was fascinated by photography itself and in his *Photography Extraordinary* (1855) used the camera to record the thoughts of just the kind of vapid young man who would have been excluded from the pages of Smiles's *Self-Help*. There were doubtless many such characters among the undergraduates of his own college.

The Colleen Bawn, literally translated, means 'the White Girl' or 'the Golden Girl'. Her tragic story began on 29 June 1819, in County Limerick, when Ellen Harley – a fair maid of sixteen years – went missing from home. Her body was later found on 6 September, and it was evident that she had been murdered. The prime suspects were John Scanlon, a sporting squire from an influential local family, and his manservant Stephen Sullivan. They fled the area, but Scanlon was later captured and, even though he was defended by the great Daniel O'Connell, he lost his case and was sent to the gallows. Sullivan was similarly convicted at a later date. The sad story inspired several plays and books. This photograph could well show an actress playing the part of Ellen, or simply a young countrywoman dressed as a typical Irish lass for the entertainment of tourists.

COPYRIGHT

Gipsies were one group who believed less in self-help than in luck. This rare and early photograph by W. & D. Downey of Newcastle, *c.* 1865, was taken on location, probably in the Newcastle area.

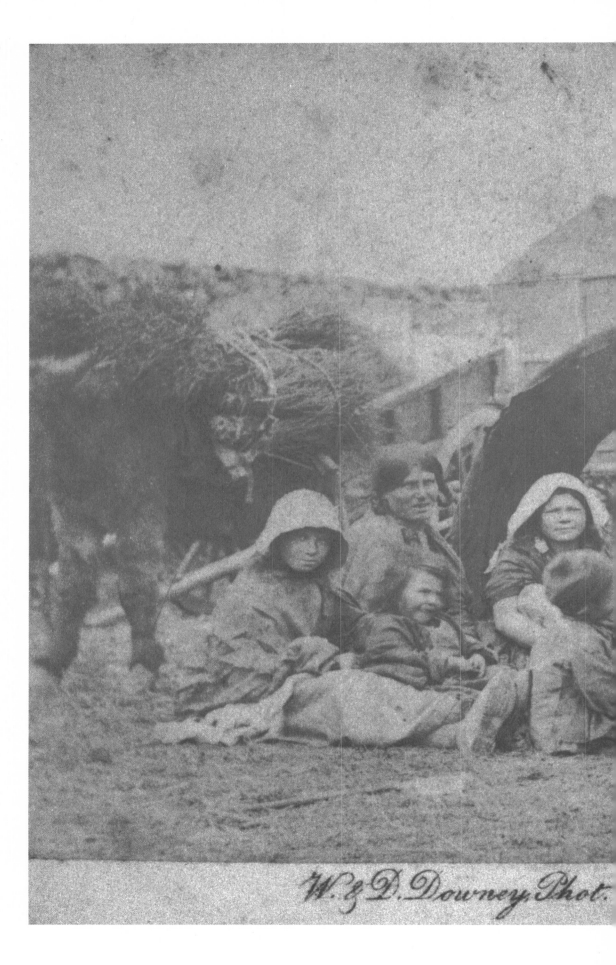

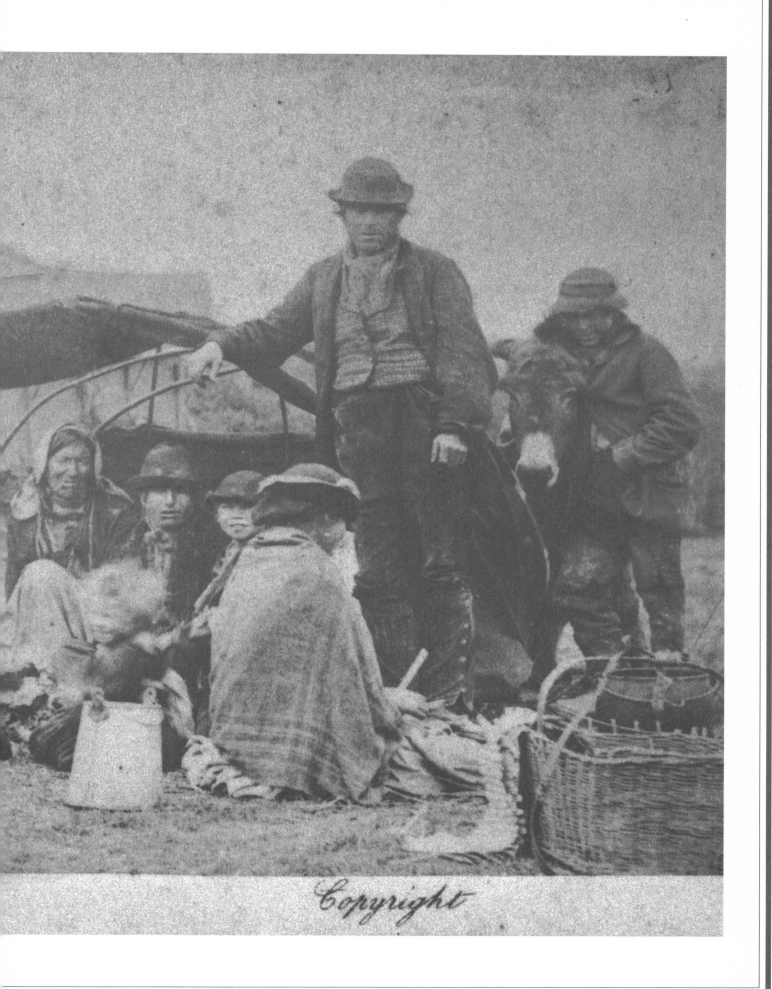

Copyright

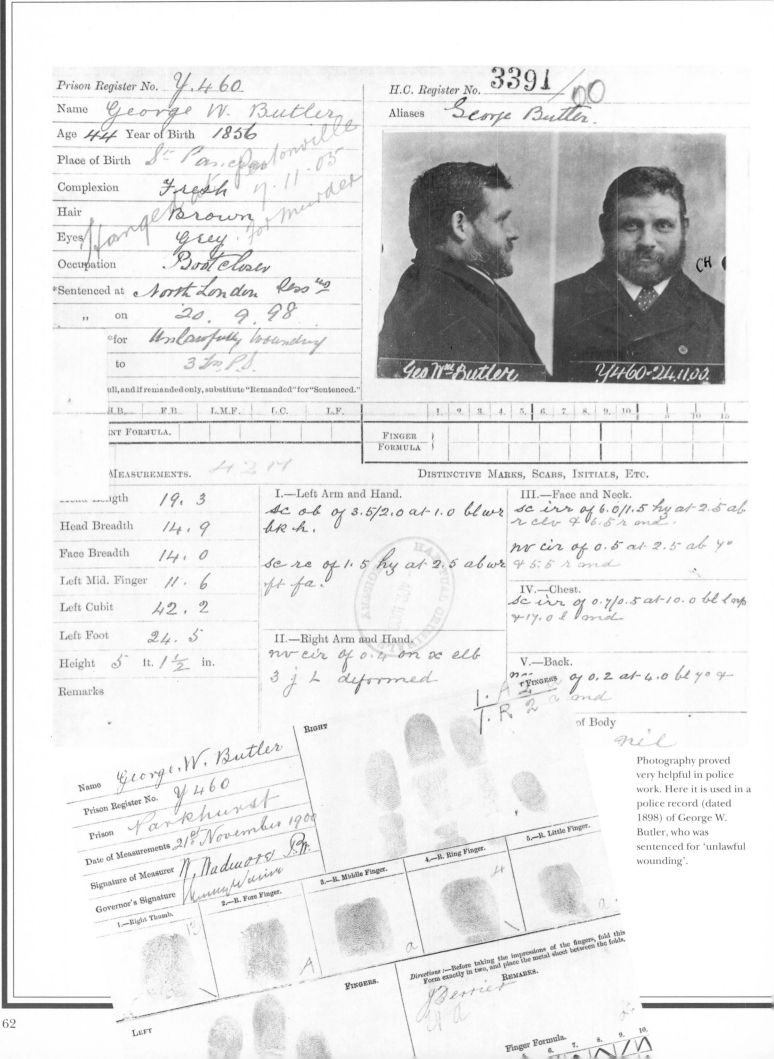

Photography proved very helpful in police work. Here it is used in a police record (dated 1898) of George W. Butler, who was sentenced for 'unlawful wounding'.

Left: Mr Toole, the Puelly housebreaker. This photograph derives from Victorian stage melodrama, which was unimpressed by self-help.

Despite the emphasis
on individual self-help,
most Victorians praised
the family as the basic
institution of society,
and traced the
development of the
individual within it
through the seven ages
of man. In each stage
he was dependent not
only on his own efforts
but also on family
support.

Glusburn,
CROSSHILLS.

Marriage was the social bond that was most criticized by Victorian rebels like Samuel Butler. Not all marriages were happy, as his personal experience showed, but not all marriages were unhappy either. Happy moments were recaptured in photographs. Not many photographs of marriages were taken, but there were some of courting and honeymooning couples – like this one of Robert and Lucy A. Robinson on the Isle of Wight.

Cabinet Portrait

Arthur Debenham.

28. Union S.^t Ryde. I.W.

Right: With large
numbers of young
people, there was an
acknowledged place
in Victorian society
for the old, as typified
by this elderly
gentleman.

Below: A large family
group spread
themselves across the
photographer's studio.
A visit here was a
family outing, and
there are many such
photographs. A
suggestion of one of
the glass walls can be
seen on the right.

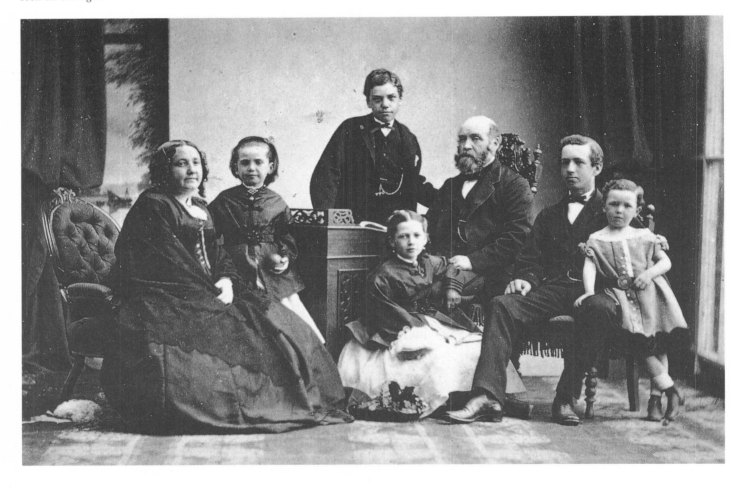

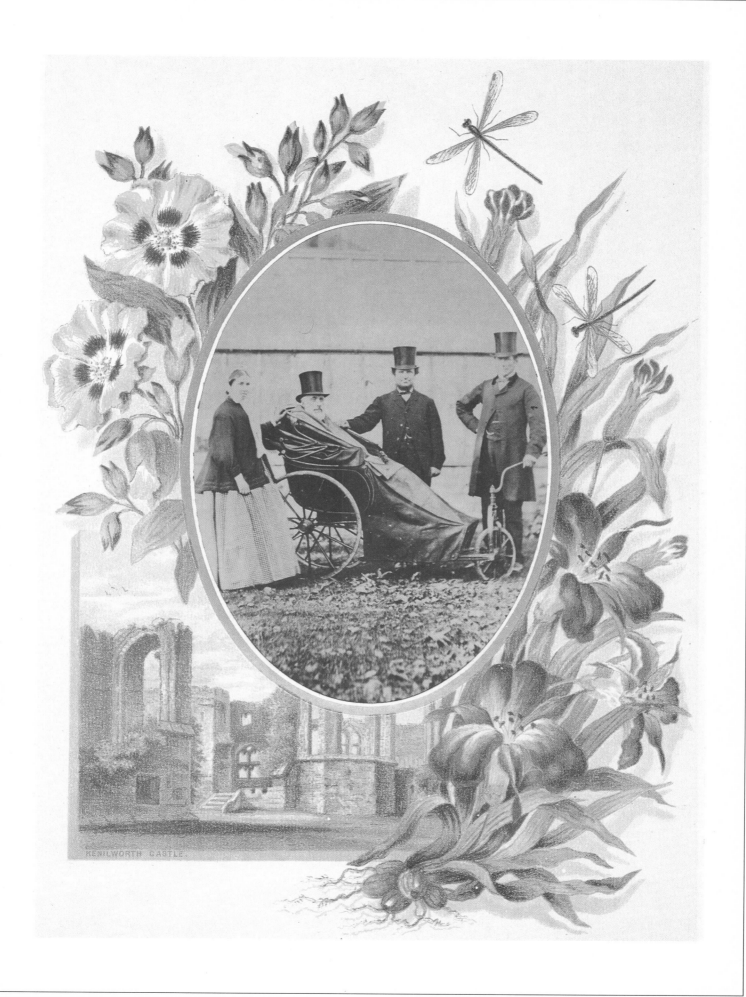

KENILWORTH CASTLE.

Family albums abound. This personal album, the front cover of which bears his initials in brass (*below*), was compiled by George E. Barnes. Here we see him (*above left*) as an undergraduate at Trinity College, Cambridge, and later as a clergyman. There was little self-help in this progression from undergraduate to 'the cloth', common in Victorian times. The cutting from *The Times* informs us of Barnes's second-class degree.

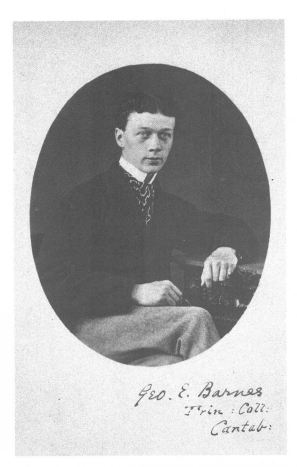

Geo. E. Barnes
Trin: Coll:
Cantab:

CAMBRIDGE, JUNE 19.
GENERAL EXAMINATION FOR ORDINARY B.A. DEGREE.
Examiners.—Samuel George Phear, B.D., Emmanuel College ; Herbert Newman Mozley, M.A., King's College ; William Edmund Currey, M.A., Trinity College ; Thomas William Dunn, M.A., St. Peter's College.

FIRST CLASS.			
Abbey	Caius	Winder	Sidney
Alford	Corpus	Winterborn	Christ's
Archdall	Corpus	Woffindin	Catherine
Atkinson	Jesus	Woods	Christ's
Baines	Trinity	Wray	Downing
Bellingham	Trinity	**THIRD CLASS.**	
Blunt	Pembroke	Akenhead	Caius
Bull	Sidney	Andrew	Jesus
Campbell, D.	Corpus	Banks	Jesus
Chapman	Christ's	Bedford	Queens'
Flood	Queens'	Boden	Trinity
Foster, A.	John's	Burnside	John's
Greenhalgh	Magdalene	Byrom	Caius
Grigg	John's	Chapman	Downing
Guest	John's	Churchill	Emmanuel
Huish	Clare	Clark	Magdalene
Jones	John's	Clowes	Trinity
Kempe, J. A.	Trinity	Colvin	Trinity
Legg	Emmanuel	Dalton	Caius
Martell	Jesus	Douglas	Magdalene
Muirhead	King's	Eliot	Emmanuel
Novelli	Trinity	ffolkes, Sir W.	Trinity
Ramsay	Christ's	Griffith	Jesus
Sanderson	Sidney	Hedges	Trinity
Scott	Jesus	Hind, W.	Emmanuel
Thurlow	Caius	Hudson	Emmanuel
Williams	Queen's	Jones	Emmanuel
SECOND CLASS.		Judd	Corpus
Amphlett	Trinity	Kiddle	John's
Balfour, B. R. T.	Trinity	Kirby	Trinity H.
Barnes	Trinity	Lane	Emmanuel
Bidwell	Clare	Lawson	Trinity H.
Bowling	Emmanuel	Ledgard	John's
Clarke	John's	Lowe	Jesus
Davies, R. P.	John's	Mann	Emmanuel
Day	Peter's	Manners	Catherine
Denison	Trinity	Moore	Trinity H.
Denny	Trinity	Peake	John's
Field, J.	Clare	Pelham, J. B.	Trinity
Franklyn	Trinity	Pershouse	Emmanuel
French	Emmanuel	Richardson	Jesus
Girling	Sidney	Royds	Trinity H.
Gordon	John's	Ryder	John's
Gordon, G. H.	Trinity	Simpson	John's
Greaves	Catherine	Smith, R. K.	John's
Greene	Peter's	Smith, C. H.	Emmanuel
Harrison	Clare	Speck	John's
Hind, C.	Emmanuel	Stevens	Corpus
Hoare	Trinity	Tarbutt	Clare
Hunter	Caius	Taylor	Trinity
Iredell	Christ's	Tottenham	Jesus
Lloyd	Trinity	Waite	Christ's
Martyn	John's	**FOURTH CLASS.**	
Matthews	Jesus	Bevan	Trinity
Maxwell	John's	Curteis, R. W.	Trinity
Newcombe	Corpus	Drew	John's
Nicol	Trinity	Duncan	Pembroke
Oldfield	Queens'	Fagan	John's
Olivey	Corpus	Gaches	John's
Park	John's	Hird	Emmanuel
Reynolds	Trinity	Humfrey	Trinity
Stallard	John's	Hunt, F. H.	Trinity
Thomas, R. E.	Corpus	Langham	Corpus
Timms	Trinity	Shorting	Emmanuel
Tweddell	Clare	Staley	Christ's
Whigham	Trinity	Templer	Trinity
Wilkinson	John's	Weighell	Jesus
		West	John's

(left margin, vertical:) THE TIMES, SATURDAY, JUNE 20, 1868.

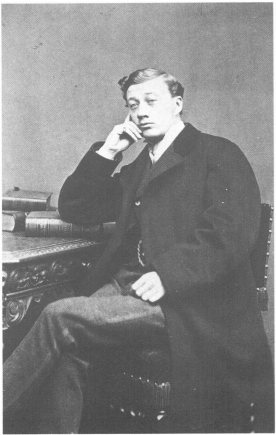

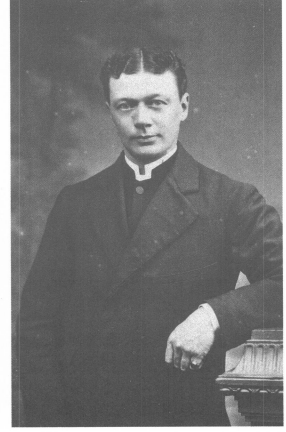

Various members of Barnes's family: his brother W.R. Barnes *(above right)* with a friend, his eldest brother William Junior *(below right)*, in an extremely relaxed pose, his horse and groom and one of his dogs.

"Bob".

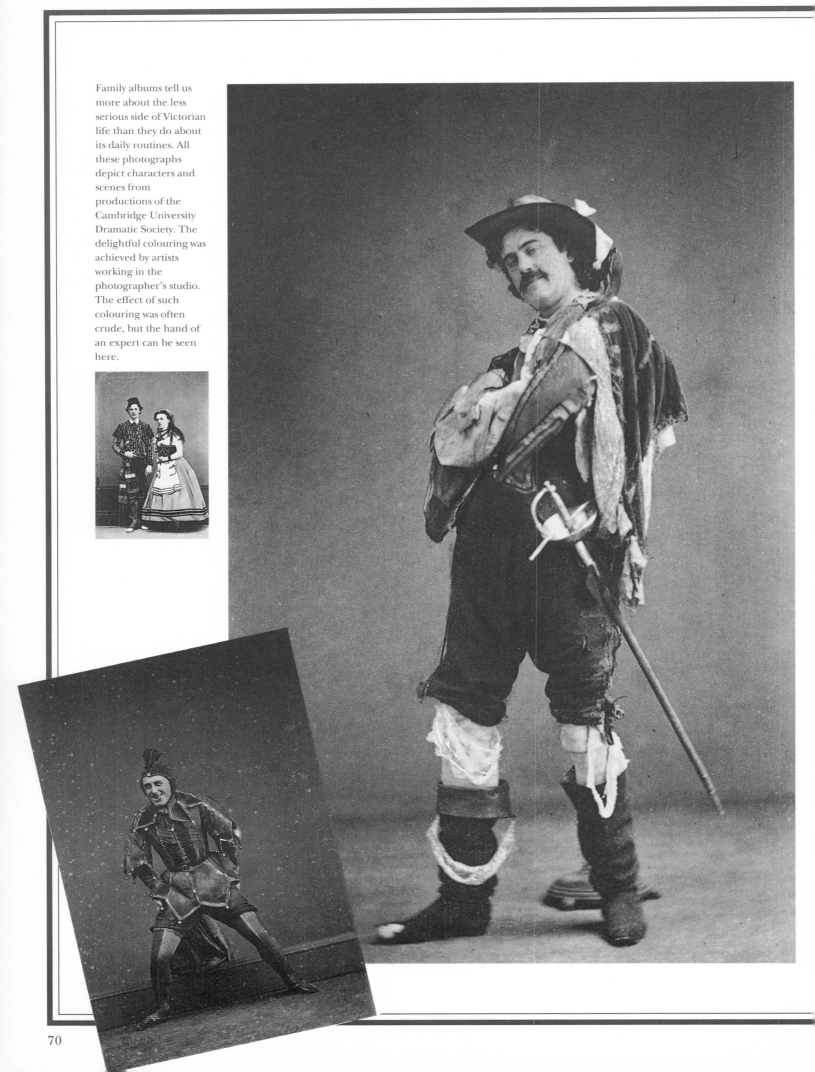

Family albums tell us more about the less serious side of Victorian life than they do about its daily routines. All these photographs depict characters and scenes from productions of the Cambridge University Dramatic Society. The delightful colouring was achieved by artists working in the photographer's studio. The effect of such colouring was often crude, but the hand of an expert can be seen here.

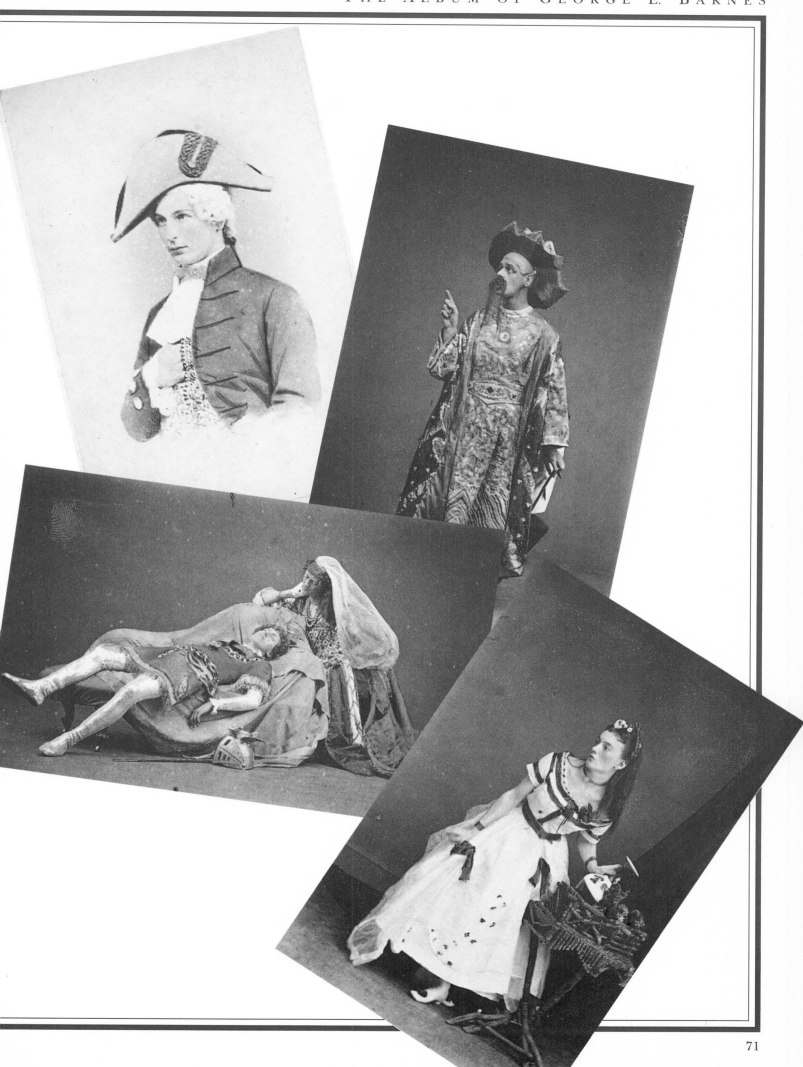

CHAPTER FOUR

WORK

'As steady application to work is the healthiest training for every individual', wrote Samuel Smiles, 'so it is the best discipline of a state. Honourable industry travels the same road with duty; and Providence has closely linked both with happiness. The gods, say the poet, have placed labour and toil on the way leading to the Elysian fields.'

This proclamation, one of the most eloquent testimonials to work ever pronounced, was by no means unique. Carlyle could be just as eloquent. Both he and Smiles were contrasting the work effort both of employers and employed with the idleness of the aristocracy. 'Be counselled,' Carlyle told the aristocracy in his own imitable style. 'Ascertain if no work exist for thee on God's earth; if thou find no commanded-duty there but that of going gracefully idle? Ask, inquire earnestly, with a half-frantic earnestness.'

Neither writer made much of a theme often to be focused on in later years – that employers worked harder than their employees. It would, indeed, have been a difficult theme to sustain in the mid-Victorian years. Dickens was right to say that if the English working classes were not the most hard-working people in the world, they were certainly the hardest worked. There were other problems, too, in sustaining the later thesis. There were enough employers who, having made their money, retired into a life of idleness for commentators to write in general about them, and there were other employers who brought up their sons quite differently from the way they had been brought up themselves. In comfortable homes daughters were generally actively discouraged from being anything but idle, although they were encouraged to 'do good'.

The gospel of work, like 'doing good', had religious undertones. An 'endless significance lay in it'. To work was to pray: *laborare est orare*. 'Work while it is called Today, for the night cometh when no man can work.' Work was related, too, to upbringing, as it was to be for Margaret Thatcher. For Carlyle it had been his father from whom he had learnt that 'man was created to work, not to speculate, or feel or dream'. 'Olivia', a twentieth-century survivor from a Victorian household – not a religious household – wrote in 1969 of how, 'in spite of an almost militant agnosticism, attached without the smallest tinge of hypocrisy to the ideals of the time', she had been taught 'duty, work, abnegation, a stern repression of what was called self-indulgence, a horror and terror of lapsing from the current code'.

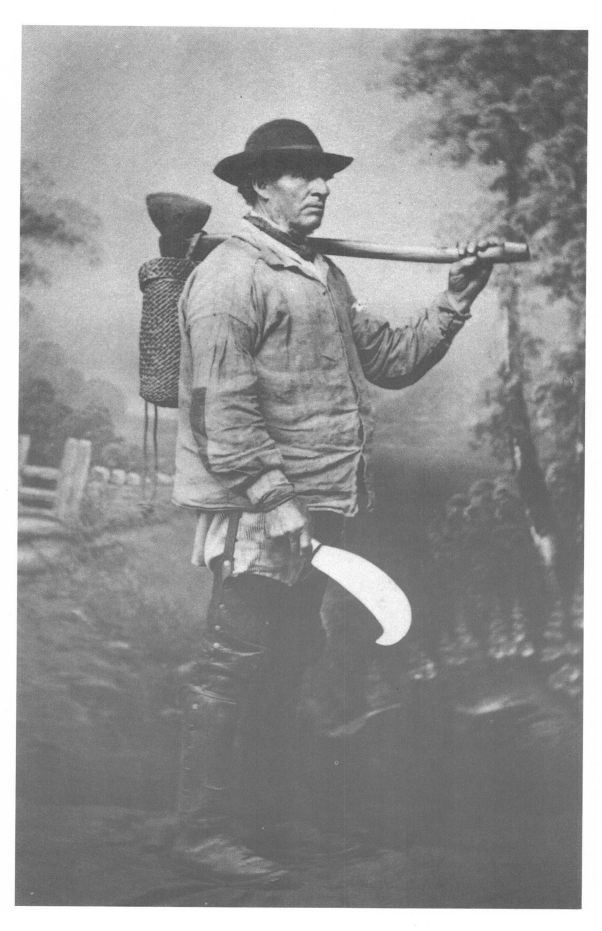

Rural workers were
depicted more often
than industrial workers.
This striking portrait by
Edward Reeves shows a
farm worker or
woodsman equipped for
hedging or coppicing.
He is suitably set against
a rustic backdrop.

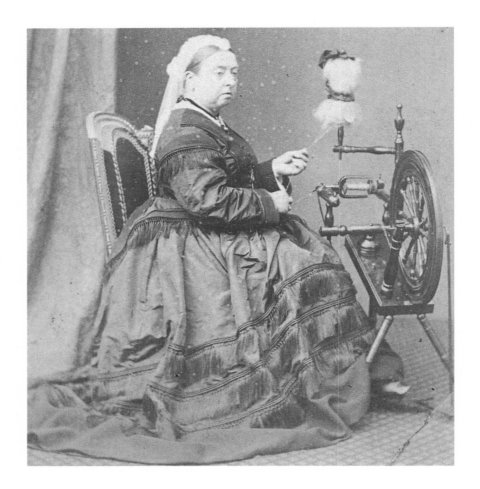

Even the Queen could work. In this photograph Queen Victoria sits and spins. It is not certain whether or not photographs such as this reassured her loyal subjects that even their Queen had the common touch. Most other photographs present her in more formal poses. By the end of her reign she had probably been photographed far more than any of her subjects.

Where parents left off – or failed to inculcate the right lessons – schoolteachers took over. Matthew Arnold, son of Thomas Arnold, the great headmaster of Rugby, knew how much his father had insisted on teaching 'a paramount sense of the obligation of duty, self-control and work', driven by an 'earnestness [this was another favourite Victorian word that Oscar Wilde was to make fun of] in going forward 'manfully' [another favourite word] with the best light we have'.

Not everyone was in a position to develop any sense of 'calling', one of the reasons for pursuing a mission in life. Indeed, while Victorian England depended on work, it was often other people's: in the home the work of domestic servants; in the street and in the factory and the field the unskilled work of 'labourers'. Much of this work was drudgery, like blackleading firegrates or carrying buckets; most of it was routine. Far more of it was physically exhausting and more badly rewarded than it now is, and not surprisingly much of it has subsequently been 'mechanized' – heaving, dragging, digging, tunnelling, wheeling.

It was not only the factory that was a centre of characteristic Victorian work. The country estate was another, and the main workers associated with it – from the elaborate hierarchy of indoor domestic servants to gardeners and gamekeepers – were photo-

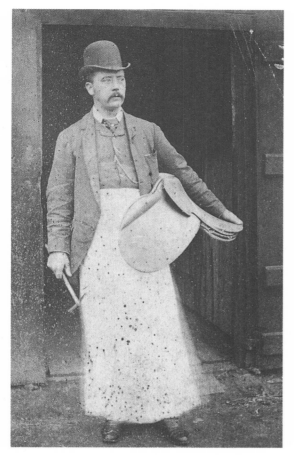

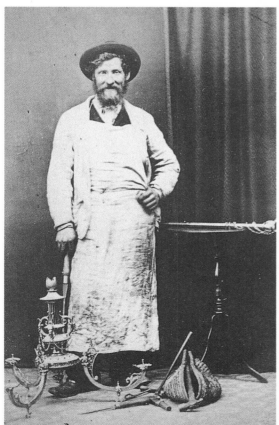

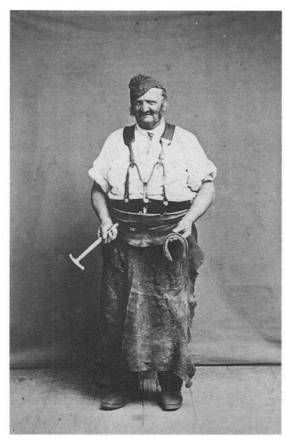

Photographs of artisans are rare, but here *(clockwise from top left)* are a saddler outside his workshop, proudly showing the fruit of his industry; a slaughter house attendant from Yorkshire wearing his uniform; a seasoned blacksmith posing awkwardly with hammer and shoe; and a cheerful chandelier maker seemingly about to install his chandelier.

graphed far more frequently than factory workers. A few Victorians had the sense to realize that domestic service on such a scale would not last forever. As one clergyman wrote in 1871, 'the cultivated class will do well not to fix too firmly on the axiom that it has a right to be waited upon.'

Through long hours of manual work, rural or industrial, bodies were more strained than heads, and the strain has been described vividly in working class diaries and autobiographies. It was the actual experience of work that concerned their writers, not the precept to work. It was their kind of work which listeners to the music-hall star Harry Clifton (1832-72) knew about when he told them 'Always Put Your Shoulder to the Wheel':

> Work, Boys, work and be contented
> As long as you've enough to buy a meal.
> For that man, you may rely,
> Will be wealthy by and by
> If he'll only put his shoulder to the wheel.

A different source, Henry Mayhew, in his *London Labour and the London Poor* (1861), describes every kind of work that did not require putting your shoulder to the wheel from scavenging to pickpocketing. For large numbers of Mayhew characters, stealing was itself a way of working. Yet he can quote a London coalbacker:

These scenes in a north-east Yorkshire tannery in the 1880s show *(right)* men pausing during their work of scraping hides and posed more formally in a group with the owner or manager outside in the yard. Close inspection of the interior photograph reveals the political leanings of the owner: there is a portrait of Mr Gladstone on the workshop wall.

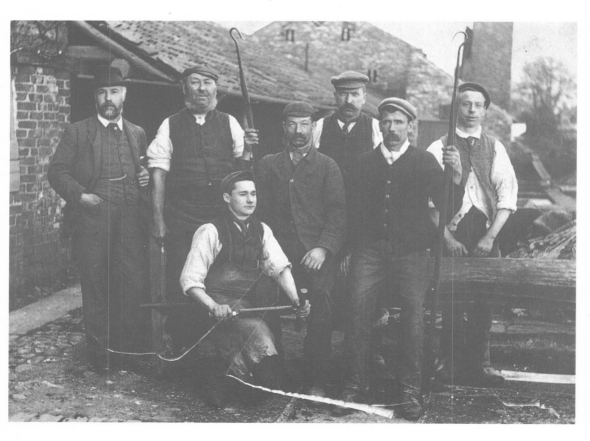

Our work's harder than people guess at, and one must rest sometimes. Now if you sit down to rest without something to refresh you, the rest does you harm instead of good, for your joints seem to stiffen, but a good pull at a beer backs up the rest and we start lightsomer. Our work's very hard. I've worked till my head's ached like to split...feeling as if something was crushing my back flat to my chest....Sometimes we put a bit of coal in our mouths to prevent us biting our tongues...but it's almost as bad as if you did bite your tongue, for when the strain comes heavier and heavier on you, you keep scrunching the

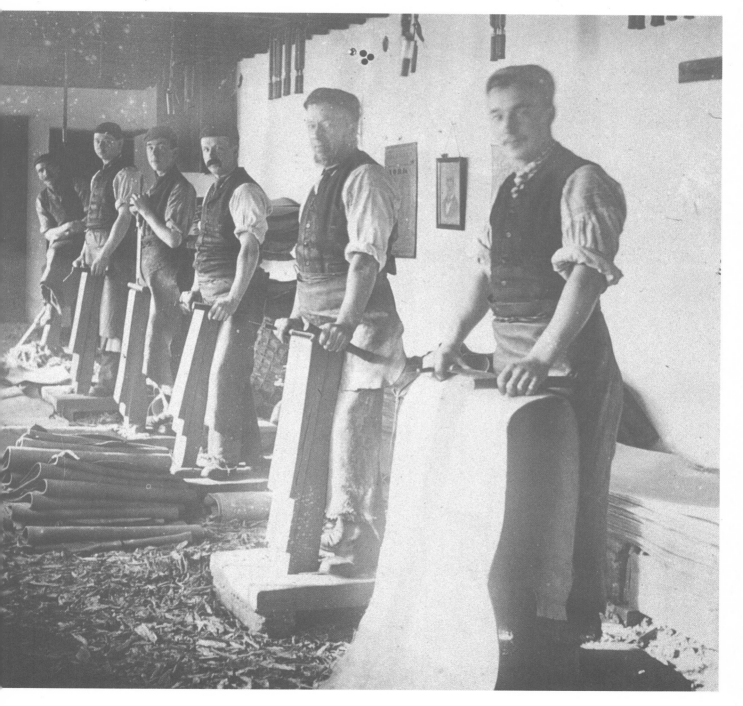

Uniforms have traditionally signified respectability and authority, and they were prominent in the Victorian fire service, the police, the post office and the railways. The photograph of the fireman from an American brigade *(below left)* focuses on his large elongated helmet. Railway workers *(below right)* had a particularly secure place in Victorian society. They were proud of their status and of their engines and their stations. The first steam engines were still within living memory, and the great railway engineers were among Smiles's heroes.

coal to bits, and swallow some of it, and you're half choked.

Not much of a gospel of work could have been made out of that. Nor could much of a gospel have been made out of factory work 'under orders'. Industry had imposed new disciplines, beginning with the discipline of the clock: it rested on rules. The result was that in the West Riding, for example, if you were an 'operative' or a 'hand', you had to get out of the factory and into the chapel to catch a gospel; in Durham and South Wales, if you were a miner, you had to get out of the mine.

There was more children's work (including work in factories and mines) at the beginning of Queen Victoria's reign than there was at the end, and more women's work at the end (including work in offices and shops) than there was at the beginning. Yet the cotton industry was sustained by women's work at the beginning, and at the end many children were still employed in small workshops. As late as 1905 a visitor found three little children – a girl of eleven, a boy of nine and a boy of five – in a Birmingham workshop 'working as fast as their little fingers could work'.

The sense that people were being exploited was not shared by all observers of such scenes, the kind of scenes that were not photographed. One technical problem was lack of light. A more serious

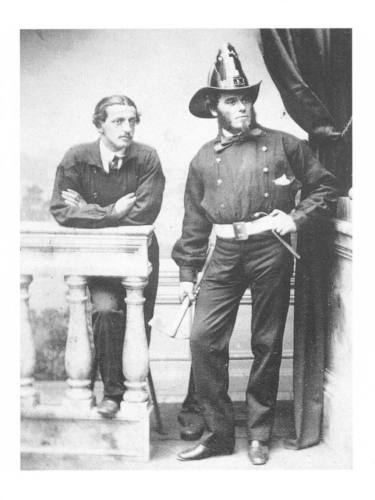

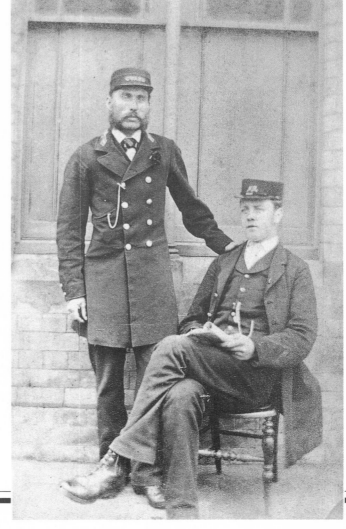

problem, however, was lack of interest. As Gus Macdonald wrote in his *Camera, A Victorian Eyewitness* (1979), 'Trade unionists never found a way to recruit the camera to their cause.'

Victorian work was mainly illustrated, when it was illustrated at all, in paintings and engravings. A popular book like C.L. Matéaux's *The Wonderland of Work* (1883), with plentiful illustrations, guided its young readers into 'a busy world, where order, skill and industry reign supreme'. 'What subjects are more worthy of admiration and respect', Matéaux asked in his preface, 'than the crowded masses of stout-hearted toilers – men, women, aye! and sometimes children too – who press about its courts..., good and true to the end of time?'

It was a not uncharacteristic claim in the nineteenth century that the laws of life would persist until the end of time. William Morris, however, would have none of this. He drew a sharp distinction between work 'under orders' and 'creative work', the kind that, according to Ruskin, had made possible the production not of factories or mines but of cathedrals. Some labour, Morris argued, 'far from being a blessing', was a curse. 'It would be better for the community and for the worker', he maintained, 'if the latter were to fold his hands and refuse to work,' or go to the workhouse [the revealing word for the place to which paupers were sent] or the prison.'

Life was tough for the fishing fraternity of the east Yorkshire coast, seen here gathering shellfish for use as bait. This scene was taken on the beach at Filey by the local photographer, Walter Fisher.

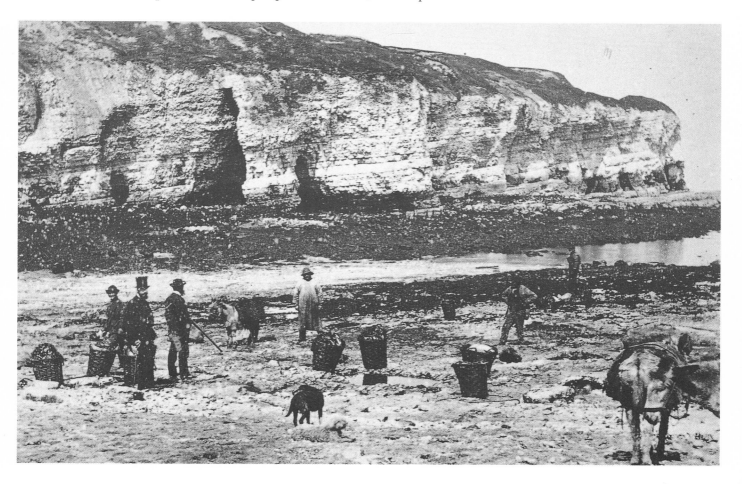

This page: This 'Scotch Washing' scene *(above left)* was a card from a series produced by Macara of Edinburgh of traditional trades and crafts for sale as curios. It contrasts sharply with the woman by her wash tub *(above right)*. Mill girls *(below left)* were employed in large numbers in Lancashire and Yorkshire, counties that had led the way in the process of industrialization. Mills broke old continuities in work rhythms and relationships. The two milkmaids *(below right)*, engaged in a traditional way of life, appear to be wearing some kind of uniform: their striped apparel may have been peculiar to the farm or estate where they worked.

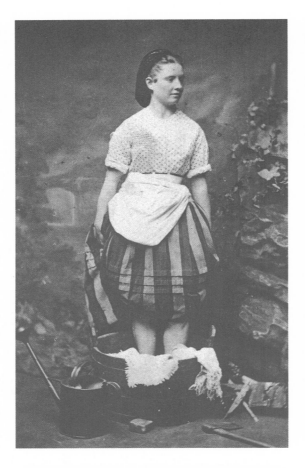

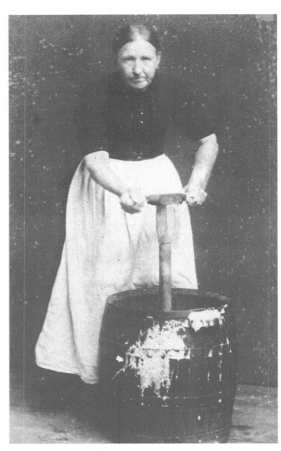

Opposite: Fisher girls like this were a common sight on the quaysides of Portobello and Leith, near Edinburgh. They were favourite subjects for studio photographers, and local studios would entice them into their premises with the promise of a small fee or some free portraits. Hundreds of copies might then be printed for an active market. There was always a demand in middle-class London drawing rooms for such photographs.

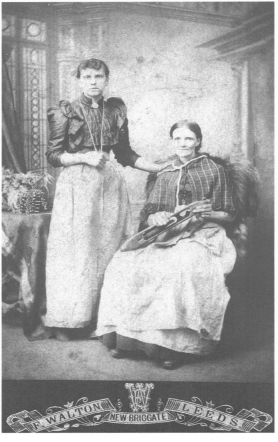

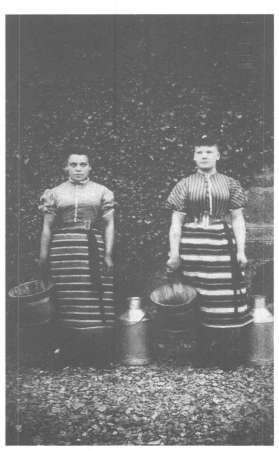

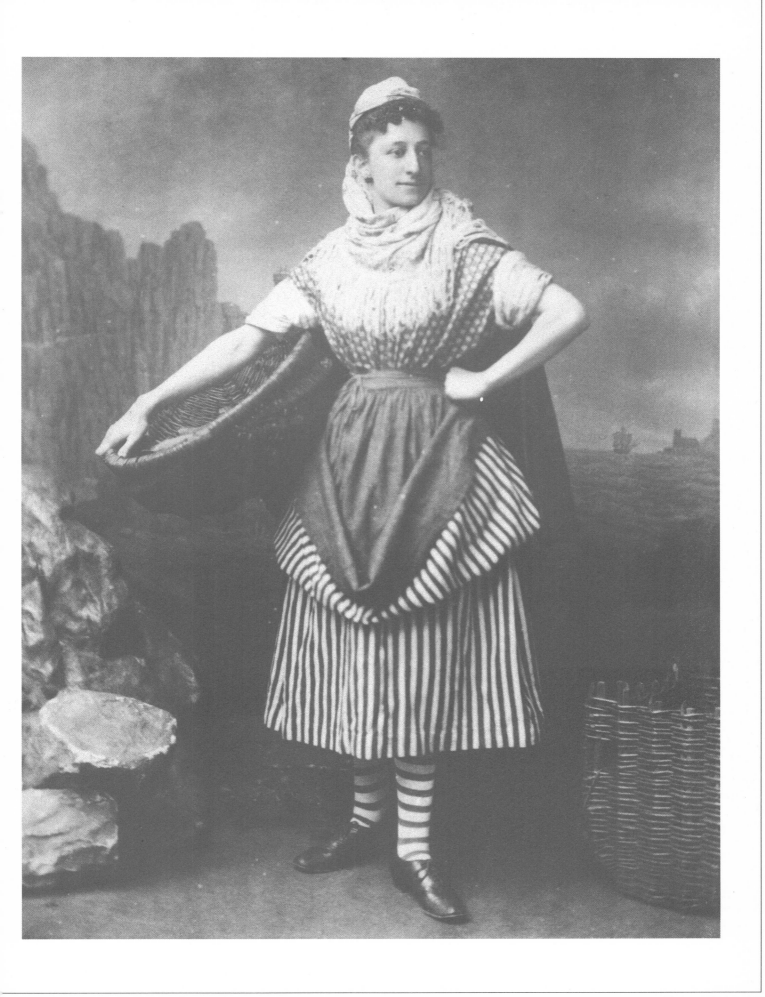

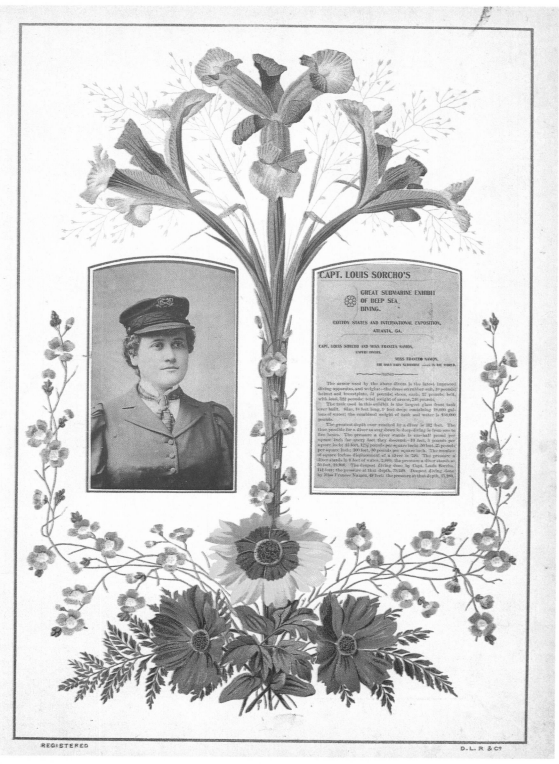

Opposite: These girls, probably in their teens or early twenties, were employed in the Lancashire coal mines as pit-brow workers, grading and cleaning coal and filling railway wagons. Their life was tough, and the women were clearly a breed apart. James Millard was one of several Wigan photographers who recorded these remarkable women. Their likenesses had commercial value at the time as curiosities and have since become favourites with social historians.

Miss Frances Namon, the only woman submarine diver in the world. This remarkable woman's unique job was also the entertainment of a fascinated public.

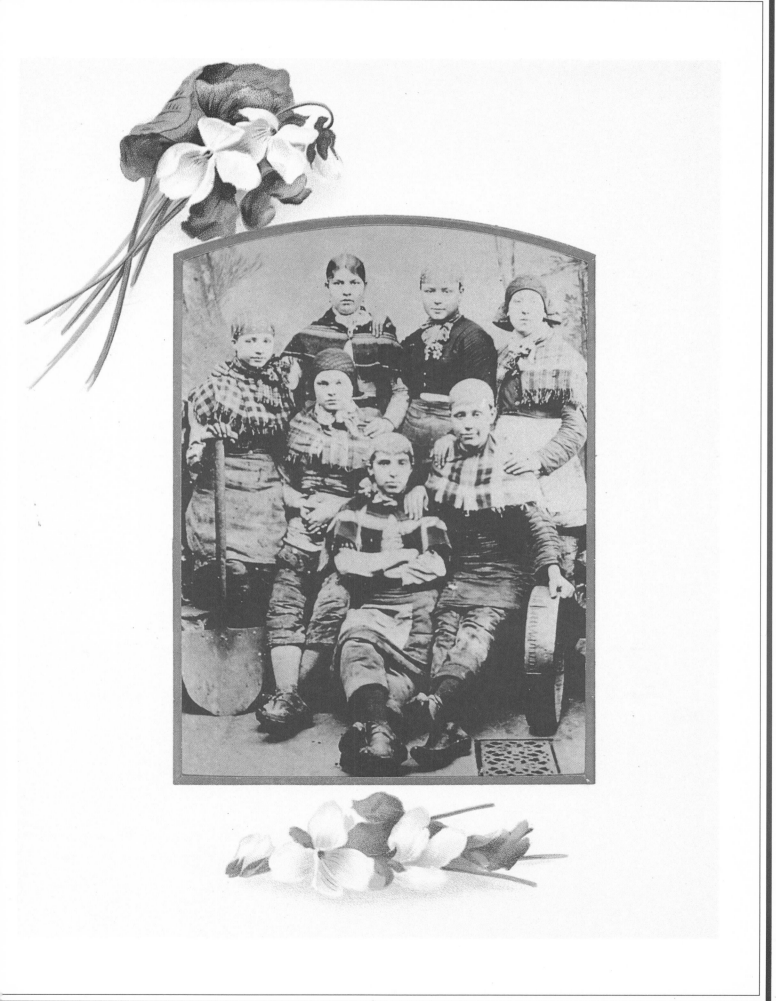

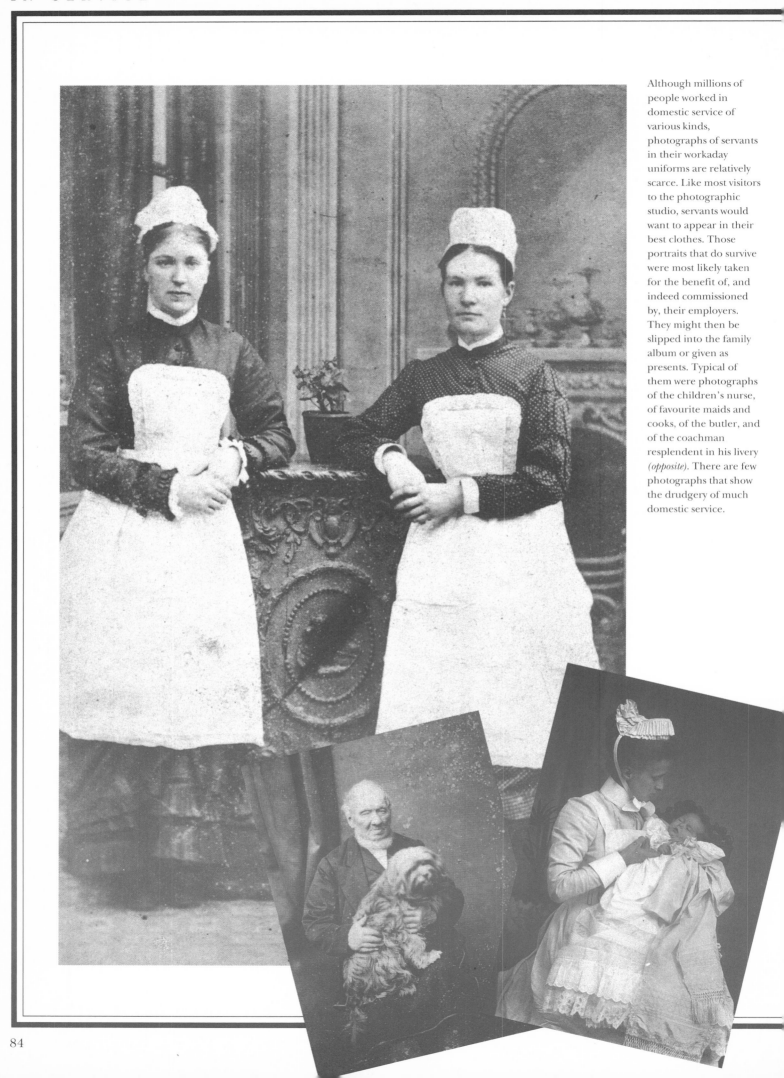

Although millions of people worked in domestic service of various kinds, photographs of servants in their workaday uniforms are relatively scarce. Like most visitors to the photographic studio, servants would want to appear in their best clothes. Those portraits that do survive were most likely taken for the benefit of, and indeed commissioned by, their employers. They might then be slipped into the family album or given as presents. Typical of them were photographs of the children's nurse, of favourite maids and cooks, of the butler, and of the coachman resplendent in his livery *(opposite)*. There are few photographs that show the drudgery of much domestic service.

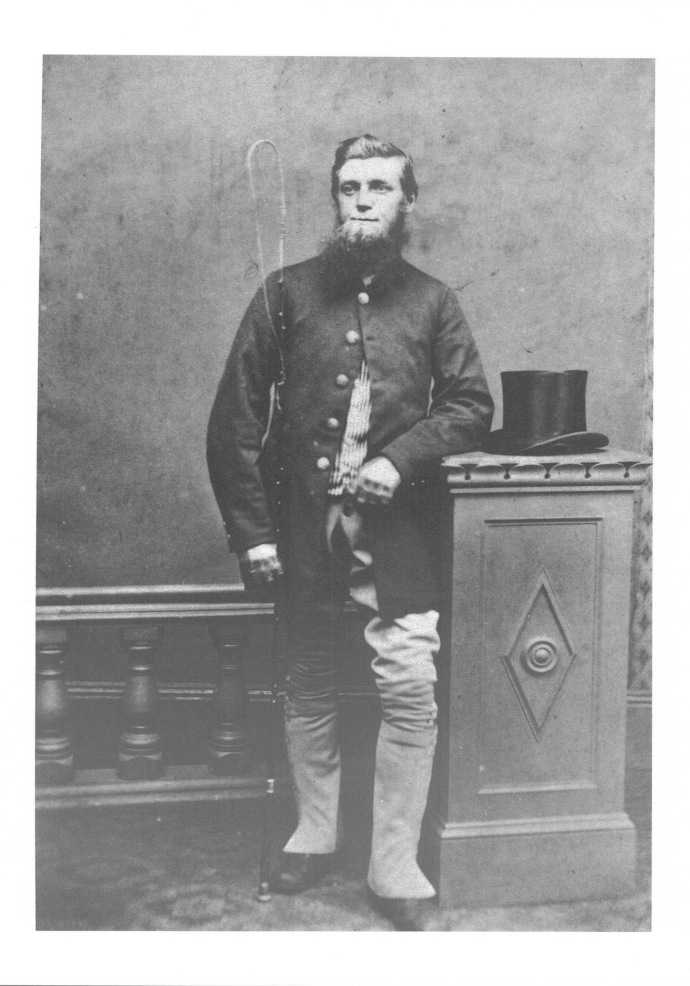

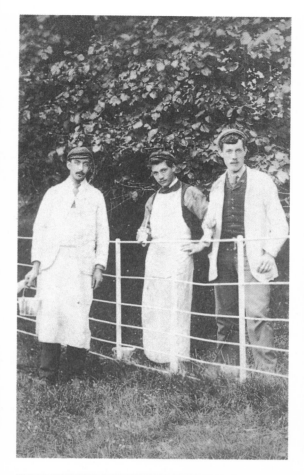

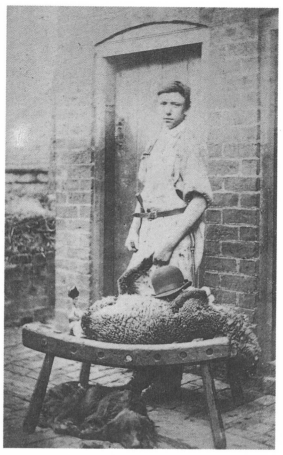

Facing page: A milkman about to deliver milk from the cans he bears on the yoke around his neck. When these were full, their weight was substantial. Yet this heavy labour was more usually associated with women. Heavy work did not mean more pay: until the last decades of the Victorian period there were marked skill differentials.

Clockwise from top left: Estate workers painting an iron fence; a butcher slaughtering a sheep; a rather jolly painter and plumber with his cart; and a group of gardeners in the doorway of their potting shed.

A most unusual photograph of the owner or tenant of a smallholding, surrounded by ducks, chickens, a goat and his trusty hound.

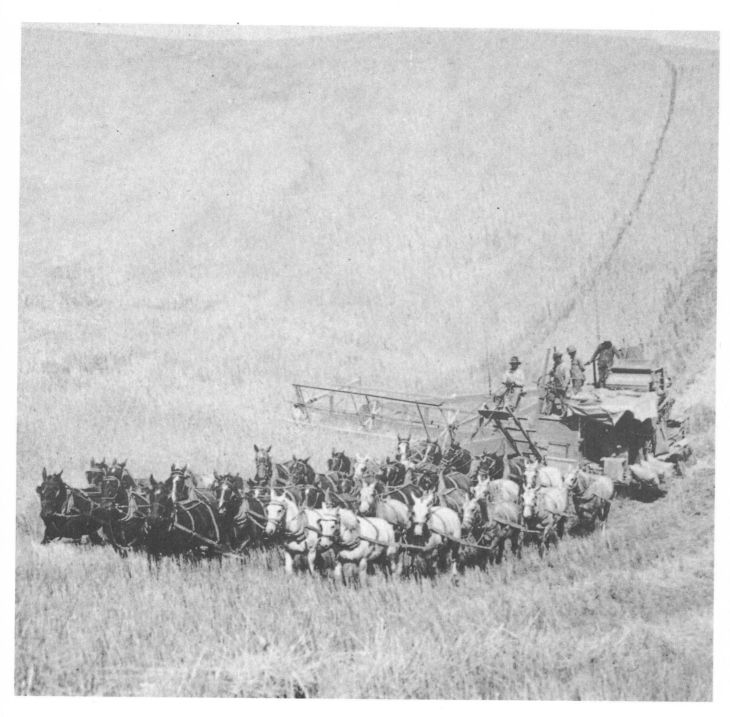

Opposite: A team of woodmen pause for a drink while cutting down a giant sequoia in Converse Basin, California, 1902.

This remarkable farming scene depicts a thirty-three-horse team pulling a harvester in Walla Walla, Washington. It is not surprising that the United States pioneered mechanized farm equipment that reduced both human and animal labour.

CHAPTER FIVE
LEISURE

The late Victorians had more time to spare than the early Victorians, although they might complain of 'being whirled about, and booted around...as if they were all parcels, booking clerks or office boys'. Life had speeded up and distances had narrowed. The telephone, invented in 1876, was used by only a small number of customers in 1900, and wireless, introduced twenty years later, was not yet associated with broadcasting, but the popular scientific magazines that proliferated during the 1890s were full of predictions of how science would raise expectations and, not least, propel entertainment in the century to come. So, too, was the *Daily Mail*, launched in 1896.

Time to spare had always been spent in different ways at different times by different types and classes of people. Much of it passed by quietly in the home and noisily on the streets, yet there were always specially managed institutions offering entertainment and pleasure. Some were organized on club lines; some charged for performances or services. Some catered for the 'rough', others for the 'respectable'. 'Rough' and 'respectable' alike had to restrain their activities – by law, if not by choice. Sunday was treated as a day apart, 'the day that the Lord hath given'.

In early Victorian England fears had been expressed that in the large cities most people were being deprived of any time to spare. 'The entire labour population of Manchester is without any season of recreation,' Dr Kay, a keen social observer, had complained in 1833, 'and is ignorant of all amusements, excepting that very small portion which frequents the theatre. Healthful exercise in the open air is seldom or never taken by the artisan of this town.' There seemed to be as much of a leisure problem in the new urban setting as there was a problem of public health or of public order.

Certainly the idea of a 'season' devoted to leisure (like the London season or the old Bath season) meant nothing to the industrial population, employers or employed. Nor did most of the old holidays. Regularity of work was paramount. Old pastimes might survive, though they might be thought to be under threat, and in village as well as in city and town the public house was the only real leisure centre outside the home – and Church or Chapel.

The railways changed this state of affairs, if not at once, and with them another landmark date, 1841, entered the historical calendar. It was then that Thomas Cook of Leicester transported his first temperance excursion, famous only in retrospect, from Leicester to Loughborough: return tickets cost 1 shilling. Cook was to

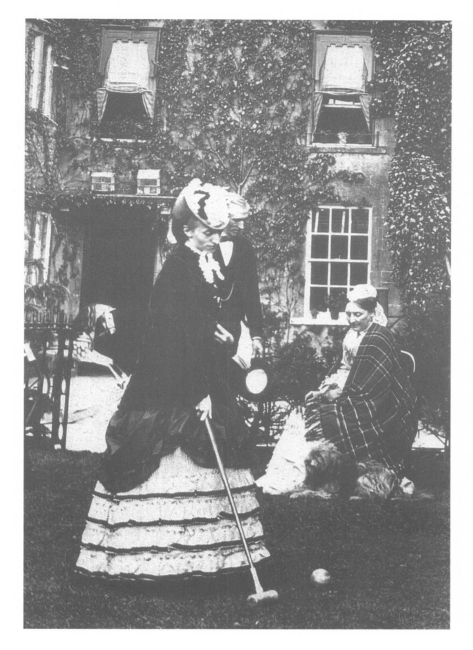

In this vignette of middle-class life taken by Mr Taylor of Chippenham, *c*.1870, in a client's garden, we see two ladies of the house, one lanquidly holding a croquet mallet. The family dog dozes nearby, caged birds chirp above the door, and a rocking horse awaits the children.

make his name and his fortune from middle-class foreign travel, as were the authors and publishers of guides and handbooks, who for the most part described places in words (and maps) rather than pictures. Sometimes publishers of *cartes-de-visite* and stereoscopic landscapes supplied what was missing.

From 1839, the landmark date in the history of photography, one leisure event has been picked out by James Walvin in his admirable survey *Leisure and Society, 1830-1950* (1978):

> The little village of Littleborough experienced on Saturday last a considerable accession of company. They were mostly clerks, warehousemen, and the decenter sort of operatives, with some families and children – the two latter fewer in number, proba-

An athlete proudly displays the numerous medals he has been awarded. Victorians treasured the medals, diplomas and trophies that they won for all manner of achievements.

bly in consequence of the broken weather. The day passed off without the least irregularity or disturbance, and not a small proportion of the visitors attended service in the afternoon at the church.

Littleborough was on the new Manchester–Leeds railway line, and 'the decenter sort of operatives' had organized their own excursion without the aid of Thomas Cook. The weather was mentioned specifically, as it was to be so often in English leisure history, and religion figured in the chosen leisure fare even on a Saturday.

All that was missing in 1839 was a photograph of the trip. By the end of the century, there would have been photographs. By then, too, a new national leisure network, dependent on the railways, had been created, and with an increase in disposable incomes and some shortening of the working week (including a free half-day on Saturdays) an increasing number of people had been able to take advantage of it. It is interesting to compare the 1839 picture of a Littleborough excursion with Osbert Lancaster's picture of the avowedly middle-class seaside resort of Littlehampton after the end of the period:

The unbutlinized Littlehampton represented the English seaside at its best. Separated from the sea by the wide expanse of green, rows of bow-fronted Regency villas looked across the Channel: on the sands pierrots, nigger minstrels, and on Sundays Evangelical Missioners, provided simple entertainment for those who had temporarily exhausted the delights of digging, paddling and donkey rides.

This was 'gentle', even genteel, leisure, and there was much of it.

Another town on the south coast that figured prominently on the mid-Victorian and late Victorian leisure map, Brighton, was less gentle and never genteel. It had an older history as a centre of pleasure that preceded the Prince Regent's enthusiastic adoption of Regency Brighton as a favourite *rendez-vous* for Court and aristocracy. Yet the railway changed its character fundamentally. The first excursion train ran from London to Brighton at Easter 1844, three years after the line was opened, and already by 1850 73,000 railway passengers arrived in Brighton in one week alone. On one day in 1862, Easter Monday, no fewer than 132,000 visitors descended on the town.

Punch, which made more of the seaside than any other periodical – a whole anthology has been produced called *Mr Punch and the Seaside* – noted in 1870 how unpopular the day 'tripper' might be among the local inhabitants of the places he visited:

> What does he come for?
> What does he want?...
> Why doesn't he stay at home,
> Save his train fare,
> Soak at his native beer,
> Sunday clothes wear?
> No one would grudge it him,
> No one would jeer.
> Why does he come away?
> Why is he here?'

Shopkeepers, landlords of public houses and owners of donkeys – or cameras – would have answered these questions with some difficulty.

In the North of England, largely outside the range of *Punch*, trippers were more acceptable. There were several new nineteenth-century holiday resorts there, as socially graded as the people who visited them. The most popular in the long run was Blackpool, although it did not acquire its famous Tower until 1894.

There were marked differences in the range of available leisure amenities in different places in different parts of the country, whether or not they were considered as 'holiday resorts'. Brighton had a race course as well as piers. New Brighton, across the Mersey from Liverpool had steamers. Liverpool itself acquired a magnificent hall for performances of music and a distinguished art gallery. Manchester put on a great Art Exhibition in 1857 which attracted thousands of visitors, including Dickens, Napoleon III and train-loads of working men and women brought in by Thomas Cook.

There was much talk in what were far from bleak mid-Victorian years both of 'art for the millions' and of 'music for the millions'. Indeed, these were years when the 'celebrities' of opera – and even more of the stage – were favourite subjects for photographers and for salesmen of *cartes-de-visite*. Long before the camera began to be taken into the theatre, actors and actresses flocked to photographic studios, sometimes on the eve of a performance, sometimes on a departure, when they wished to leave memories behind.

There were divides between 'professionals' and 'amateurs' – although amateur actors and actresses were just as keen on photography as professionals – and there were even bigger divides between 'rough' and 'respectable' leisure activities, with boxing as prominent in the first category as hymn singing was in the second. Yet in music – and in sport – the divides were not impossible to

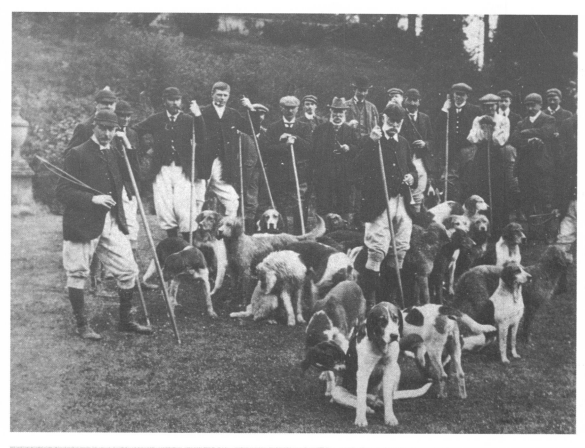

Left: 'After a hard run with the otter pack': a hunt in Wiltshire around the turn of the century. Hunting was a popular sport in many parts of the country. In general there was a decline in 'cruel sports' in Victorian England, prompted by the 'Victorian conscience'.

Below: An excursion, most probably on the River Severn, as the steamer was registered at Tewkesbury. Such local outings figured prominently in the annual round.

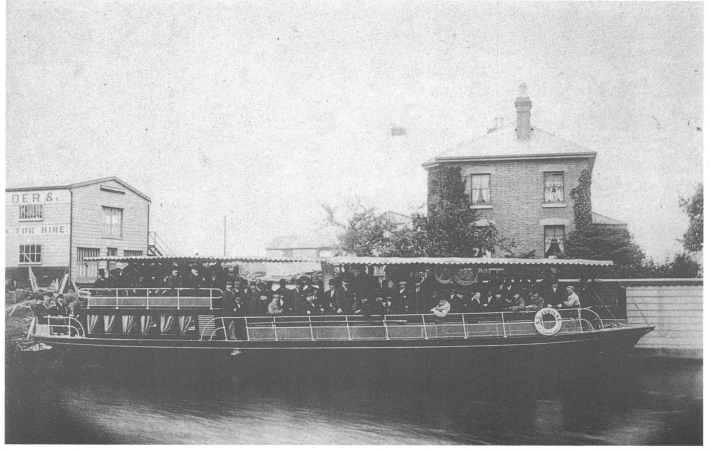

cross. Nor were they within the family. The husband might frequent the pub, the wife attend the chapel, and their children might be initiated into both.

Outside the home, music festivals had choruses that included factory workers, Malcolm Sargent began his career on the pier at Llandudno, and Arthur Sullivan dreamed of writing classical music but instead made his name through Gilbert and Sullivan light operettas and 'The Lost Chord'. This was a song that could be sung in both chapel and pub; and between 1872 and 1900, in a golden age of sheet music, it sold half a million copies. By the end of the century brass bands came to be associated not only with northern factories and factory towns – the famous brass-band contests had begun at Belle Vue, Manchester, in 1853 – but also with the Salvation Army, which created its first brass band in the traditional southern cathedral town of Salisbury.

London as a metropolis always had a vigorous leisure life of its own, crowded as it often was with visitors. The Crystal Palace, moved out to Sydenham, was a unique place of entertainment, recorded by Delamotte in an impressive series of albumen photographic prints. Later came the music halls: there were twenty-eight of them by 1868.

There had been a further legacy of 1851 – the culture complex associated by the end of the century with the Victoria and Albert Museum, the Natural History Museum, the Science Museum and

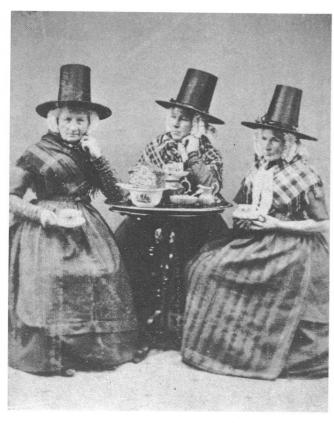

Above left: Three Welsh women in national costume taking tea. Quaint *cartes* like this were sold in great quantities to tourists.

Above right: Tom Thumb (Charles Sherwood Stratton, 1838-83) was just one of P.T. Barnum's company of unusual people and circus acts. This group was photographed by Mathew Brady in 1863 to commemorate Tom's marriage to Lavinia Warren. Also in the group are Commodore Nutt and Minnie Warren, the attendants. Tom Thumb won fame and fortune and was a great favourite of Queen Victoria.

the Albert Hall. The foundation stone of 'the V & A' was laid in 1899 by Queen Victoria herself in the last public function of her reign. The kind of 'leisure culture' represented there was deemed to be 'useful', even 'elevating', and there were providers of such useful and elevating culture in every great provincial city. Indeed, much culture was assertively provincial. It had a life of its own, but it could easily be patronized from – at times controlled from – above. So also could open-air recreation in the park. Indeed, many parks were presented to their community by patrons of 'useful culture', who often had their parks named after them. Gardens and allotments gave the opportunity for a more competitive culture, although prizes for the best roses or marrows might be handed out by titled ladies and gentlemen.

Although photographs never made their way into the Victorian newspapers which advertised the varied 'events' of the leisure world and went on to record its happenings in words, photographers recorded far more of this leisure story than they did of the story of work. Indeed, they themselves were often at the centre of the leisure scene, and their studies were leisure attractions in themselves. Alfred Sharp's studio, for instance, was famous on Brighton's Chain Pier. Walter Fry, another Brighton photographer, with his studio in East Street, produced photographs of the local scene that varied widely in subject matter and in style, but which provide an invaluable record of life as it was lived. (He also photographed Mark

Above: Commodore Forto and his sister used their diminutive stature to bask in the reflected fame of Tom Thumb.

Right: A young lady in
gipsy clothes, playing a
mandolin. Gipsy
costume was highly
popular as fancy dress
even in aristocratic
circles.

Far right: This lady with
her harp looks slightly
uncomfortable about
the whole prospect of
having her photograph
taken. She was not
unique in this. The
camera registered
embarrassment as
much as pleasure.

Twain.) His photographs now form part of Hove Library's collection.

Alas, when Sir Benjamin Stone embarked on his National Photographic Record in 1897, Brighton figured through its churches rather than through its beach or through the people who found pleasure on it. By then, however, we have George Ruff's beach pictures, one of them printed in Gus Macdonald's *Camera, A Victorian Eyewitness* (1979), and, above all, family snapshots. One of these – a view of the promenade – is printed in Brian Coe's and Paul Gates's *The Snapshot Photograph* (1977). 'Snapshot photography', they stress, was 'primarily a leisure activity', and the leisure world that it recorded was already in existence before the Kodak camera.

The whole world of sport, much photographed in the twentieth century and a major subject of television, was relatively little photographed during the Victorian years. Sport, whether aristocratic, like shooting, or democratic, like football, does not figure, indeed, in the index of Thomas's *The Expanding Eye*. There were excellent photographs of mountaineering, however, and, nearer home, of bathers, and there is one fascinating 1884/5 photograph of boxers by Eadweard Muybridge, the pioneer of motion pictures, which is reproduced in Macdonald's book. Sporting heroes, like actors and actresses, had to make their way to the studio, where they would be posed against forests, lakes or seashores, but at least one fox-hunting sportsman took along his trophies with him when he went to George Cooper's studio in Hull.

The history of sport is now as much of a specialized subject as the history of photography, and again it brings out curious patterns of cultural cross-influence in the nineteenth century. Some football teams, like Everton, were spawned by churches; others, like Stoke City, had their origins in places of work. In the early years of soccer, class lines were often drawn and crossed. Thus, after a working-class

Blackburn Olympic team defeated the Old Etonians in a Football Association Cup Final in 1883 – the Cup Final, like the Derby and the Boat Race, was already a national event – they were welcomed back to Blackburn by a brass band.

For social rather than aesthetic reaons it was probably more likely that cricketers – or oarsmen – would be photographed than footballers, but there is a *carte-de-visite* of the American prize fighter John Heenan. There are also many photographs of cyclists. Cycling was a vigorous leisure activity, important because it was popular – approved of equally enthusiastically by the socialist Blatchford and Alfred Harmsworth, founder of the *Daily Mail* – before the term 'sporting nation' was coined to describe a country where there seemed to be room for every kind of spectator sport.

Below left: Henry Irving (1838-1905) was one of the most celebrated actors of Victoria's reign. He received great acclaim for his Hamlet, his portrayal of Shylock in *The Merchant of Venice* and as Mattias in *The Bells* – a production in which he was so popular that it was regularly revived for over thirty years. He is seen here in the role of Cardinal Wolsey in *Henry VIII, c.*1892.

Below centre: Adelaide Neilson (1846-80) was an English actress who began her career in 1865 as Julia in Sheridan Knowles's *The Hunchback.* She travelled to America in 1872, where she gained great popularity during two successful nationwide tours. This photograph shows her as Juliet in *Romeo and Juliet*, one of her best roles. Sadly she was to die suddenly upon her return to England, not long after this photograph was taken.

Right: Mary Anderson (1859-1940) was an American actress who played a wide variety of roles all over the United States after her debut as Shakespeare's Juliet at sixteen years of age. She came to London in 1883 where she performed most notably in plays by Shakespeare and W.S. Gilbert. She retired in 1889 and married the following year.

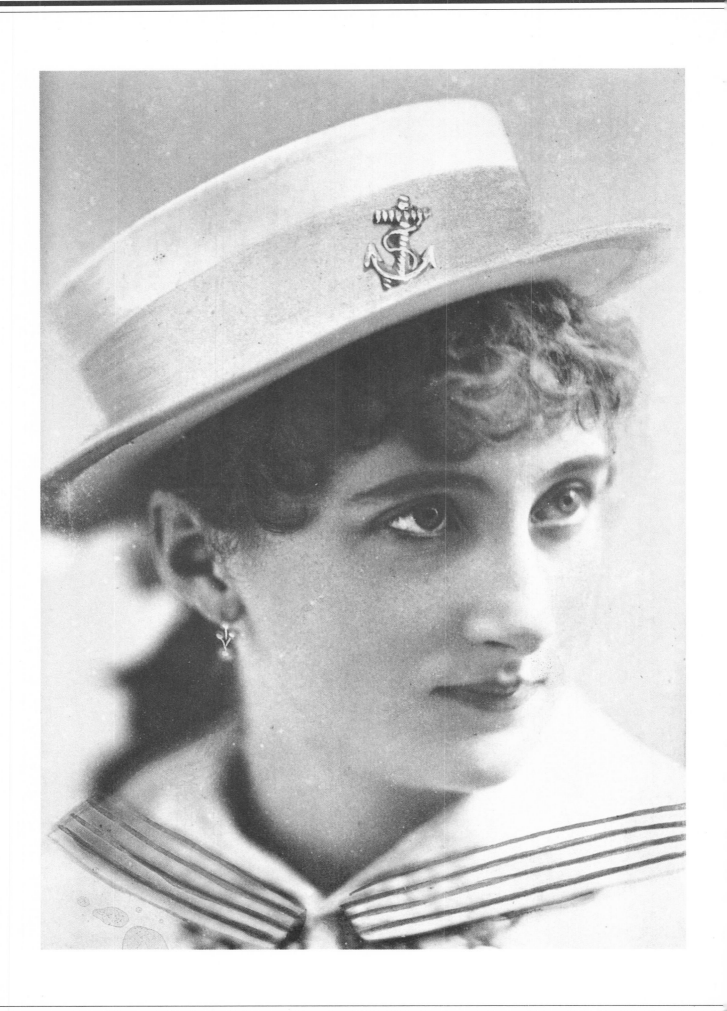

Opposite: A delightfully tinted cabinet portrait of Maud Branscombe, the American actress and noted beauty. José Maria Mora, the photographer, was clearly entranced by her as he was reputed to have made over three hundred different photographs of her alone. His customers must have been similarly impressed since sales soared to over 30,000 prints. Cuban-born Mora began his photographic career in 1869 when he came to New York and worked as an assistant in Napoleon Sarony's studio. It was not long before he struck out on his own, and his photographic business became the largest in New York.

Right: Lady Argyle dressed as Little Red Riding Hood.

Above: The Royal Hand
Bell Ringers and Glee
Singers with their
carillon of 131 bells and
extraordinary costumes.
Right: This theatrical
depiction of a proposal
of marriage relates to
an amateur production
in the Stroud area in
the mid-1880s.

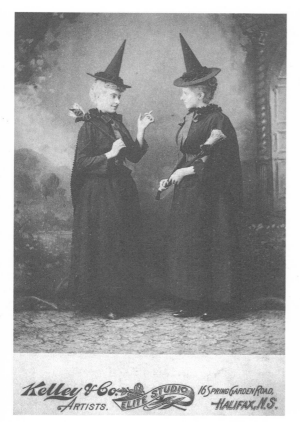

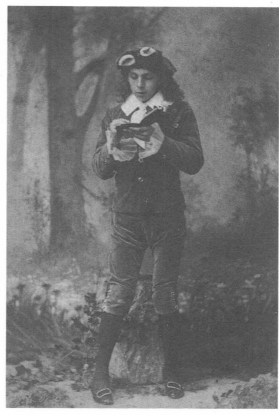

Far left: These witches from Nova Scotia do not appear threatening as they chat pleasantly in the photographer's studio. They may have been getting ready for a Hallowe'en party.

Left: Photographs of actors and actresses, amateur or professional, were very popular and there was a brisk demand for *cartes-de-visite* of celebrities. This photograph is of a foppish actor in the aesthetic mould.

Below far left: Arthur Lamplugh Wolley dressed in sailor garb for a costume ball given by Madame Sabatiere at Menton, France. This fresh-faced young man contrasts sharply with the genuine item as seen on page 28.

Below left: Victor Dulup Singh as 'Comedy', a humorous theatrical pose from the Notman Studios of Canada. They specialized in wintry settings, often with snow falling!

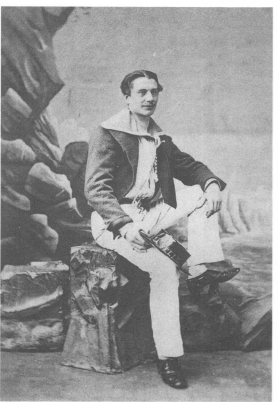

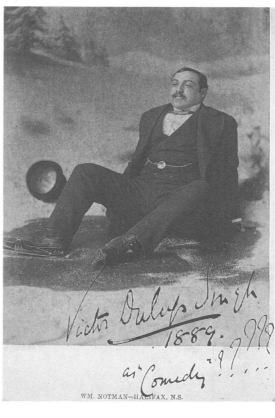

This gentleman striking a pose amidst a cascading waterfall was using the drama of the wild to promote his business as an artist. The photograph reverse bears a delightful scenic design and the legend 'H. Murgatroyd, Lithographic Artist, Designer and Illuminator'.

Left: The summit of Snowdon in the late 1860s. The photograph was taken before the building of the Mountain Railway, and the mountain top was cluttered with makeshift shacks which offered protection from adverse weather and housed vendors of assorted refreshments. It is apparent that the lady's dress made little concession to the rigours of the climb.

Below: A wayside hostelry deep in the Lakeland hills. Visits to the Lake District, the home of Ruskin, were popular, and there are just as many photographs of lakes and mountains as there are of seaside beaches.

A delightful evening photograph of a fisherman landing his catch on the Loch of Park. This is a particularly early George Washington Wilson image. Wilson established his business in Aberdeen in 1852, and as well as having a successful portrait studio he was to build a photographic empire based on landscape photography which rivalled those of the other giants, Frith and Valentine.

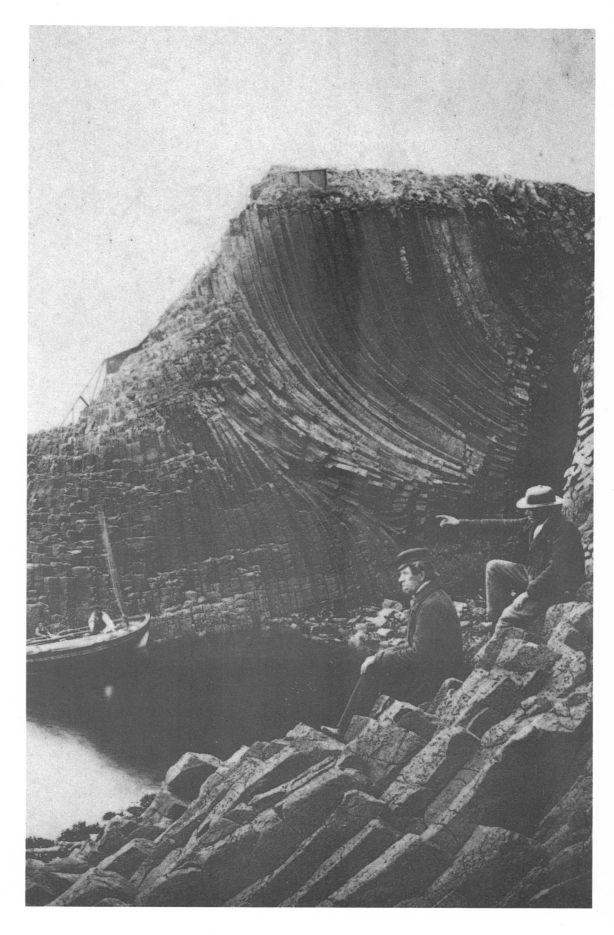

The strange strata of Clamshell Cove, Staffa, another photograph by George Washington Wilson. The figures in the foreground were most probably in his employ. This use of figures to add life and scale to a landscape was common.

Above: A girl on horseback, steadied by her groom, prepares to ride out. She rides side-saddle, which was usual for the period: for a lady to sit astride her horse was seen as rather vulgar.

Right: The cult of the body was developed during the course of the nineteenth century – 'A healthy mind in a healthy body' was a maxim derived from the classics – yet most athletes were strictly non-professional.

A mixed group of tennis players in the 1880s. It was an Englishman, Major Walter C. Wingfield, who devised a 'new and improved portable court for playing the ancient game of tennis' in 1874. The first lawn tennis tournament at Wimbledon was held in 1877.

This page and opposite: Leisure started in the nursery with rattles and toys. These photographs of children with various toys, are typical of the mid-Victorian period. Studios encouraged children to bring favourite toys, particularly dolls, to sittings as this relaxed them and distracted them from the rigours of photography. They would also hold a collection of toys on their premises. Toys were rarely photographed in their own right.

Victorian delight in the fun of the seaside holiday was obvious from the large number of photographs taken at seaside resorts. Enterprising studios threw open their doors along every promenade and there were usually photographers on the piers. For every photograph of the seaside there are two or three cartoons, but there were no comic postcards in Victorian Britain. The weather was as unreliable then as now.

T. Taylor

SCARBOROUGH

This little girl is almost overcome by the splendour of the maritime backdrop and studio set in this photograph from Morecambe ('Bradford-by-the-Sea') in the 1880s. Some studios were designed to inspire awe in adults. Alexander Bassano, who moved from Regent Street to Old Bond Street in 1877, adorned his premises with oriental carpets and plaster busts he had made himself.

Photography was never concerned entirely with 'reality'. An attempt at creating an early photographic illusion was made by F. Woodcock of Douglas, Isle of Man. Tourists appear to row across the bay in a boat set between the backdrop and cut-out 'sea'.

Opposite: A family group of children with their dog ready for a day on the beach. This was to be a favourite snapshot theme.

Three different coastal views of the Isle of Wight, a favourite haunt for tourists. Karl Marx went to Ventnor for its climate and its peace. Cowes was a busier resort favoured by Prince Albert, and Osborne remains as one of his memorials. These photographs are titled: *(above)* 'Freshwater Bay from the grounds of Plumbley's Hotel'; *(right)* 'Steephill Cove, Ventnor'; and *(opposite)* 'View from the Chine, Shanklin, looking towards Bonchurch'.

T.J.S.S. & D.

CHAPTER SIX

LOVE

However far they travelled, the Victorians made as much of the family as they did of self-help. 'Domestic virtues' were the virtues of the hearth. For the industrious Victorian photographer Francis Frith, 'a life without love and domestic joys and cares and the discipline of child-life is sorrowfully incomplete. Marriage gives solidity, purpose and energy to life....I reckon the real substance of my life to date from my wedding day.'

Frith concentrated on photographs of places at home and abroad, but in general there are far more photographs of family groups than there are of places, and in many cases the photographs were preserved to form albums of family chronicles, to be kept with old letters and diaries. They might to be on display. Sometimes there were montages too. One cabinet photograph in the Victoria and Albert Museum shows Mrs William Paget holding a photograph album. It has been reproduced in a scholarly article in the *Photographic Collector* (1985) by Janice Hart, 'The Family Treasure: Productive and Interpretative Aspects of the Mid to Late Victorian Photograph Album'.

In the family albums, often elaborately bound and clasped, quintessential Victorian things, husband and wife sometimes appear as separate individuals or as a couple at the time of their engagement when presents were often exchanged. That was the beginning of their private story which, it was confidently expected, would usually have a happy ending. The sense that marriage went with love and that love was romantic love was stronger than it seems to have been in earlier centuries.

This was certainly the language of the family album, often associated, as in birthday cards, with sentimental words. There was also an accompanying Victorian language of flowers, and the thick card pages might be bedecked with floral ornament. Yet, as Jenni Calder has written in her *Women and Marriage in Victorian Fiction* (1976), even in the Victorian novel 'it is virtually impossible to get away from the concept of marriage as a financial transaction'.

For one contemporary observer writing of 'real life' in 1854, 'a great proportion of the marriages we see around us did not take place from love at all, but from some interested motive, such as wealth, social position, or other advantage; and in fact it is *rare* to see a marriage in which true love has been the predominating feeling on both sides.' A different problem, familiar both in real life

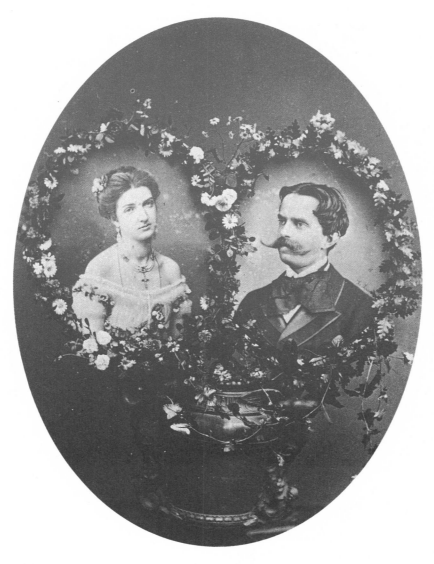

An unusual montage by Le Lieure of Turin. Two portraits were taken individually of the couple shown in this photograph and were then printed, mounted into the heart-shaped bower and rephotographed. This kind of sentimental composition was most likely devised in commemoration of their engagement. Victorian sentimentality was not an exclusively British product, and this montage is a precursor of the montages of engaged and married couples floating in bouquets of flowers or even in champagne glasses.

and in fiction, was the *mésalliance* when sons or daughters were married to social 'inferiors' or where there were sharp religious differences. Love did not always find a way.

The fact that divorce was an expensive and complex process and that at the end of the century only 0.2 per cent of marriages ended in divorce by no means implied that all marriages were happy. And certainly few marriages were free from domestic tragedy. A high rate of infant mortality and a significant rate of mortality of mothers in childbirth disturbed or broke 'marital bliss'. So, too, did killer children's diseases like whooping cough and scarlet fever. The family album often recorded memories of woe.

The infant mortality rate was highest in poor families, those which would be unlikely to possess elaborate albums; and we know less of the inner life of these families than we do of middle-class and aristocratic ones. Within marriages there were marked differences according to social class. Among aristocratic families, where wives might have substantial wealth and, indeed, a separate income, they

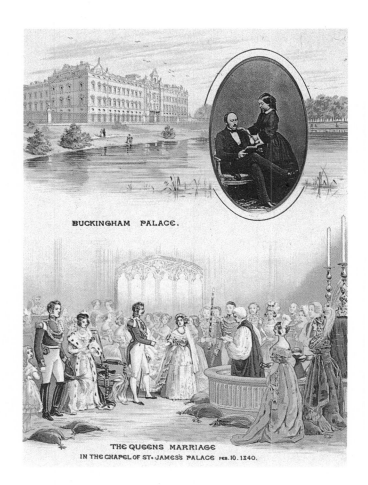

BUCKINGHAM PALACE.

THE QUEENS MARRIAGE
IN THE CHAPEL OF ST. JAMES'S PALACE fEB.10.1840.

A simple and touching portrait of Victoria and Albert. Taken from Mayall's 1860 series of the royal family, it carries with it a certain intimacy and tenderness. Note the Queen's lowered eyes; the Prince resolutely reads on. Although he was never a popular figure, this particular image of the Queen and Consort was a highly popular one which can regularly be found in private family albums. Note the elaborate non-photographic surround.

might be far more 'liberated' than middle-class wives. Among poorer families there was always a distinction between the 'respectable' and the 'rough'.

Inside middle-class families love set within the context of marriage was idealized, and it was contrasted sharply with lust. Tennyson presented the pattern:

> Love for the maiden, crown'd with marriage,
> no regrets for aught that has been,
> household happiness, gracious children,
> debtless competence, golden mean.

After marriage there would be a place in the family album also for innumerable photographs of children. They would usually be dressed up: occasionally they might seem genuinely spontaneous. Some children might be carrying toys or riding decorative rocking horses; others might have beside them a dog or a cat – and they must have been even more difficult to keep still than the children.

Victorian families were often large (the average in 1861 was 6.2 children) and Queen Victoria had set the pattern. A fall in middle-class family size began in the 1870s, though the size of working-class families fell more slowly. Unlike some of her subjects, Victoria was unsentimental in her attitude to the children displayed in her

TRACING THE TRACK OF HER LOVER.

Registered.

'Tracing the Track of her Lover': a novelty card with rather slap-dash colouring, but a worthy depiction of all those sweethearts left at home while their menfolk risked life and limb abroad. The parting was another favourite Victorian image for *genre* painters. Much Victorian photography focused on *genre* themes.

albums. Babies she once described as no better than little cabbages. There were aristocratic and middle-class families, too, where children figured more prominently in albums than they did in the home, where they were tucked away in nurseries and where, when they entered the drawing room, they were expected to be seen and not heard.

In the case of upper-class families, photographs might also include servants, particularly 'nannies', to whose care little children were confided, and, once again, domestic pets – horses as well as dogs and cats. A large number of pictures was also taken of exteriors of family houses – the Americans called them 'homes' – with, for technical reasons, fewer pictures of interiors.

Whatever the social class of the family, it was the interior life of the home, however, that was felt to matter most. The Englishman's home was his castle and 'interlopers' were to be kept out. The term might include salesmen or inspectors, and in the poorest families even social workers. Family friends were not interlopers. The Victorians made as much of friendship as they did of love, and family friends figure in many Victorian albums as prominently as family members:

> Grateful thanks you will receive
> If your Portrait here you leave.

In working-class streets neighbours figured prominently, too – for example, in the street photographs taken by Paul Martin, a young London wood engraver turned photographer, during the 1890s.

For most Victorians the 'very *idea* of family life' was invested, as Thomas Arnold put it early in the reign, with a 'peculiar sense of solemnity'; and in the mid-Victorian years – in 1869 – John Stuart Mill noted solemnly, if without rhetoric, how 'the association of men with women in daily life is much closer and more complete than it ever was before. Men's life is more domestic.'

Believing as he did that women were subjugated, Mill would doubtless have added that women's life was too domestic. They were tied to the home. It is not surprising, therefore, how many Victorian books were written about the management of the home, some of them very practical, like *Cassell's Book of the Household* (1895), or Mrs Haweis's *Art of Housekeeping* (1889), dedicated to her daughter (the latter included a chapter called 'Houses for the Happy'). The most famous book of all is Isabella Beeton's *Book of Household Management* (1861).

Mrs Beeton's family history is as striking as her recipes. Born one year before Queen Victoria came to the throne, she married when she was twenty years old and died of puerperal fever at the age of twenty-eight. She had four children, the first of whom died at the age of three months. Her second child died three months after the

Patented by Window and Bridge in 1864, the diamond cameo portrait attracted brief popularity. Licences to use the process were granted to several major London studios, although it never seemed to catch on outside the metropolis. These small images were ideal for mounting in jewellery.

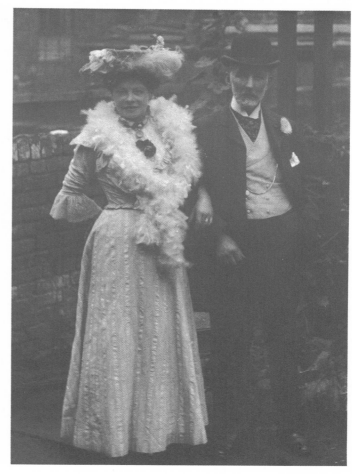

age of three months. Her second child died three months after the publication of *Household Management*. She herself had been brought up in a large family, for although her father, a wholesale draper, died when she was only five years old and left behind him only four children, her stepfather had four children by his first marriage and he and her mother went on to produce thirteen children, thus making twenty-one in all.

If Mrs Beeton was among the best-known of Victorian women, this was only to her readers. There were other women who never married who left their mark on the whole of society. Octavia Hill, the housing reformer, was one, Florence Nightingale another. The proportion of unmarried females over forty-five in the population was about 12 per cent in the 1850s, falling to 11 per cent in the 1880s before rising to 14 per cent in 1901.

Unmarried relations, aunts and uncles in particular, might figure prominently both in family life and in charitable activity, but charity was far from being their exclusive preserve. It might draw on other forms of love, love as compassion, and paterfamilias might find ample time to devote to it. So, too, might his loving wife. There was always a massive Victorian philanthropic effort, usually described as 'good works'. It was sometimes related to politics, but

Above left: A striking portrait of a middle-class couple on their wedding day. Wedding photography did not really burgeon until the twentieth century, when the photographer became as prominent before and after the ceremony as the clergyman. In Victorian times marriage photographs, for technical reasons, were taken in studios rather than at the church door. *Above right:* An older couple clearly of working-class background photographed in their back yard on their wedding day. Note the bridegroom's enthusiasm.

A delightfully informal family group on the steps of their house in Scotland. Even grandmother, despite her regal appearance, seems amused.

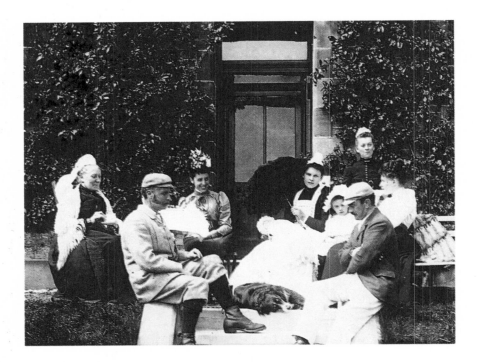

more often to religion – insofar as the two can be easily separated.

During the last decades of the century more women deliberately challenged from the platform the view that woman's place was the home: they hoped to become workers in the world's affairs not 'idlers'. A minority of them fought for 'liberation' from 'the doll's house'.

So long as women, whether married or unmarried, were placed on a pedestal, there was a double standard. Bachelors could sow wild oats; women were usually denied sexuality. They were expected, at least in 'respectable' circles, to be 'pure' in thought as well as in deed. 'Fallen women' were ostracized or patronized. Yet there were large numbers of prostitutes. For Francis Wey, a French visitor to England in the 1850s, 'the family circle might be rigid and puritanical', but 'vice' was 'crudely displayed in public. Anyone who takes a walk in broad daylight through the London parks will ascertain the truth of my statement.'

There seems to have been more private vice than vice on display. For all the sexual taboos – or, more likely, because of them – husbands could live 'secret lives' and write about them at length behind locked doors. Blackmail was always a threat. There were always 'other Victorians', as Steven Marcus has called them. Reactions could be bitter. 'If I am a prostitute, what business has society to abuse me?' 'a prostitute' wrote to *The Times* in 1858. 'Have I received any favours at the hands of society? If I am a hideous cancer in society, are not the causes of the disgrace to be sought in the rottenness of the carcass?'

Although there were Victorians like Dr William Acton, the Samuel Smiles of continence, who argued that 'intellectual quali-

ties are usually in an inverse ratio to the sexual appetites', the Victorian age was 'not a golden age of sexual propriety'. 'Impropriety' was frowned upon, but everyone did not follow the same sexual code. Wey was surprised to find English girls 'talking of love without more scruple or emotion than a housewife discussing jam-making or spring cleaning'. In the shop and on the stage there was always a place for the *risqué*. The word was French, the appeal English.

Within this context it is interesting to note how strongly nudity could titillate the Victorians, whether it was expressed in statues, in museums, at exhibitions, or in photographs. On a visit to Brighton just before he returned to France, Wey was surprised to discover how men went into the water 'stark naked'. In his famous diary the Reverend Francis Kilvert could present a kind of verbal photograph when he described a 'beautiful girl...entirely naked on the sand':

> There she sat, half reclined sideways, leaning upon her elbow with her knee bent and her legs and feet partly drawn back and up, she was a model for a sculptor, there was a supple slender waist, the gentle down and tender swell of the bosom and budding breasts, the graceful roundness of the delicately beautiful limbs and above all the soft exquisite curves of the rosy dimpled bottom and broad white thighs.

Kilvert's innocence in an often nasty world was one of his most attractive qualities, but there was nothing innocent in Henry Hughes's photographic establishment in Pimlico which was raided by the police in 1873. No fewer than 130,240 obscene photographs and 5000 stereoscopic slides were confiscated. During the 1870s there seem to have been two large manufacturers of pornographic photographs, one at Clapham, the other at Kentish Town. Photographers themselves were among the main critics of this trade.

Left: Dr Mary Walker stands boldly before the camera in this 1870s photograph by Elliott & Fry. Her dress and views on women's equality were remarkable at a time of female subservience. Emancipation was slow, but there were always women rebels who asserted the rights of their sex. Historians have become increasingly interested in their attitudes and achievements.
Far left: A study of the hands of this nurse reveals some of the rigours of the caring profession. Nursing acquired a new prestige in Victorian England. During the Crimean War, Florence Nightingale, 'the lady with the lamp', fought hard to win her own way. However, she was never a believer in women's rights.

 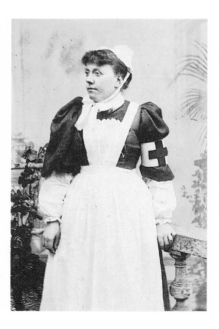

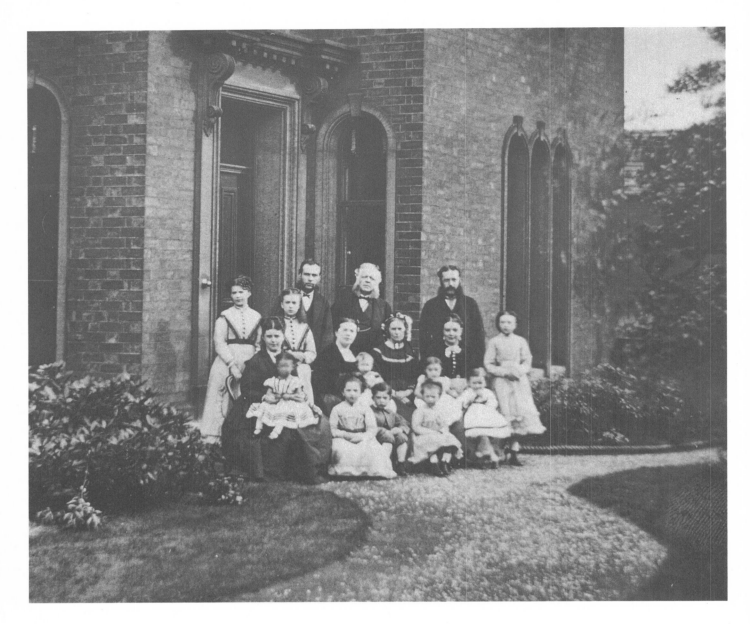

Taken outside the family residence, this photograph reflects Victorian middle-class aspirations – a grand home with a large family. The head of the household, paterfamilias, stands in the centre with an array of children and grandchildren.

Opposite: Photographs reveal social milieus, and this family probably stood a little lower in the social scale than the family on the facing page. The backdrop chosen for their portrait suggests something worthy of attainment. The obvious apprehension on the faces of the members of the family suggests that they were sharing in an infrequent experience.

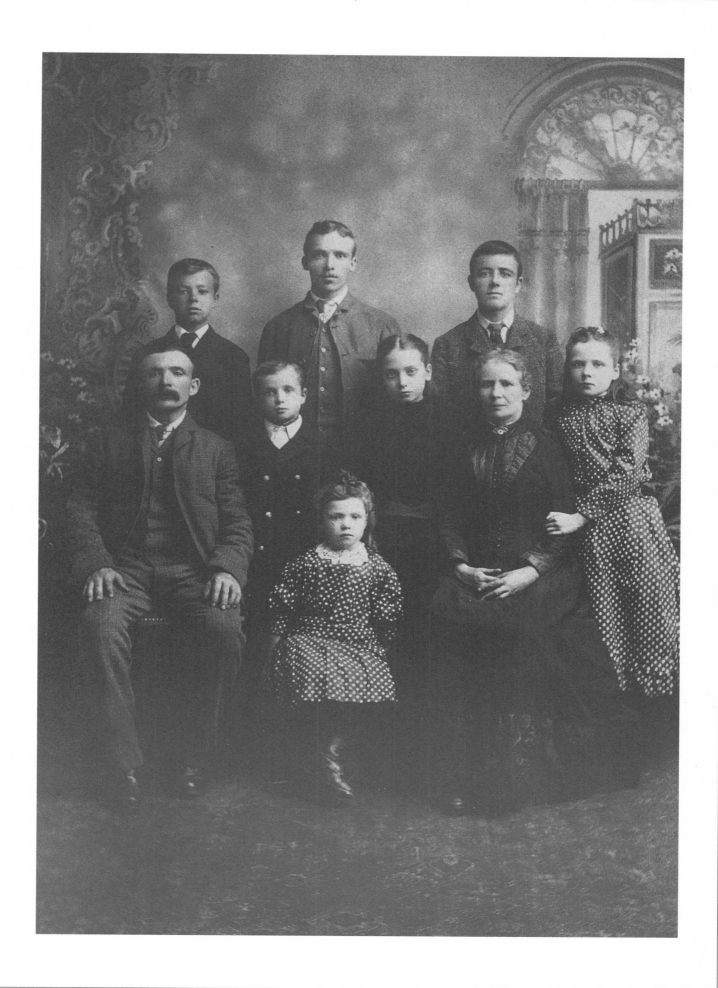

Facing page: An uneasy portrait of a father and his daughter. The formality and the sense of distance between the two is heightened by the girl's attempt to hold her father's down-turned hand.

By way of contrast to the photograph on the facing page this photograph captures a more intimately friendly relationship between a father and his daughter, whom he has clearly just asked to 'watch the birdy'. The father's pose is more relaxed than his daughter's.

Opposite: Many fresh and uninhibited portraits of children were made: they were not yet burdened, it seemed, with the cares of their elders. Yet children were more often than not 'dressed up'. Scottish costumes and sailor suits were favourite choices. The little girl with the bow in her hair almost seems to challenge the viewer. The two sisters just personify their love and caring for each other in the closeness of their pose.

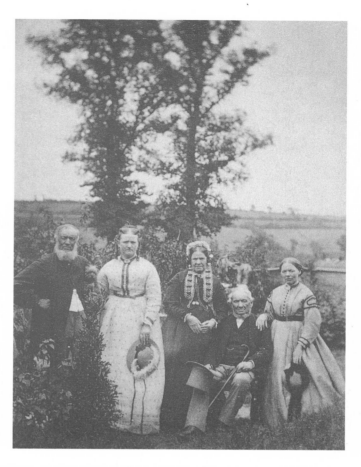

Right: The picture of this unusual group, taken outdoors, appears to have been used as a birthday card. The reverse bears the legend 'Wishing you many happy returns of the day...Geo Braund, Sept 26 1870'.
Below: Many photographers offered an 'at home service', which was ideal for elderly or disabled people.

This design was used on a *carte-de-visite* reverse by P. Sebah of Constantinople. The individuality of some of the designs for the backs of *cartes-de-visite* involved as much art as the photographs themselves.

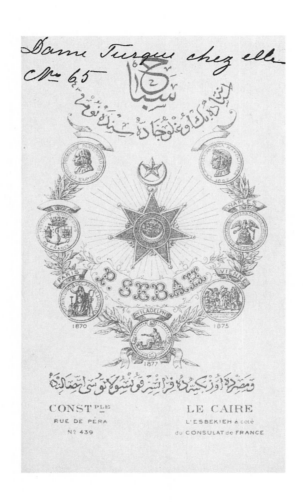

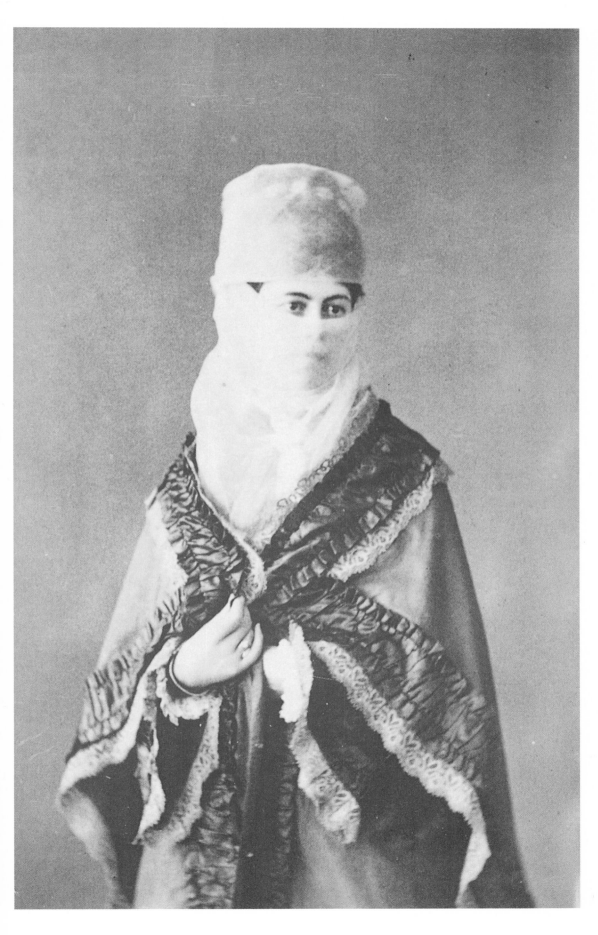

Sebah made a large series of photographs of young Turkish women for sale to tourists and voyeurs alike. The inference was of harem girls and forbidden fruit, but most probably his subjects were street girls 'dressed up'. Most Turkish women would have been afraid of exposing their faces in front of the camera, let alone the photographer.

A strange story lies behind the cabinet reverse *(below)* and accompanying photographs here and overleaf. The grandiosely titled Crystoleum Company is not traceable in any photographic context in London. However, a subsidiary of Caspar and Co., glass manufacturers, with this name was registered between 1885 and 1904. During the period 1885-9 they had premises in Regent Street, but not at No. 223: that number was occupied by a firm of hosiers. The conclusion is that either the company was not in the premises long enough to be recorded in any directory, or (more likely) that it was a *poste restante* for a company offering material of a dubious nature. A photographic business of the same name is recorded in Brighton directories between 1882 and 1884, but no connection has been established.

Right: This young woman earns a few shillings by draping herself across a tacky set.

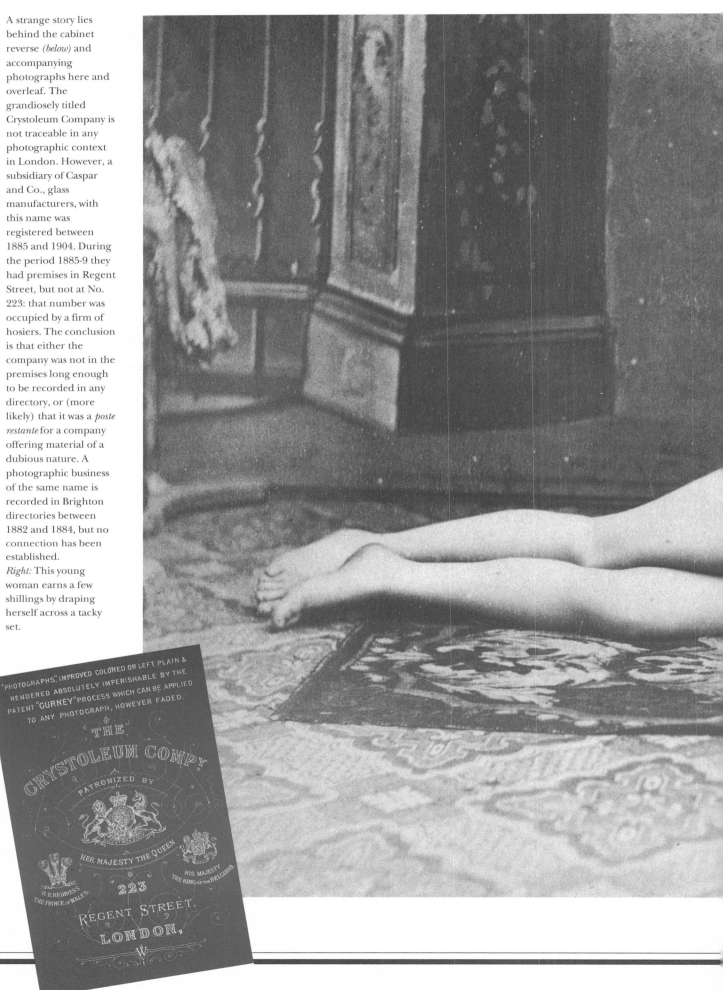

"PHOTOGRAPHS", IMPROVED COLORED OR LEFT PLAIN & RENDERED ABSOLUTELY IMPERISHABLE BY THE PATENT "GURNEY" PROCESS WHICH CAN BE APPLIED TO ANY PHOTOGRAPH, HOWEVER FADED.

THE CRYSTOLEUM COMP?

PATRONIZED BY

HER MAJESTY THE QUEEN

H.R.HIGHNESS THE PRINCE OF WALES

HIS MAJESTY THE KING OF THE BELGIANS

223

REGENT STREET, LONDON, W.

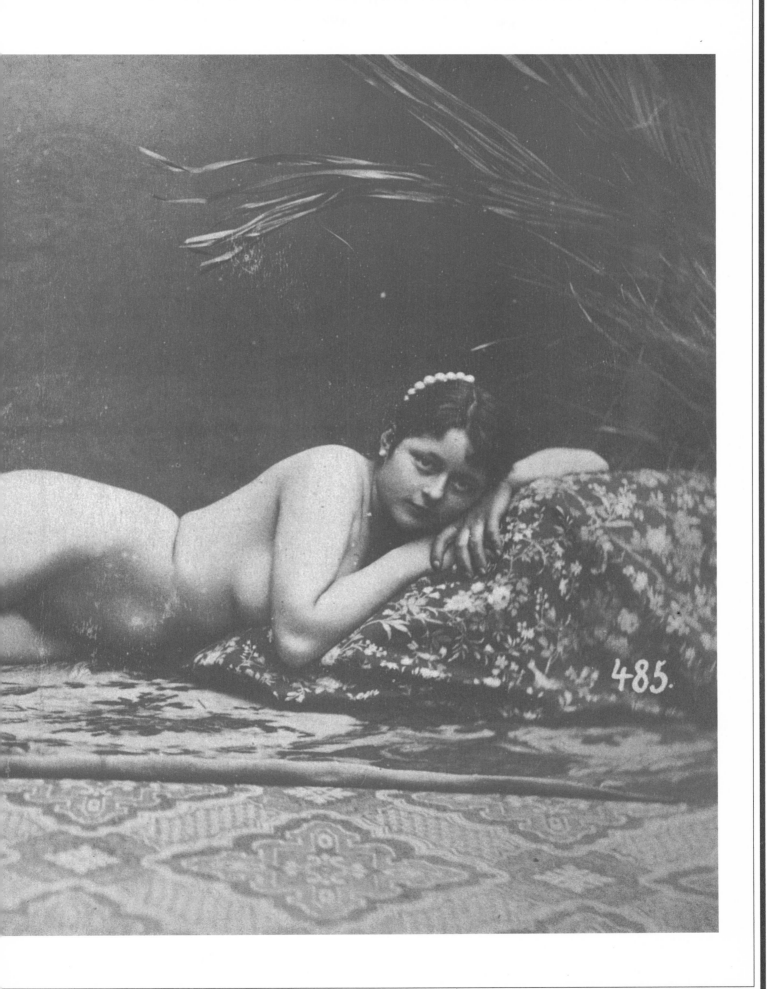

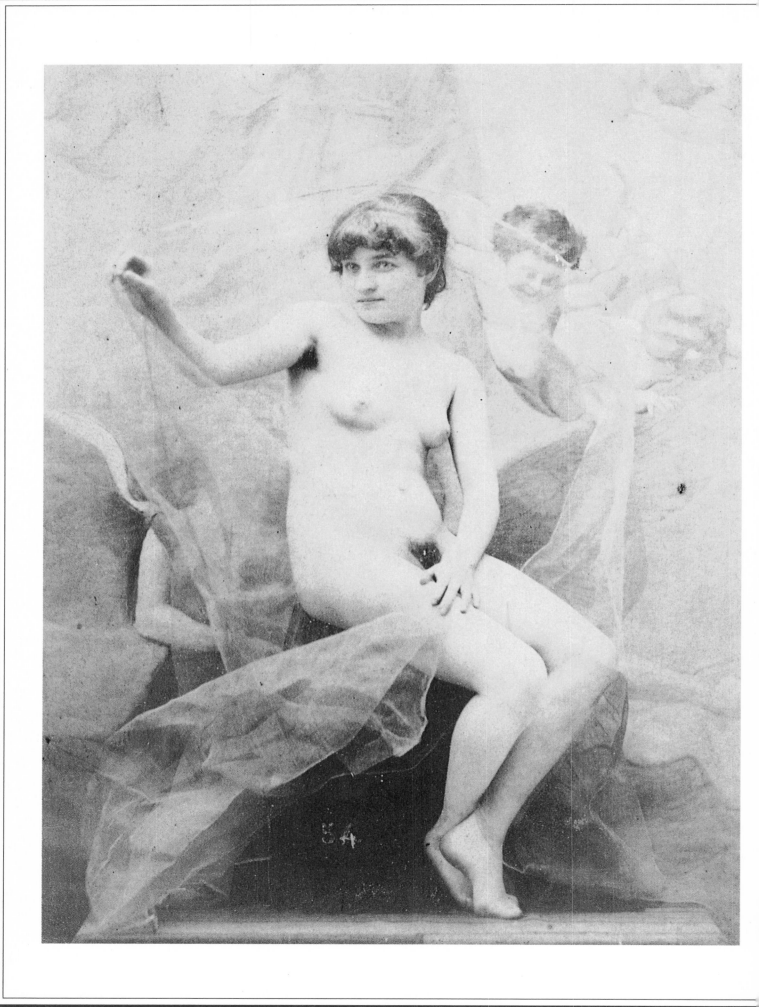

Opposite: This nude, clearly a young girl, poses in classical style. The number which was scratched on the negative would be used for ordering. This type of 'soft porn' was often sold under the spurious cover of poses for artists' reference.

Right: Four 1860s cards depicting slightly *risqué* subjects. What was *risqué* was a matter of judgement, not least for French visitors.

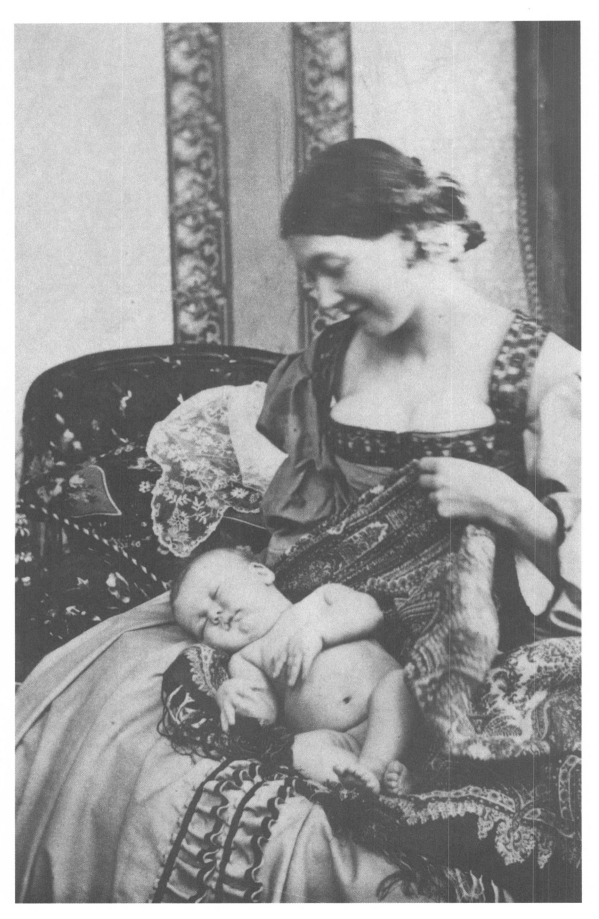

For the Victorians sentiment very quickly turned into sentimentality, as in this card of a mother and baby with the sickly title 'The Little Treasure'. The popularity of such cards illuminates Victorian attitudes, although Queen Victoria herself would have been the first person to tear them up.

Pet animals had a place in many people's hearts, and the Victorians made the most of their 'domestic pets'. These photographs show an 'at home' portrait of an elderly lady with a caged bird (probably a linnet), a rather shy little girl with a rabbit and a most unusual portrait of a little girl with her Jack Russell terrier and a piglet with a ribbon round its neck. Victorians went to the zoo to look at what they were told were 'wild animals'.

CHAPTER SEVEN

PRIDE

The Victorians were often reminded from the pulpit that pride was one of the seven deadly sins, the primal sin in the Garden of Eden, yet this did not prevent them either from pontificating proudly or from behaving apparently effortlessly like 'lords of creation'.

Some preachers drew a distinction between 'legitimate' and 'inordinate' or 'overweening' pride, but in practice it was an awkward distinction to draw. Nor did it impress foreigners:

> Pride in their port, defiance in their eye,
> I see the lords of human kind pass by.

For his part, Dickens's character, Mr Podsnap, a powerful but not unrepresentative caricature, was equally unimpressed by foreigners. 'Mr Podsnap's world', we read in *Our Mutual Friend* (1864/5), 'was not a very large world, morally; no more even geographically: seeing that although his business was sustained upon commerce with other countries, he considered other countries, with that important reservation, a mistake, and of their manners and customs would conclusively observe, "Not English".'

It was not always easy to separate personal pride and national pride. It was often stressed, however, that personal pride could lead to a fall, as both Dickens and Trollope knew well: *'Facilis descensus averni'* – 'Easy is the descent into the abyss'. Yet such personal pride could also go with fear – fear of losing face; fear sometimes of being found out. Feminine pride in appearance was obviously transient too, as indeed was the feminine ideal of beauty.

That was the negative side. Pride was buttressed by feelings of 'Englishness' that went with personal identity. During the mid-Victorian years the English and the French seemed to be perpetually set against each other in terms of temperament, way of life and institutions, and Podsnap's 'abroad' began at Calais. Under Palmerston, British institutions seemed designed as much for export as British goods. Nonetheless, women's fashions were dictated in France, and photography does much more to illustrate them than fashion plates.

Male fashions were left untouched by Paris just as British Protestantism and with it British anti-Roman Catholicism were very different from any continental models. In a country with an Established Church (some members of it refused to be called Protestants) and a broad spectrum of 'Dissent' outside it, both

Title page of an album of the mid-1880s on a maritime theme, bridging the Atlantic divide with its depiction of the Stars and Stripes and the Union Jack.

Above: Wilhelm II, King of Prussia and Emperor of Germany, was the eldest grandson of Queen Victoria and always held a special place in her affections. When the Queen died at Osborne, on the Isle of Wight, in 1901 she was in Wilhelm's arms.

Below: This particular portrait of Viscount Palmerston was probably made around the time he took office as prime minister in 1855. Since he was then in his seventieth year, some judicious reworking of the photographic image has attempted to rejuvenate him a little. Indeed, he had to live up to his reputation as 'Lord Evergreen'.

Churchmen and Dissenters were prominently represented in the gallery of characters in *cartes-de-visite*. Some of the *cartes* suggest, as do Trollope's six Barchester novels, that pride was not entirely a secular sin.

Most 'Englishness' was taken for granted until the last years of the nineteenth century. Nor did it need any cult of the flag. It was assured enough for W. S. Gilbert to parody it in *HMS Pinafore* (1878). The Royal Jubilees of 1887 and 1897 were public displays of pride, however, and there was an obvious need for pride, some politicians thought, when 'Great Britain' faced united European opposition soon afterwards during the Boer War. France for once joined hands with Kaiser Wilhelm's Germany, Britain's new commercial rival.

Yet there were other longer-term forces at work, for by the end of the nineteenth century there had been many signs of cultural and political reawakening both in Scotland and in Wales, which were encouraging Englishmen to define what was specifically English in Britain. By then, too, it seemed ironical to the Scot, James Thomson, that he was taught at school to say

> I thank the goodness and the grace
> Which on my birth have smiled:
> And made me in these Christian days
> A happy English child.

In England itself there remained such strong local differences that they often overshadowed national differences between England and its neighbours. Indeed, local pride came before national pride. When Tom Brown in Thomas Hughes's famous novel *Tom Brown's Schooldays* (1854) talked of local pride, he was forthright as when he talked of manly sport or muscular Christianity. 'I was born and bred a West-countryman, thank God!' he once exclaims, 'a Wessex man, a citizen of the noblest Saxon kingdom.' A Yorkshireman would have said no less about his county, particularly if a Lancastrian were present.

The response to local places, like the response to local people, might include pride and fear, particularly when the places were industrial cities, recognized as new social phenomena. While local histories and local pageants expressed pride in the numbers of people who lived in them and pride in the wealth that they generated, fears were regularly expressed also that numbers were dangerous to health and order and that wealth would prove precarious.

There was never any unanimity of response, though pride of place – in the big cities 'civic pride' – predominated on balance as it predominated overwhelmingly in the literature that boosted the merits of new places, like Middlesbrough in England and all the many new places across the oceans, like Birmingham, Alabama, and

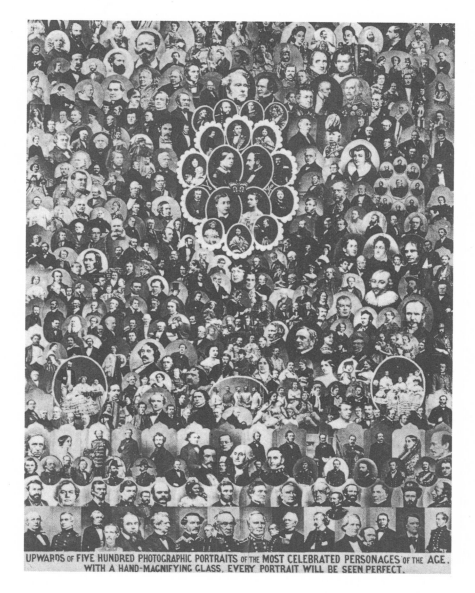

UPWARDS OF FIVE HUNDRED PHOTOGRAPHIC PORTRAITS OF THE MOST CELEBRATED PERSONAGES OF THE AGE. WITH A HAND-MAGNIFYING GLASS, EVERY PORTRAIT WILL BE SEEN PERFECT.

A superb example of the skills of a montage artist. All these portraits would have been cut from *cartes-de-visite*, pasted up and then rephotographed. The original must have been highly impressive.

Melbourne, Victoria. Town halls were symbols of pride. So, too, were city coats of arms, mayoral chains and statues in the park; and there could be pride even in smoke. Nonetheless, the coats of arms and mayoral chains could be thought vulgar, the smoke could be called offensive, and large parts of the cities could be feared as unknown territory, *terra incognita*, through which it was dangerous to pass.

Not surprisingly, in photographic views of places pride of place is revealed more often than fear or disgust. Many *cartes-de-visite* were self-consciously 'scenic'. They included striking landscapes as well as famous buildings, and some of them were designed to stimulate pride when a new building was erected or when an old institution was celebrating an anniversary. In their photographs schools and colleges made the most of pride as they did in their songs.

National pride was strengthened at times of international crisis. Yet it was always there. John Bull was a permanent national

symbol, not merely a cartoon figure in the weekly pages of *Punch*. So too, of course, was the lion, 'the proudest of beasts'. Lions were prominent in the heart of London in Trafalgar Square, along with the statue of the great hero, Nelson.

The Victorians had their gallery of heroes, not all of them national, however, for there was a place for Garibaldi as well as Nelson. Indeed, during the Victorian years the 'admiration' of great figures, national and international, was turned, in the words of Edmund Gosse, from a virtue into a religion. The heroes came from past and present, so that when Macmillan published its *English Men of Action* series in 1889 the first three volumes were devoted to General Gordon, Henry V and Livingstone, the last of which was written by Thomas Hughes. Livingstone was, of course, a Scot, and he was 'discovered' in Africa by a naturalized American, Henry Morton Stanley. Of the twenty-two figures who were subsequently deemed worthy of inclusion in the Macmillan series, sixteen were naval or military officers. They were always prominent too, proud in their uniforms, in albums of *cartes-de-visite*.

Nelson was a hero of the oceans, and it was pride in the Navy – the Royal Navy and the Merchant Navy – that sustained national pride throughout Victoria's reign: 'Britannia rules the waves'. The Army, small in size, with no conscripts, never commanded the same popular support – despite interest in particular generals – and the 'little wars' which it fought abroad in distant lands of empire often produced more disillusionment than pride. So, too, the longer they lasted, did the bigger wars – the Crimean War of 1854-6, which ended with no major gains, and the Boer War which saw out both the century and Queen Victoria herself.

Scenes from both wars were selectively recorded by photographers. Of Roger Fenton's Crimean photographs, which never hinted at the horrors of war (including disease), the *Illustrated London News*, founded as a panoramic periodical in 1842, wrote that 'the historian of the war in future years will be seen bending over these memorials, and comparing them with the *literae scriptae* [written records] of the correspondents of the journals'. It is the non-photographic illustrations in the *Illustrated London News* that stand out in retrospect as genuine communications between correspondent and public. *Punch* in 1855 had included a satirical item in the form of a postscript to a lady's letter to an officer in the Crimea, stating that she was sending him 'a complete photographic apparatus' to amuse him in his 'moments of leisure': 'If you could send me home, dear, a good view of a nice battle', she went on, 'I should feel extremely obliged.' There were no correspondents in a position to oblige.

Photography fared better during the American Civil War to which Darrah has devoted a whole chapter. As he rightly says,

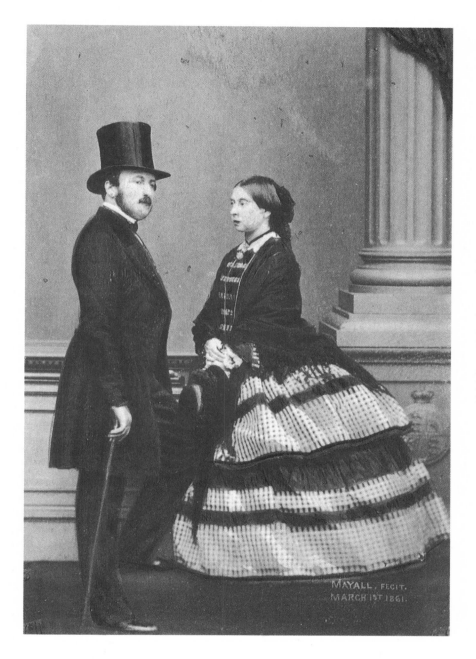

MAYALL, FECIT.
MARCH 1ST 1861.

Prince Albert and Queen Victoria, taken from the 1861 series by Mayall. Because of her 'petite stature' the Queen is often seen standing while Albert is seated in their photographs taken together. Incidentally, this was subsequently a pose adopted by many couples when being photographed during this period. However, in this photograph the Queen stands on a step with Prince Albert, perfectly complementing his wife, standing half one step below and half on her level. He neither towers over the monarch nor makes her look ridiculous above him.

'photography was more intricately involved in the American Civil War than in any other historical event in the nineteenth century'. It had many uses too, including propaganda, well described by Kathleen Collins in a 1988 article in *History of Photography*, 'Living Skeletons: *Carte-de-visite* Propaganda in the American Civil War'.

There was a popular as well as a historical dimension to pride, evident in the late 1850s, for example, when there was wild talk of French invasion and when 'Volunteers', satirized in *Punch*, mustered their forces; and in the 1870s, when it seemed for a time that the country would have to rally round the prime minister, Benjamin Disraeli, to fight with the Turk against the Russian. During the last decade of the nineteenth century it was demonstrated that patriotic pride drew on stronger and more profoundly zenophobic senti-

ment than *bourgeois* Podsnappery: it could stir crowds. And this in itself made anti-imperialists afraid.

Popular pride might be inculcated at school, both through textbook lessons, and the reading of adventure novels, like those by G.A.Henty – his annual sales were around 200,000 by 1900 – and 'healthy papers for manly boys'. 'What Englishman is there who cannot reflect without a glow of pride or a thrill of enthusiasm', asked the boys' paper *Pluck* in 1895 – pluck and pride seemed to go together – 'that his native land can claim as her own the heroic commander ['Bobs', Lord Roberts] and the not less heroic army which was capable of performing such an achievement [as the march through Afghanistan from Kabul to Kandahar]?'

Much of the adult popular Press took up such themes too, 'beating the drum'. And so did Music Hall. Rudyard Kipling, however, struck a different note in his *Barrack Room Ballads*:

When you're wounded and left on Afghanistan's plains,
And the women come out to cut up what remains,
Just roll your rifle and blow out your brains
An' go to your Gawd like a soldier.

A lady in her pony chaise in front of her fine house in Dublin. The groom steadies the horses so that they will not move and appear blurred in the long exposure. The Victorian age, which saw so many inventions in communications, was still the age of the horse.

Kipling struck a different note, too, in his famous poem *Recessional* (1897), written in the year of the Golden Jubilee, which suggested that all would not remain the same as it was:

Far flung, our navies melt away,
On dune and headland sinks the fire:
Lo, all our pomp of yesterday
Is one with Nineveh and Tyre!

If pride often went with fear, it would also go with doubt:

Let us go hence: the night is now at hand;
The day is overworn, the birds all flown:
And we have reaped the crops the gods have sown,
Despair and death; deep darkness o'er the land
Broods like an owl.

No Victorian photograph could quite catch that mood expressed by the poet Austin Dobson. The doubt has been forgotten by those twentieth-century writers – and politicians – who have looked back with nostalgia to a Victorian time when Britain was 'truly great'.

The five children of a wealthy family with their three nurses and a pet donkey. Nurses and governesses figured, if not always prominently, in family scenes. The rich Victorian family could not have done without them.

The partnership of Hills and Saunders was established in 1860 in Oxford by Robert Hills, a hair cutter and peruke maker who had taken up photography in 1856, and John H. Saunders, about whom little is known. They were enterprising businessmen, who quickly appreciated the opportunities of a chain business and chose the best locations for branch studios with lucrative prospects. They opened studios at Cambridge, Eton, Harrow, London, Rugby, Aldershot and Yorktown (Sandhurst). The bulk of their business in consequence was academic and military. Nonetheless, perhaps because of the close proximity of the Eton branch to Windsor, the company received many royal commissions.

The photograph above shows Hills and Saunders's shop front in Eton as it is today – unchanged in over 120 years.

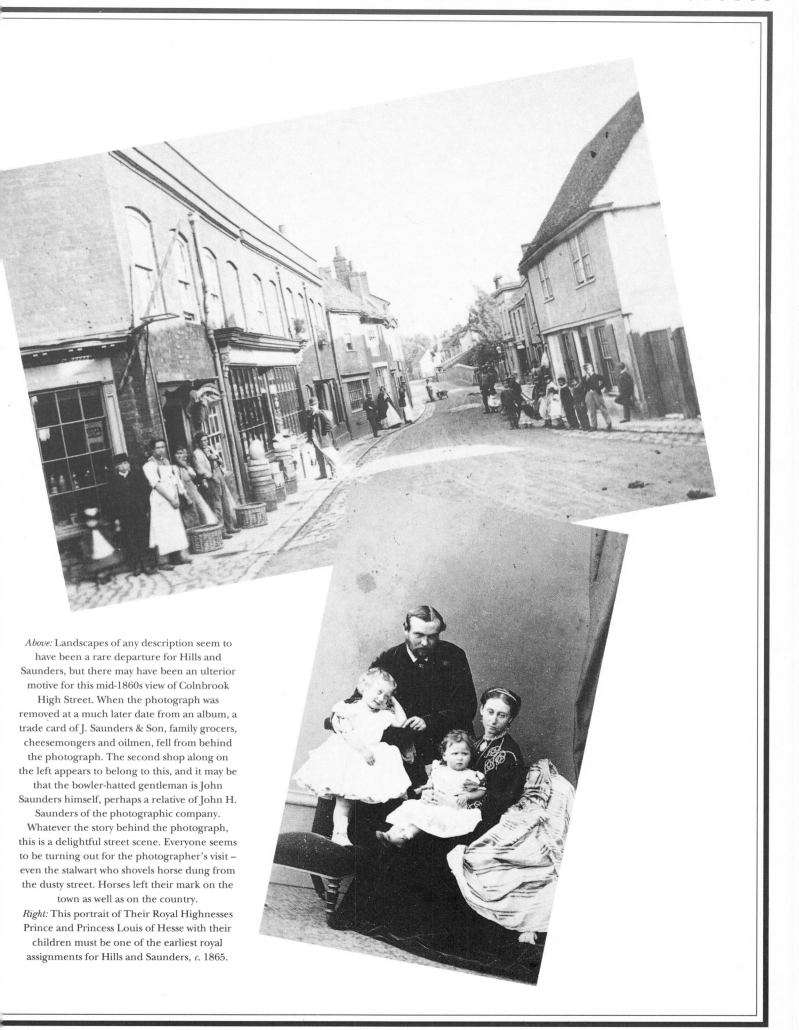

Above: Landscapes of any description seem to have been a rare departure for Hills and Saunders, but there may have been an ulterior motive for this mid-1860s view of Colnbrook High Street. When the photograph was removed at a much later date from an album, a trade card of J. Saunders & Son, family grocers, cheesemongers and oilmen, fell from behind the photograph. The second shop along on the left appears to belong to this, and it may be that the bowler-hatted gentleman is John Saunders himself, perhaps a relative of John H. Saunders of the photographic company. Whatever the story behind the photograph, this is a delightful street scene. Everyone seems to be turning out for the photographer's visit – even the stalwart who shovels horse dung from the dusty street. Horses left their mark on the town as well as on the country.

Right: This portrait of Their Royal Highnesses Prince and Princess Louis of Hesse with their children must be one of the earliest royal assignments for Hills and Saunders, *c.* 1865.

An unidentified Scottish castle, very much in the style of Balmoral, by Charles Reid, a landscape photographer of note whose speciality was cows and sheep. This photograph was probably a special commission by the lord and lady of the house who can be seen on horseback.

By way of stark contrast to the building on the facing page, this humble residence was also photographed with and for the benefit of its proud owners. A photograph of a home – castle or cottage – was just as desirable as a likeness of its owners.

Left: Women's fashion in both clothes and hair went through numerous changes during Queen Victoria's reign, while male fashions changed far less. There were many changes before and after the mid-Victorian 'age of the crinoline'. Fashion photographs were far more revealing than older fashion plates, but the best advertisements were those of clients actually wearing new fashions.

Opposite: An informal group, posed as if out for a Sunday promenade.

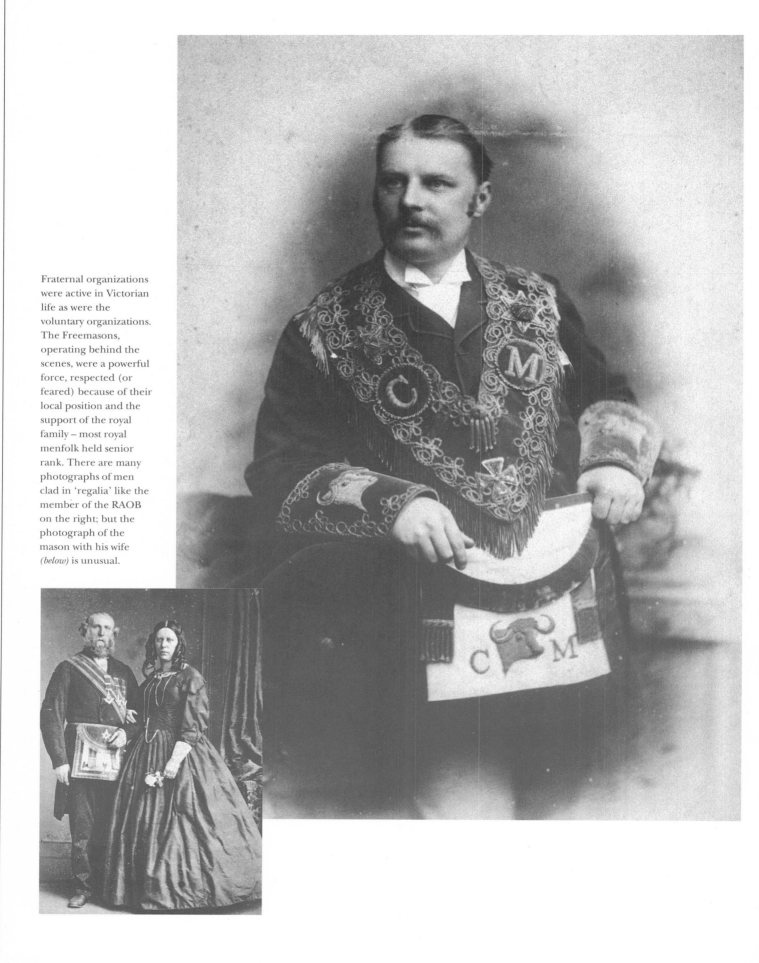

Fraternal organizations were active in Victorian life as were the voluntary organizations. The Freemasons, operating behind the scenes, were a powerful force, respected (or feared) because of their local position and the support of the royal family – most royal menfolk held senior rank. There are many photographs of men clad in 'regalia' like the member of the RAOB on the right; but the photograph of the mason with his wife *(below)* is unusual.

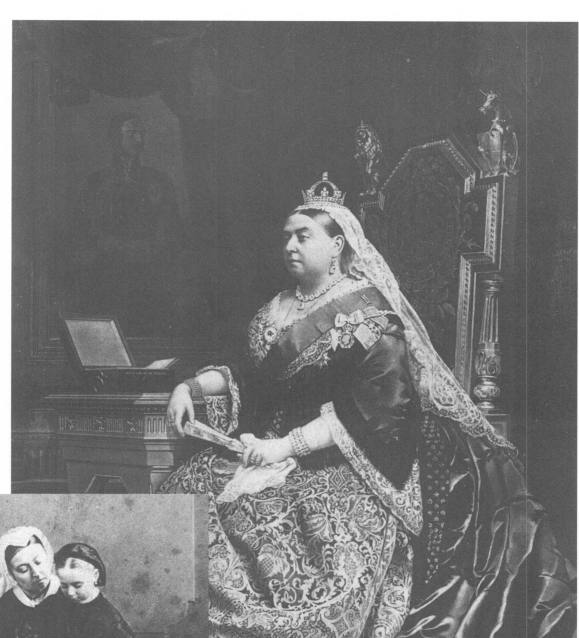

Below: A charming informal portrait of Queen Victoria with her youngest child, Princess Beatrice, on her lap.

The archetypal image of Victoria, regal, strong and proud. However, in this classic study by Alexander Bassano a touch of sentiment steals into the picture in the ever-present vision of her beloved Albert.

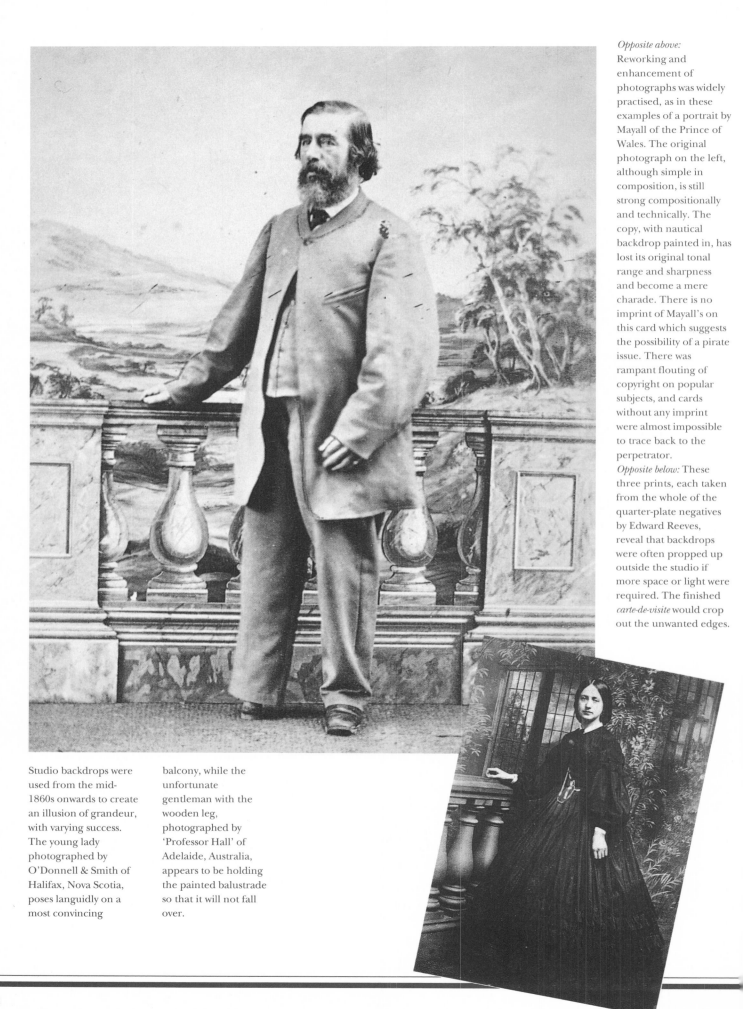

Opposite above: Reworking and enhancement of photographs was widely practised, as in these examples of a portrait by Mayall of the Prince of Wales. The original photograph on the left, although simple in composition, is still strong compositionally and technically. The copy, with nautical backdrop painted in, has lost its original tonal range and sharpness and become a mere charade. There is no imprint of Mayall's on this card which suggests the possibility of a pirate issue. There was rampant flouting of copyright on popular subjects, and cards without any imprint were almost impossible to trace back to the perpetrator.

Opposite below: These three prints, each taken from the whole of the quarter-plate negatives by Edward Reeves, reveal that backdrops were often propped up outside the studio if more space or light were required. The finished *carte-de-visite* would crop out the unwanted edges.

Studio backdrops were used from the mid-1860s onwards to create an illusion of grandeur, with varying success. The young lady photographed by O'Donnell & Smith of Halifax, Nova Scotia, poses languidly on a most convincing balcony, while the unfortunate gentleman with the wooden leg, photographed by 'Professor Hall' of Adelaide, Australia, appears to be holding the painted balustrade so that it will not fall over.

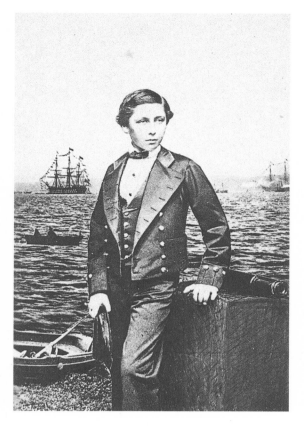

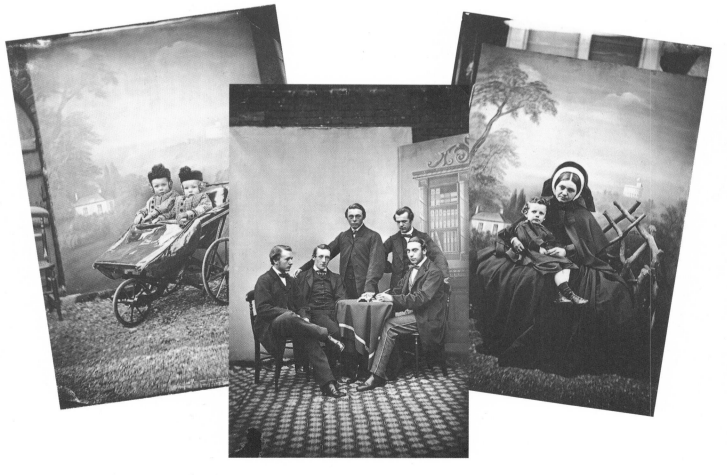

A cartoon from *Punch* by John Leech, *c.* 1862. This timeless photographic joke pokes fun at the enthusiastic amateur and his less-than-wonderful photography.

INTERESTING GROUP POSED FOR A PHOTOGRAPH

BY A FRIEND OF THE FAMILY

INTERESTING AND VALUABLE RESULT.

This page and opposite: Leech had an eye for the disasters of the studio as well as its triumphs. Here are three wonderful examples of studio mishaps in practice, comparable with film out-takes in the twentieth century.
Left: This baby in Edward Reeves's studio is intent upon undressing and falling off the chair, but Edward struggles on and obtains an unusual but very natural portrait.
Opposite above: A somewhat tense and miserable mother and son stare dolefully at the camera, while an ornamental balustrade sphere sits growth-like on the boy's head.
Opposite below: This little girl clearly had no intention of sitting for a portrait, so the operator at Downey's studio did the best he could.

Camille Silvy, allegedly a French aristocrat, who sometimes styled himself Camille de Silvy, came to England in 1859 and purchased a studio at 38 Porchester Terrace in London's Bayswater. He took up the newly popularized *carte-de-visite* with gusto, photographing the rich, the famous and the royals (all except Queen Victoria, who never sat for him). Silvy's studio was lavishly furnished and decorated with a wealth of art and antiques, unlike the sham props used by so many lesser studios. His style shines through in all his portraits, from which one naturally assumes that he took all of them himself. More likely, he indoctrinated a select few of his staff (at the height of the business known to have numbered about fifty people) with his artistry and technique. It is uncertain how they actually survived, but remarkably Silvy's daybooks (except one missing volume) now reside in the National Portrait Gallery in London. (*Continued on page 163.*)

Left: A most unusual coloured Silvy *carte-de-visite* of Princess Leiningen.

(*Continued from page 162.*) Copies of almost all the portraits are neatly pasted in with the client's name, the date taken and the negative number, thus providing a unique record of a studio! After the *carte-de-visite* boom in the mid-1860s, business tailed off and by 1869 Silvy had closed his studio and returned to France. Strangely and sadly, most of his later life remains a mystery and there is no trace of him after 1871, when he was reported to be recovering from injuries received in the bombardment of Asnières, a suburb of Paris, during the Franco-Prussian War. Silvy's portraits on these pages, with their wonderful poise and feeling of light, have all survived in their original richness of tone as a result of meticulous printing and gold toning procedures. His logo is shown *opposite below.*

CHAPTER EIGHT

EMPIRE

Between the mid-1870s, when Russia and Turkey dominated world headlines, and the beginning of the First World War in 1914, in the first instance a European war, large parts of the earth's surface, some of them far outside Europe, were taken over as colonies. The period of division of the world between the great powers has been identified as 'the age of imperialism', and Britain was a main actor in the story: it increased its territories by around four million square miles.

Unlike some of the other great powers, such as Germany, Britain already had an empire before the 'partition' or 'scramble' began. Indeed, it had lost large parts of one empire in the eighteenth century following the revolt of the American colonies, and it had gained elements of a new empire at the peace settlement of 1815 that ended the long wars against Napoleon and the French Revolution.

When Queen Victoria came to the throne, Britain held sway over a cluster of widely separated territories ranging in size from Canada to Barbados in the American hemisphere and in Asia from India, although it was not directly under the British Crown, to Singapore. They were diverse in other respects too: some were predominantly 'white', like the settlements in Canada and Australia, the latter originally convict settlements. Others were, to use the adjective of the time, predominantly 'native'.

As photography developed there was an increasing interest, expressed also in museums of anthropology, in 'native ways'. In *cartes-de-visite* and stereographs the 'natives' themselves were sometimes treated as exotic specimens, not least when they were produced, as some were, not in London but in Auckland, Melbourne or Durban. There were many 'natives', however, particularly American Indians, who clearly appealed sympathetically to their photographers. There was a strong sense, too, among some photographers that they were recording dress and ways of life that were under threat and that would soon disappear. In Britain anthropologists like the director of the Pitt Rivers Museum, which moved to Oxford in 1883, regarded photographs as 'so important an adjunct to a museum, that he tried 'to buy all I can'. Only photographs now remain of the aboriginal inhabitants of Tasmania.

Photographs often show 'western' objects brought from outside into the life of 'native people'. They tell us little, though, about the economics of empire, except when they show ships and har-

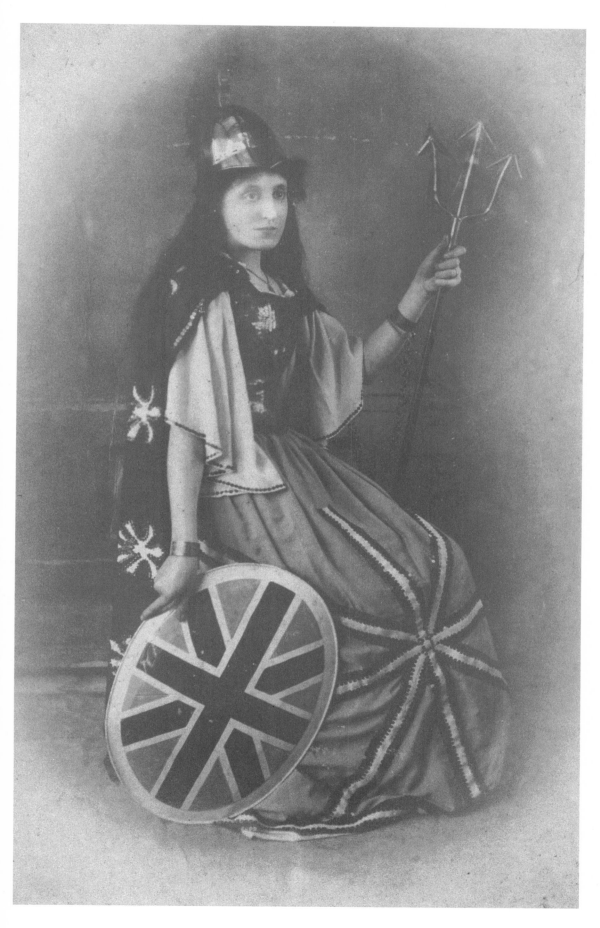

A mournful young lady dressed as a not very impressive 'Britannia', most likely for a pageant connected with the Queen's Diamond Jubilee in 1897. 'Britannia' symbolism was strong throughout the whole reign.

General Gordon, charismatic leader of men, who was tragically slaughtered at Khartoum with his company in 1885 just three days before relief arrived. He was an archetypal Victorian hero. The Prime Minister, Gladstone, who was blamed for his death, called him 'a hero of heroes'.

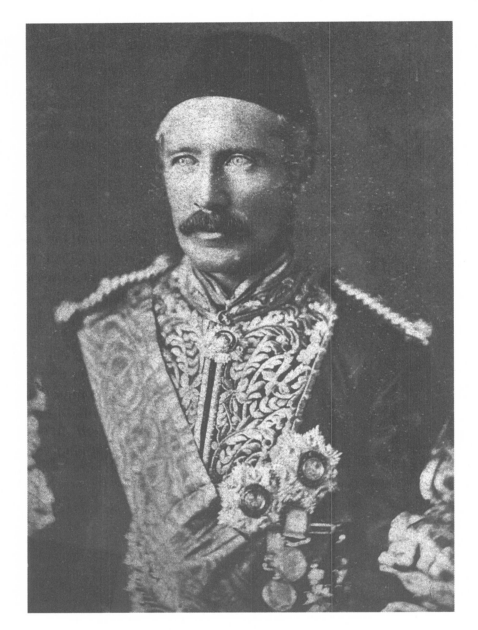

bours. There are, however, revealing photographs of Japan taken by the Italian photographer Felice Antonio Beato, who accompanied a British naval squadron in 1862 as it attempted to open up Japan to foreign trade.

As far as the boundaries of empire were concerned, the remarkable growth of British international trade and finance during the mid-Victorian years did not necessarily involve a further extension of imperial control. Indeed, the word 'imperialism' was not generally used in its modern sense during this period: it was essentially a late Victorian 'ism', even then placed, to begin with, inside inverted commas. It was possible during these years to increase British wealth overseas through what has been called 'informal empire' in countries like Argentina. Yet there was continuing expansion of territory, for example, in West Africa, where existing settlements

were expanded along the coast and further inland. In some parts of the world 'protectorate' rights were acquired, as in the Malay States.

The result of widely scattered initiatives was a world in which, as Bernard Porter has put it in *The Lion's Share, A Short History of British Imperialism, 1850-1970* (1975), 'New Orleans was as essential a part of the British imperial machine as Newcastle, Calcutta as important as Cardiff, the Cape sea lanes to the east as vital as the Great Northern Railway.'

'Formal empire' posed problems as much as it opened up opportunities. It also generated arguments. What should be the attitude towards indigenous cultures and institutions? Missionaries had strong views about the right answer to this. So did humanitarians who wanted to destroy the slave trade and all that went with it wherever it could be found. What was meant by 'trusteeship' applied to colonial territories with inhabitants of a different colour and cultural background? Obviously it had nothing to do with equality.

One argument for 'empire' was that it extended the rule of law. Yet to protect trade gunboats might seem more essential than magistrates. How and when should force be used to support trade? China was bombarded twice before Hong Kong and Kowloon were taken over – on different terms – in 1839 and 1860. In West Africa soldiers were used to defeat the Ashanti before the Gold Coast Protectorate was turned into a Crown Colony in 1874.

Mr and Mrs Henry Morton Stanley. Stanley, a naturalized American, was an illegitimate child born in north Wales in 1841. Most famous for his meeting with Livingstone thirty years later, he married Dorothy Tennant in 1890. Two years afterwards he was renaturalized as a British subject, and from 1895 to 1900 was a Member of Parliament. Stanley was not only a discoverer but also a developer, and he was a founder of the Congo Free State, recognized internationally in 1885.

Theodore Roosevelt as a young man, treading boldly through the forest in search of bears. Roosevelt became president of the United States in 1901 as a result of McKinley's assassination. As Governor of New York he had been described as 'a bull in a china shop', but he proved to be a powerful president interested not only in expansion but also in conservation.

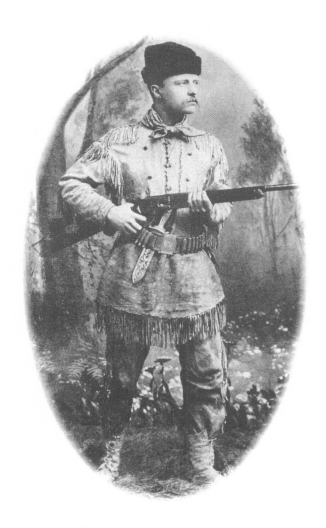

In those parts of the Empire that were being settled from Britain what should be done about 'responsible government'? In fact, different things were done – for example, in Canada and in the West Indies. When the Confederation of Canada was created in 1867, responsible government was far advanced, but by then responsible government in the Caribbean had retreated. In Australia and New Zealand, separated from Britain by great distances, the task of establishing 'white dominion' over large 'open spaces' with relatively small local populations posed different questions.

Many interests, often competing ones, were involved 'on the spot' in each colonial situation at different points on what has been called 'the periphery of empire': traders and settlers, missionaries and subalterns; and despite the rise of the telegraph, it took time for details of what was happening to reach London. It also took knowledge and required imagination for ministers and civil servants at Westminster and Whitehall to appreciate what lay behind the unfolding of distant events. There was a similar distance problem 'on the spot', not least where trade was concerned. News from China might arrive in Hong Kong slowly. Cape Town was far removed from the South African 'diamond fields' developed later in

the century, which gave their name to Queen Victoria's 1897 Jubilee.

There are many photographic views of empire 'on the spot'. Indeed, more than one soldier encouraged other soldiers to take them. John MacCash, a surgeon in the army of the East India Company, suggested in 1856 that a British officer should make himself 'master of photography in all its branches'. He should know how to use plate glass and metallic plates'.

In Britain itself, which welcomed photographs from overseas, there were always at least two points of view about what was going on and what should go on. There was a continuing 'argument of empire', to use A. P. Thornton's enlightening phrase developed in his book *The Imperial Idea and its Enemies* (1959). At one end of the general argument were the views of so called 'little Englanders' who, while they welcomed the increase of trade and consequently of wealth, were averse both to acquiring territory and to 'showing the flag'. John Bright, the most prominent of them, opposed the Crimean War, sharply criticized Palmerston's China policy and resigned from Gladstone's government in July 1882 when British guns were employed to bombard Alexandria in order to protect British interests in Egypt. For him and for others of his persuasion colonies were millstones or, worse, a huge system of 'outdoor relief'(a poor law term) for the British aristocracy. For Richard Cobden, friend of Bright and apostle of free trade, writing in 1857, 'If France took the whole of Africa, I do not see what harm she would do us or anybody save herself.'

At the other end of the general argument were the views, romantic or toughly 'realistic', of people who believed that imperial power would confer benefits on the rest of the world in the nineteenth century in the same way as the Roman Empire had con-

Below: The American Indians have always held a fascination for the so-called civilized world, and the myth of the Red Indian was powerful in late Victorian England. Here are three contrasting images of the 'red man': *Left:* Albert Tobias appears as the glamorized Western ideal of an American Indian chief in feathered head-dress and much decorated buckskin. *Centre:* The celebrated hero 'Anpetu-Tokeca' has renounced his ethnic garb and clad himself in the white man's respectability. *Right:* When the smoke had cleared by the turn of the century, this Hopi Indian, weaving his blanket in Wolpi, Arizona, was viewed as a useful member of society, even though he was confined to a reservation.

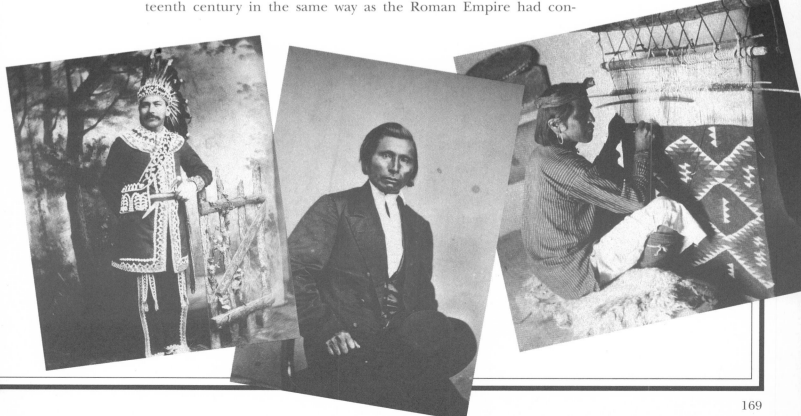

Above: On reaching Port Said in Egypt, this merchant seaman visited the studios of G. Massaoud Frères for his 'likeness' and, unable to be home for Christmas, he added a seasonal greeting to his portrait. This idea was probably very popular in ports the world over, since sailors were often at sea for months, if not years, at a time.

Left: The International Exhibition, held in 1862 in South Kensington, London, was an attempt to repeat the success of the Great Exhibition of 1851, a marvellous showcase in which nations could display their artistic and scientific achievements.

ferred benefits on the ancient world. *Pax britannica: Civis britannicus sum.* Benjamin Disraeli felt the appeal of the romance of empire and favoured a 'forward policy' on some at least of the frontiers of empire. It was he, too, who bought up Egypt's share (44 per cent) in the Suez Canal Company in 1876 and who had Queen Victoria proclaimed Empress of India in 1877.

India had a special place, that of 'the Jewel in the Crown', within the Empire. Yet it was not until after the 'Indian Mutiny' of 1857, when the whole position of the *raj* was threatened, that the government of India was taken out of the hands of the East India Company and placed directly under the control of the British Crown and Parliament. Their representative in India was now to be called the viceroy. These important constitutional changes did not radically change the social situation in India. Moreover, railways, a new element in Indian life after 1857 – there had been only 288 miles of scattered railway when the Mutiny broke out – strengthened the basis of British power.

There had been several photographs of the Mutiny and its aftermath – there is one very grisly 1858 photograph of the hanging of mutineers – but there were to be far more of the 'order' that followed it. It was on the viceroy's orders that photographs were taken of Indians in different parts of the country between 1863 and 1865: they were to appear in eight published volumes.

There had been for many years – and there continued to be – an argument of empire, the central argument, indeed, of all empire, concerning the longer-term future of India. Macaulay had looked forward to the creation of a free (if grateful) India as the 'proudest day in English history'. Yet by the 1880s, when the Indian Congress came into existence – the first National Congress, founded by an Englishman, was held in 1884 – a more commonly expressed British on-the-spot view was that 'we cannot foresee the time in which the cessation of our rule would not be the signal for universal anarchy and ruin'. Congress could be dismissed then as 'a microscopic minority'.

In Britain itself India figured less prominently as a subject of debate during the late Victorian years than it had done in earlier periods or than it was to do in the twentieth century. It had a special place, however, both within Britain's strategy of empire and within Queen Victoria's own private network associations, and, as far as the British public was concerned, it always figured prominently in all displays of imperial pomp and majesty. It was other places painted red on the map of Empire – some just beyond the Indian frontiers – that generated most argument.

There was always a radical outcry and a 'patriotic response' when British troops were used to fight for colonial causes: for example, in Persia in 1856-7; in Ethiopia in 1867 – the Royal Engi-

neers were given a special budget to provide photographs, although not of the campaigns; in Afghanistan from 1878 to 1881 – commercially photographed by James Burke; in South Africa against the Zulus in 1879; and in the Sudan in 1885 and again in 1896-7. The late Victorian expansion of Empire, judged more by documentary and statistical than by photographic evidence, divided the Liberal Party almost as much as did Ireland, itself thought by many to be a bastion of the Empire.

Just as there were international crises during the late Victorian years, there were imperial crises. The most dramatic of them spotlighted General 'Chinese' Gordon, who first made his name as a commander of 'irregular troops' in China and who in 1883 had spent nearly a year studying in 'the Holy Land' the Bible and the topography of Bible stories. In 1885 Gordon was killed along with the whole of a British garrison besieged in Khartoum three days before a relieving force arrived, headed by Lord Wolseley. He became a national hero, while to many people Gladstone was the national villain. Pride was wounded in 1885, and with the wounding of pride came guilt and fear. Most late twentieth-century eulogies of Victorian values leave these out.

The same fear was expressed in intensified form during the Boer War. A large number of photographs survive from the siege of Mafeking, 597 studies by three different photographers, described by John Johnson in the *Photographic Collector* in 1985.

When the siege ended, London went mad, and the verb 'mafekking' entered the language to describe the kind of high-spirited celebrating that characterized Mafeking Night. Along with guilt and fear, therefore, went elation, a heady form of release. The popular Press was an intermediary. Photography at this stage was not, although the German photographer Reinhold Thiele had caught some of the grimness of the Boer War and the Boers themselves used photographs as propaganda.

During the late nineteenth century itself the United States developed its own versions of imperialism. Then and earlier, however, it had served as a refuge for large numbers of immigrants from all parts of the world, including the British Isles, and it was out of the melting pot that popular American attitudes were created. Emigration and the hope of freedom were directly associated. But so also were emigration and empire. The processes involved in both

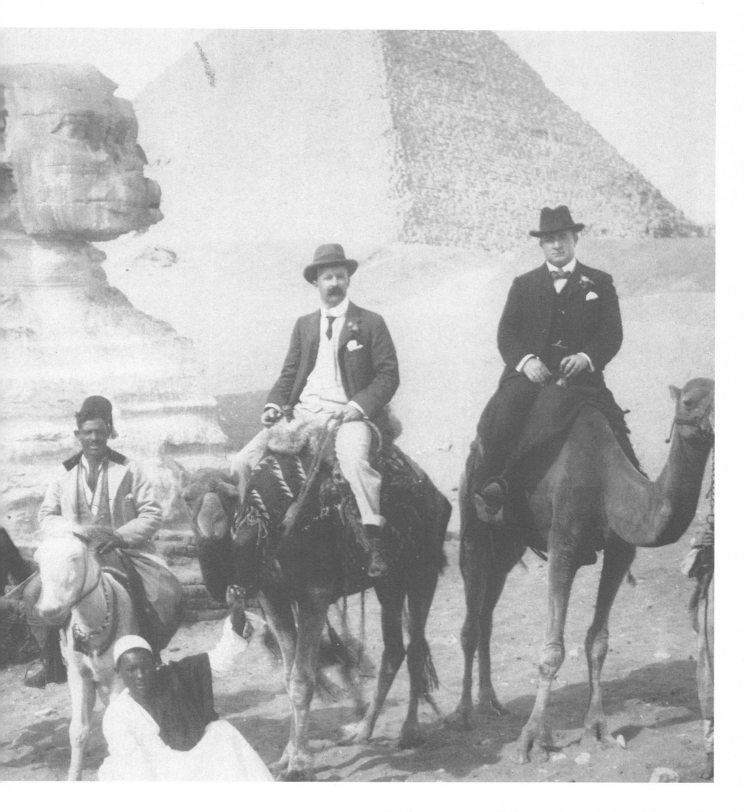

Two Europeans 'on board' their camels pause in front of the Pyramids and the Sphinx during a kind of Grand Tour. They are accompanied by local guides and, for protection, by a member of the local police or militia. According to an American newspaper, photographers visiting 'foreign parts' were most likely to cover 'the courts of Europe, the palaces of the Pashas and the Pyramides of Giza.' There are many photographs of the Sphinx.

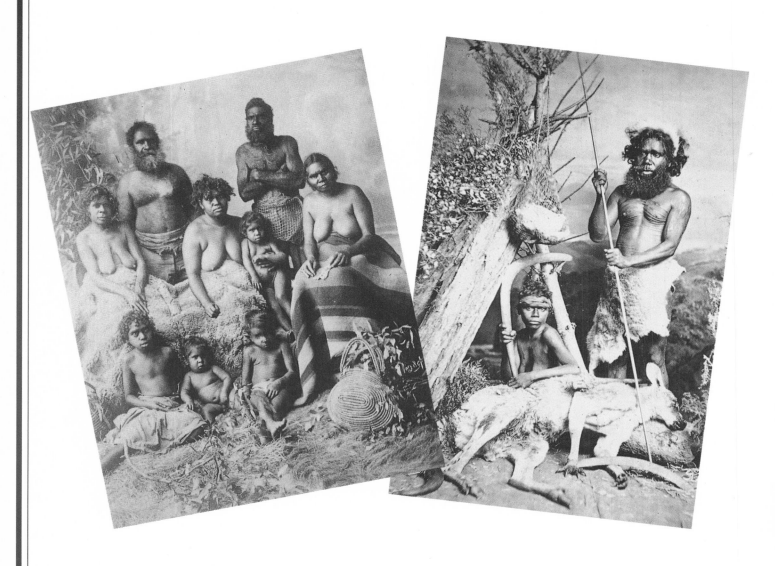

'Aborigines' were a favourite subject in whatever continent they resided. When they looked warlike it was because they had been made to look so.

cannot be separated. As many as two thirds of British emigrants leaving the British Isles between 1850 and 1880 crossed the Atlantic to settle in the United States, but most of the other third went to neighbouring Canada, to Australia, New Zealand and other parts of the Empire. Photographs record many aspects of these processes. Indeed, we can discover what life was like in 'new countries' from photographs taken by immigrants or by enterprising commercial photographers who set up studios in the outback. They recorded gold rushes, first saloons, houses and railways as well as people.

Photographs from relatives and friends sent back 'home' carried with them the dual power of the romantic and of the ordinary, a point fully appreciated by the Victorian social historian J. R. Green, author of the popular *History of the English People*, who called the *carte-de-visite* 'the greatest boon ever conferred on the poorer classes'. He chose as his first two examples a picture of 'the little girl who is out at service' and 'the boy who has gone to Canada'.

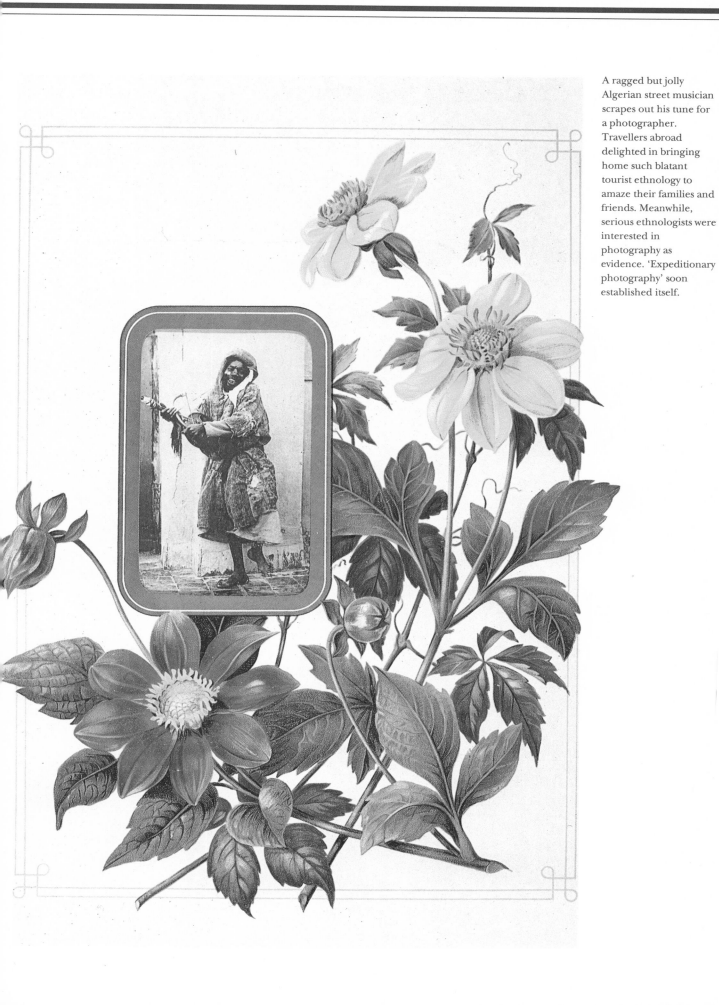

A ragged but jolly Algerian street musician scrapes out his tune for a photographer. Travellers abroad delighted in bringing home such blatant tourist ethnology to amaze their families and friends. Meanwhile, serious ethnologists were interested in photography as evidence. 'Expeditionary photography' soon established itself.

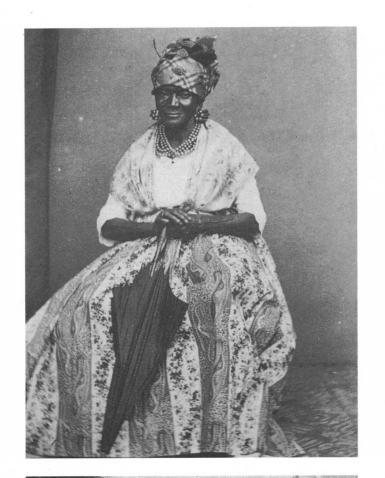

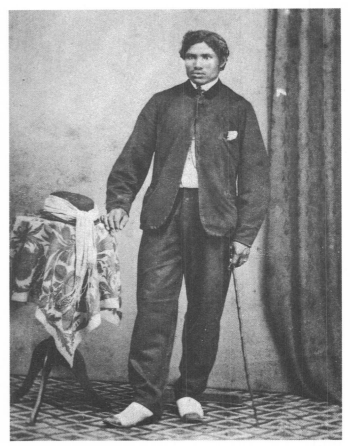

This page: A little English boy photographed with an Arab, who was probably a servant or a bodyguard for a British diplomatic or wealthy merchant family during their sojourn in Egypt. *Opposite above left:* A Creole out in her Sunday best, photographed by Hartman of St Pierre, Martinique. Scattered about Europe's colonies were photographic studios, some simple, some as pretentious as those in Europe itself. *Above right:* A coloured gentleman, origin and photographer unknown. *Below left:* Two sailors from the Japanese Navy, a photograph by Koizumi of Kioto. They have left their shoes at the studio door. *Below right:* A group of Egyptian women, two of whom conceal their whole visage from the camera's gaze. This was not just a Muslim reaction. Fear of the camera was common enough. Hostility towards it was most strongly expressed by the French poet Baudelaire. (Nonetheless he was photographed by Nadar.) Interest in foreign travel and the 'peoples of many lands' created a ready market for photographs of ethnic groups. Often they were typologized in the same way as *Punch* cartoons typologized Englishmen.

Two young soldiers in the kind of uniforms that were still worn by regiments involved in the Boer War. There was only a slow recognition of the need to camouflage, particularly in dealing with guerilla fighters. Pride came first.

Military uniforms were many and varied, although it was quite common for leading military men to be photographed in mufti. *Above left:* General Sir Colin Campbell (1792-1863), also known as Lord Clyde, had this portrait taken, shortly before his death, by the great Disdéri of Paris. A distinguished general during the Crimean War, he is best remembered for his action at Balaklava, where he commanded the 93rd Highlanders in a brief action which became known as 'The Thin Red Line'. He was also a favourite subject for the makers of Staffordshire figures. *Above right:* At the lower end of the military scale, but by no means any less important, came the 'paramedicals': disease could kill off more victims than the enemy. Ernie Cook of Jersey went away to the Franco-German War of 1870 in this modified civilian garb. *Below left:* A boy soldier of the Union Army during the American Civil War. This portrait of William Rowe is typical of a whole *genre*. It was Mathew Brady, a leading studio photographer in Washington, who called the camera 'the eye of history'. He recruited a team of photographers to assist him in his documentation of the Civil War. *Below right:* An artillery sergeant-major in front of a big gun on the parade ground.

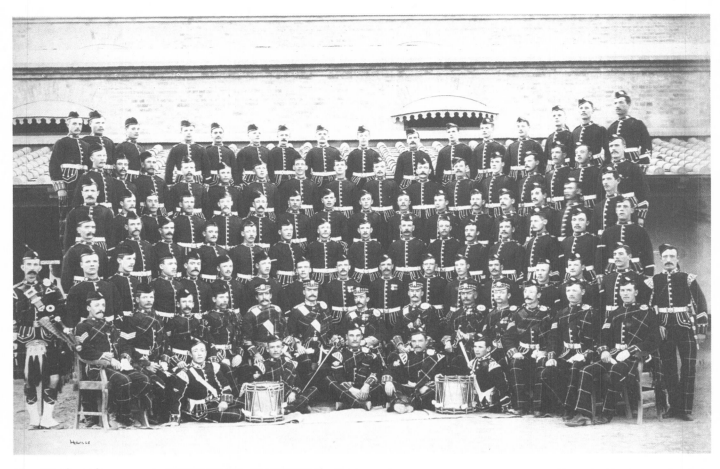

Above: Members of a Scottish regiment serving in India, *c.* 1890, by Holmes.

Right: Synonymous with the British raj was the ubiquitous pith helmet. Standard issue to regiments posted to India, it was also *de rigueur* in civilian life. Adorned with scarves it was even worn by women.

Far right: Long before the end of the century India had its own social life. This photograph shows a house-party gathering that is typical of life under the raj during the late 1880s.

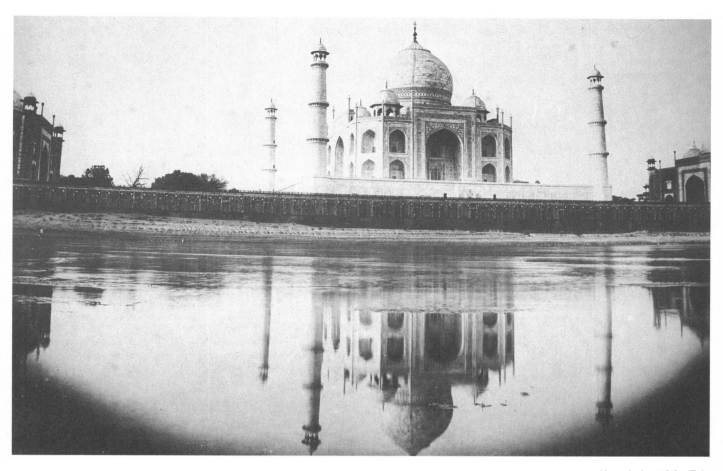

Above: A view of the Taj Mahal, one of the wonders of the world, from the riverside, *c.*1885.

Left: Gateway to Imambara, Lucknow. These views of Indian temples and gateways were sold loose by many local studios for tourists to paste in their own albums. Lucknow raised memories of the Indian Mutiny of 1857, just as Calcutta raised memories of the East India Company whose authority was transferred to the Crown after the Mutiny. In the twentieth century Sir Edwin Lutyens was to create a new symbol of imperial power – New Delhi.

CHAPTER NINE
SALVATION

Any analysis of Victorian values that leaves out religion out is bound to be superficial. The Church of England maintained in 1883 that it had 'but one plain and solemn duty' which God had set before it as 'the Church of the Nation': that of multiplying 'every force at her command' to reach the 'masses', 'lifting up the Cross of Christ'. Most Nonconformists were driven at this time by some such sense of mission. 'We are acting under Christ's commission,' one eloquent Welsh preacher told his congregation in 1885. He had committed them 'to carry the message of salvation to the whole world. As widely as the curse of sin extends, so widely must the tidings of mercy reach. This is not a debatable matter.'

Nonetheless, there was much 'debatable matter' not only between Established Church and Chapel but within them both, 'matter' that extended from fundamental questions of theology and disturbing questions of liturgy to immediate questions of tactics in face of increasing secularism. How could Church and Chapel get their message across?

With the rise of population and the growth of cities, organized religion lost some of its traditional supports, and there were as many complaints of indifference as there were of infidelity. When an Archbishop of Canterbury told Disraeli that the Church was losing working-class people in the cities, Disraeli is said to have replied 'Your Grace, it never has had them.' Yet by the 1880s there was a new fear – that large sectors of the 'masses' were turning from religion to socialism. Meanwhile Christian socialists argued that they could give new power to the gospel by proclaiming that it was 'the only power that can cast out the devils that oppress our society.'

The gospel of salvation might be preached through pictures and through music as well as through words, and by the end of the century through the magic lantern and the brass band as much as through the sermon. A famous print, 'The Broad and Narrow Way', depicted the road to salvation as Bunyan's *Pilgrim's Progress* had done, charting the many perils of the journey, including the Flesh Market, devoted to Adultery, Fornication, Uncleanliness, Idolatry, Hatred, Wrath and Drunkenness, and an Emporium of Fashion on Pride Street. No photograph quite caught this panorama.

The much photographed Salvation Army deliberately set out

THE BROAD AND NARROW WAY.

'The Broad and Narrow Way'. Morality was better conveyed through words and pictures and later through magic lantern slides than through photographs. This picture, printed in Stuttgart in 1862, was brought by an Englishman from Holland in 1868.

to convert to Christianity those who had succumbed to vice on the early stages – or perhaps even the later stages – of their journey through life: it was attacked and praised – and imitated – for its methods. From inside a doctrinally and liturgically divided Church of England the Church Army was set up in 1882 by a clergyman who deliberately copied the Salvation Army's William Booth. Its first journal was called *Battleaxe* as a counterpart to the Salvation Army's *War Cry* which still survives.

There were hymns sung in 'respectable' congregations that conveyed the same sense of struggle. The most famous of them – and it too has survived – was 'Onward Christian Soldiers' which described Christians 'marching as to war' under the Cross of Jesus. It was written in the mid-1860s by Sabine Baring Gould, a squire parson who was working not in a crowded city but in a remote Devonshire village. The Church Militant was as much

A memorial card to Dr Charles Haddon Spurgeon, one of the most popular and charismatic Nonconformist preachers of the Victorian age, who regularly drew thousands of followers to listen to his sermons. In 1861 he moved from Southwark to a huge new tabernacle at Newington: it held 6,000 people. Spurgeon left behind him fifty volumes of sermons.

needed there, Baring Gould believed, as it was in Whitechapel:

> Like a mighty army
> Moves the Church of God;
> Brothers we are treading
> Where the Saints have trod;

The continuing appeal of the hymn doubtless owed as much to Sir Arthur Sullivan's rousing tune, 'St Gertrude', as it did to the rousing words.

Hymns figured prominently in all versions of Victorian Christianity. Indeed, one of the most famous of them, 'Lead Kindly Light', was written by John Henry Newman, then an Anglican; and even after he turned Roman Catholic and went on to become a cardinal, it was still sung in Protestant churches and chapels – a favourite, like 'Abide With Me'. The other great Victorian cardinal, H.E.Manning, also a convert, believed as fervently in the Church Militant as Baring Gould. His sympathies extended to the Salvation Army too – and to the claims of London's dockers for a living wage.

In the mid-Victorian years and later in the century the gospel of salvation was challenged by atheists who believed that religion was superstition and doubted by agnostics who had lost their faith

Charles J. Longley, Archbishop of Canterbury, at the head of a divided Anglican establishment, photographed by Mayall in 1861. When Longley died, Disraeli could not find a satisfactory nominee for the vacant post. Eventually it was filled by Archibald Tait, a broad churchman. In this photograph an unusual fault in the printing process has resulted in an apparent bolt from above descending into Longley's top hat. Many real bolts were to fall into Tait's.

without discovering a new one. Much was made also during the mid-Victorian years of the antipathy between religion and science. Geologists questioned the Biblical account of creation and the development of the globe; biologists questioned the account of human evolution. Charles Darwin's *The Origin of Species* (1859), published in the same year as Smiles's *Self-Help*, became a Victorian best-seller. It provoked a bitter controversy.

Most Victorians knew less of science than they did of religion, and the argument about apes and angels left them untouched. Yet there were others, among them the most sensitive, who deeply felt the pain of doubt even before Darwin sharpened controversy. Thus Tennyson wrote some of his most memorable stanzas on the theme of doubt in his poem 'In Memoriam' (1851), stanzas which contrast

The Anglo-Catholics constituted one section of the Church of England, and Tait had to decide on how to cope with their contentious liturgical practices. Some Anglo-Catholics seceded to Rome, a minority church with a large Irish contingent. This is a photograph of a priest of the Roman Catholic Church with a chalice in his hand.

as sharply with 'Onward Christian Soldiers' as any verses could:

> I falter where I firmly trod,
> And falling with my weight of cares
> Upon the great world's altar-stairs
> That slope thro' darkness up to God.
>
> I stretch lone hands of faith, and grope...
> And faintly trust the larger hope.

'It is an awful moment', wrote one Victorian humanist, who, like others, had passed through an acute spiritual 'crisis', 'when the soul begins to find that the props on which it has blindly rested so long are many of them rotten and begins to suspect them all.'

There were, of course, victims of spiritual crises who emerged even stronger Christians after their ordeal, and there were many who found no difficulty is reconciling without struggle the claims of

science and religion. Equally important, there were humanists who, while they rejected Christianity, did not reject Victorian morality. Huxley, defender of Darwin and critic of all Christian doctrines, liked to sing hymns. The novelist George Eliot, while she found God 'inconceivable', treated the claims of duty at least as compellingly as when she had been a Christian.

'Earnestness' went out of fashion in many circles during the 1880s and 1890s, when George Eliot herself showed signs of going out of fashion too. By then there were writers who claim that man triumphed through his will, and when the will was strong enough he could become superman. When man was most alone, he was still, above all, himself. The poet W.E.Henley thanked 'whatever gods may be' for his 'unconquerable soul'.

The House of God is here represented by two extremes not of the liturgical or doctrinal spectrum but of the architectural. The grandeur and grace of York Minster *(above)*, a national treasure, is captured in this photograph by James Valentine, while the old church at Bonchurch, Isle of Wight, is still as quaint and secluded as it was in this 1860s photograph by Hudson of Ventnor.

Because of ecclesiastical restraints and technical limitations of light, photographs of people actually worshipping in church are extremely rare. However, fervent Christians in society were catered for by the studios which created religious tableaux for mass consumption. This photograph, complete with church interior backdrop, imparts the solemnity of a confirmation service.

Left: Baptism was a sacrament shared by all who believed in sacraments. One powerful section of the Nonconformists, the Baptists, believed in adult baptism through immersion. This photograph of a christening is obviously staged in a studio, and probably comes from a stereo pair.

The Duke and Duchess of York with their bridesmaids on the occasion of their wedding – 6 July 1893. Royal weddings were not as popular or historically significant in Victorian Britain as they have become in the twentieth century.

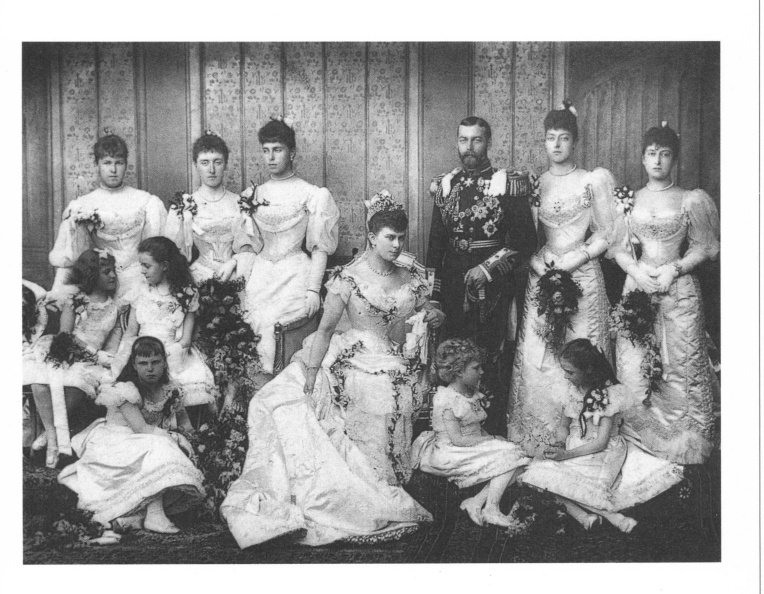

Spirit photography was a widely practised form of photographic deception during the 1860s and 1870s, when spiritualism was fashionable and the gullible public adhered to the belief that the photograph cannot lie. Photographs which have survived to the present day are rare, but this one by Londsdale Abell of Leeds, *c.*1870, is fairly typical. The ghostly effect was created by making a double exposure or allowing the subject to walk off camera part-way through a long exposure. The public was astounded and entranced. The photographer was amused and a good deal richer as a result of his labours.

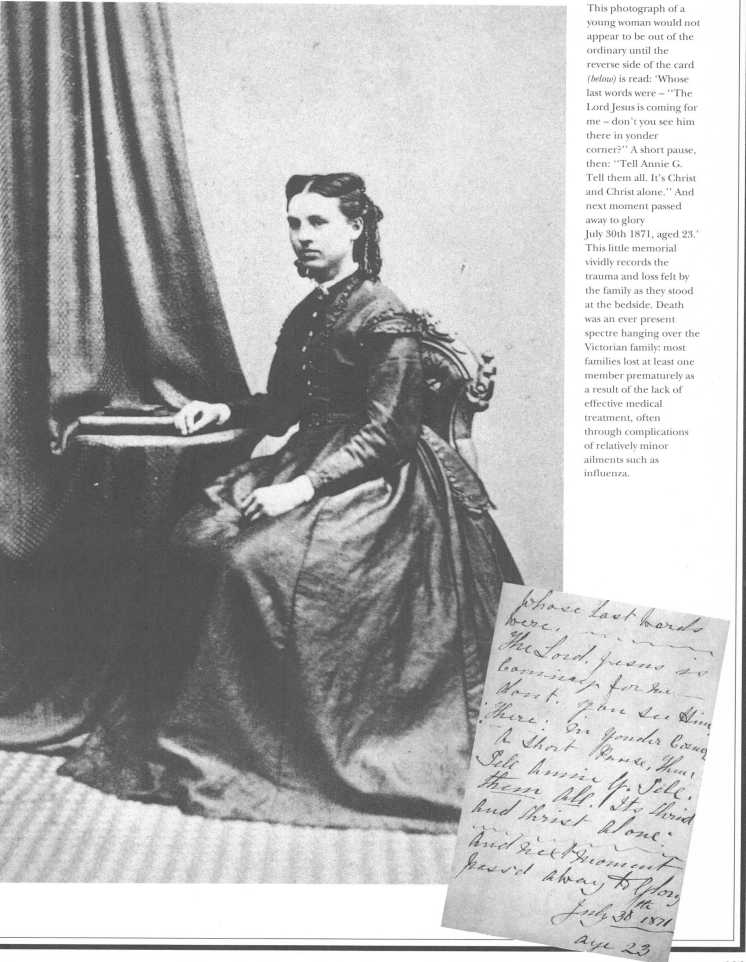

This photograph of a young woman would not appear to be out of the ordinary until the reverse side of the card *(below)* is read: 'Whose last words were – "The Lord Jesus is coming for me – don't you see him there in yonder corner?" A short pause, then: "Tell Annie G. Tell them all. It's Christ and Christ alone." And next moment passed away to glory July 30th 1871, aged 23.' This little memorial vividly records the trauma and loss felt by the family as they stood at the bedside. Death was an ever present spectre hanging over the Victorian family: most families lost at least one member prematurely as a result of the lack of effective medical treatment, often through complications of relatively minor ailments such as influenza.

A special *In Memoriam* card, with a floral tribute type of decoration for an unknown gentleman. There were as many versions of such cards as there were examples of cemetery art, much of it symbolic, most of it ornate.

In Memory of

Left: Posed as if the child were asleep, this deathbed photograph is not unusual: it has verbal parallels in novels and poems. This style of photograph suggests a coming to terms with the bereavement.
Below: 'The Necropolis, Glasgow' by George Washington Wilson captures the Victorian preoccupation with death – and with status after death. Death might be the great leveller, but surviving relatives wanted to demonstrate their sense of bereavement in visible symbols of status. Here is an incredible hotch-potch of memorials all trying to outdo each other.

C H A P T E R T E N
INSPIRATION

'To constitute a good portrait and at the same time a pleasing picture', an American *carte-de-visite* photographer wrote in 1864, 'the original should be represented under such circumstances of position, arrangement, light and shadow, and accessories, as shall suggest character, while also conducing to pictorial effect.' This thoroughly straightforward proposition doubtless set out in plain words what most Victorian studio photographers were seeking to achieve. Yet for some photographers the words were too plain and the intentions far too restricted.

A more ambitious photographer and writer, H.P.Robinson, who liked to philosophize about photography, believed that 'ninety-nine out of every one hundred photographic portraits are the most abominable things produced by my art'. Nonetheless, his own financial fortunes as a local photographer in Leamington were transformed when *carte-de-visite* photography was introduced in 1859. 'Professional photography', he noted in his *Autobiographical Sketches*, 'is not all art and poetry.'

For Robinson, the art came chronologically before the business. He learnt to engrave, to sketch and to paint – and to read Ruskin – before he held a camera. 'I was prepared by all my surroundings', he wrote, 'to become a photographer for years before I first smelt collodion.'

Other artist/photographers born in the age of the camera did not necessarily have the same training, but they often had the same attitudes and the same aspirations. The term 'inspiration' does not figure in the index of Walter Houghton's indispensible book, *The Victorian Frame of Mind, 1830-1870* (1957), but it was as much of a Victorian key word as 'imagination'. Inspiration, 'divine' or otherwise, involved, it was felt, more than 'copying', and that is one reason why Ruskin, for all his interest in daguerreotypes, was suspicious of the claims of photography to be an art.

The fact that there were significant photographers who were interested in far more than 'conveying the scene' limited the relevance of such strictures. So, too, did the fact that they wished to do far more than satisfy their customers. For Robinson photographers were more likely to produce pictures direct from nature than painters were. They were more concerned, too, with detail, and although that they could not deal with colour directly this might make them more sensitive to light and shade.

A tranquil study of a lady watercolourist by Henry Peach Robinson. The subject is perfectly complemented by the backdrop. Robinson believed in the artistic possibilities of photography largely through pictorial composition, the subject of his *Pictorial Effect in Photography* (1868).

During the 1850s there were some photographers, including dealers in *cartes-de-visite*, who set out to reproduce works of art with as much enthusiasm as George Baxter produced his multi-colour prints. Indeed a writer in the *Gazette des Beaux Arts* in 1863 claimed that the best and most noble use of photography was in the reproduction of great works of art. It was certainly the most profitable. The American photographer John P. Soule abandoned photography in general for the photographic representation of works of art in 1873: he left behind him 25,000 different negatives.

Oscar Rejlander, one of the most famous photographers who stuck to his own work, had practised painting in Rome, and when his 'combination' photograph 'The Two Ways of Life' was exhibited

The archetypal artist/ aesthete, clad in his velvet suit, lounges in the studio. The assumption is that this was actually the artist H. W. Holder. The velvet suit made famous by Oscar Wilde was part of the garb of the aesthete: it went with lilies in the hand.

at the Manchester Art Treasures Exhibition of 1857 – among 600 photographs – it drew attention not only to its theme but also to its technique. Measuring 31 x 16 inches, it was the product of no fewer than thirty individual negatives of figures printed on to one or two sheets of albumen paper with several backgrounds, the two sheets mounted together to form a unified composition. 'This magnificent picture, decidedly the finest photograph of its class ever produced, is intended to show', one critic stated, 'of how much photography is capable.'

Robinson, who exhibited three photographs in Manchester, was directly influenced by Rejlander, but he was influenced also by Dr Hugh Diamond, who had used photography in the interests of science as superintendent of the Surrey County Asylum and who was one of the first members, along with Roger Fenton, of the Photographic Society, founded in 1853. This body, which was to become the Royal Photographic Society in 1893, was a major influence in publicizing photography. Yet there was a clash within it be-

The Misses Dene, including Dorothy (left), the inspiration of many of Lord Leighton's later works. *The Bath of Psyche (left)* was one of Leighton's most famous paintings of her. Lewis Carroll had often exchanged earlier models with Leighton, whose peerage was announced two weeks before he died in 1896. His relationship with Dorothy, an actress as well as a model, was the subject of gossip which damaged her more than him.

'With love from the little ones' – a special cabinet photograph, compiled and rephotographed in the studio to be given as a present.

tween those members who believed that photography was a 'practical science' that could not be properly called art and those who did not. During the l890s there was to be a split.

For Robinson and many other art photographers, photography was an adjunct to 'high art' – or a version of it – not an alternative. They did not hold the much quoted opinion expressed by Delaroche in 1839 that after the invention of photography art was dead. Nor did they delight in the fact that the number of miniature paintings on display at the Royal Academy fell sharply until in 1870 there were only thirty-three.

For their part, not all artists felt that the lens was superseding the brush. Some of them – Ingres perhaps the first – were keenly interested in photography as an aid to their own work.

The view that photography was art was related to the idea of art itself which during the mid-Victorian years focused firmly on beauty. Art 'elevated', and because it elevated it also inspired. The painter G.F.Watts, one of the inspirers, was himself inspired on one occasion to paint a portrait after a photograph by Julia Margaret Cameron, most remembered of Victorian art photographers. She was a close friend of Tennyson, whom she photographed, and her view of art was essentially the same as his. Using large negatives that necessitated long exposure and employing out-of-focus effects, she wanted her portrait photographs to reveal the 'inner features' as well as the outer features of her subjects. Yet not all of her subjects were Victorian. Like Tennyson, her fancy played over past times and over eternal truths, and she was strongly influenced by classical art, including Rennaissance allegory.

Before 'high art' photography reached its climax during the l890s with the split in the Photographic Society and the formation of the Linked Ring, its claims had been sharply challenged by P.H.Emerson in his *Naturalistic Photography* (l889). Given the power of the camera, there was no need, Emerson believed, for the photographer to contrive effects through the elaborate arrangement of people and scenes.

The Linked Ring was organized by George Davison, dismissed by Emerson as 'an amateur without training and with superficial knowledge', but a pioneer of 'impressionist photography'. Remarkably, he was to become managing director of Kodak (Europe) in l900.

While the rituals of the Linked Ring, like the earlier career of Fox Talbot, were quintessentially English, the story of photography was as truly international at what was then the end as it had been in the beginning. The members of the Photo Club of Paris believed just as strongly in the artistic goals of photography as did the Linked Ring itself. And the argument was to continue. Emerson changed his mind about naturalism: he was not the last to do so.

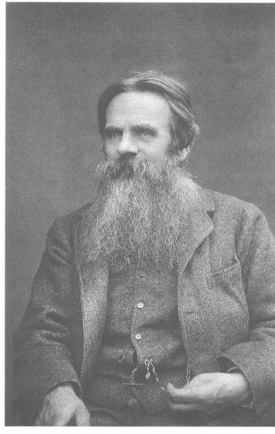

Above left: The artist, etcher and caricaturist George Cruickshank, photographed by H. J. Whitlock of Birmingham on 4 May 1866, in a pose almost identical to that of a well-known photograph by Maull & Polyblank ten years earlier. Cruickshank, in line with a succession of great caricaturists, played an active role in Victorian life.

Above right: One of the most photographed artists of the age, William Holman Hunt, seen here as he appeared in *Men and Women of the Day* by Barraud of London, *c.*1888. Noted for his paintings on religious themes, Hunt was a founder member of the Pre-Raphaelite Brotherhood. His most famous painting was *The Light of the World.*

Far left: Myles Birket Foster, the watercolourist and illustrator, peruses some prints, which are unidentified in this mid-1860s portrait by Cundall, Downes & Co. The casual nature of the pose is relatively uncommon for the period, least of all in art photography, where everything had to be arranged.

Left: Lady Butler (*née* Elizabeth Thompson) was a renowned painter of battle scenes. In 1874 she exhibited *The Roll Call* at the Royal Academy, purchased by the Queen.

The backs of *cartes-de-visite* and cabinet portraits were often just as interesting as the photographs on the front, if not more so. The dual role of the legend on the reverse set out the photographer's claim to authorship and artistry. These designs went through many phases between 1860 and 1900 and were at their most elaborate during the 1880s, with cherubs, cameras, easels, flowers and birds of great diversity in lush profusion. Some were arch, few naturalistic.

This unique design for a *carte-de-visite* was specifically commissioned by W. H. Fawn of South London from neighbouring engravers W. S. Cackett in Newington Butts. Individual designs such as this are not rare, but make a refreshing change from the mass-produced designs. Some engravers were contemptuous of *carte-de-visite* styles and treatment. At best, they believed, the photographers were dealing in 'novelties'.

The photographs on this page are by Frank Meadow Sutcliffe who will always be most fondly remembered for his stunning photography of life and landscape in and around Whitby, on the north-east coast of Yorkshire. For many years Sutcliffe ran a successful portrait studio, and it was with the respectable income that this business brought in that he gained finance for his artistic departures. However, he never had much enthusiasm for this line of work and his real joy was to be out and about with his camera, whether it was among the fishwives on the quayside or enjoying the tranquillity of the surrounding countryside.

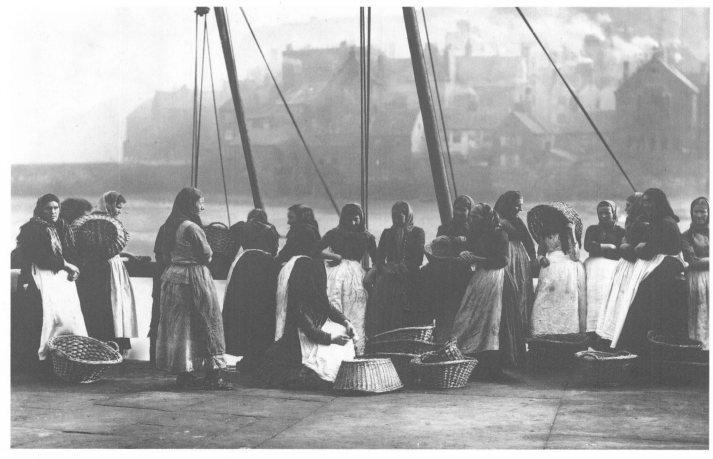

Some examples of the work of Henry Peach Robinson who, like Sutcliffe, was a photographer who will be best remembered for his art photography – most notably using combinations of several negatives to create a finished picture. However, he also had to generate the funds to make this possible. After early experimentation with wet plates he decided to open a studio in Leamington during 1856. At first business was slow, but with the advent of the *carte-de-visite* in 1860 he was soon rushed off his feet.

Mᵣ & Mᵣˢ BUSTIN AND SON

ART PHOTOGRAPHERS,

HEREFORD & ROS

ESTABLISHED 1858.

NECATIVES PRESERVED FOR FUTURE O

Pictures of all Kinds carefully co
d this or any other portrait redu
t or enlarged to life size
il or water colo

Mᵣˢ H.R.Williams
35. MILSOM STREET
BATH.

Mᵣˢ Shavham
or an old Yeomᵣy
woman

MISS CUMBER,
3. Pollet Street,
GUERNSEY.

Mᵣ & Mᵣˢ WARD,
CROYDON,
COPYISTS.
IS
E. FLORENCE,
NICE.
ES⁹ 1851.

OPPOSITE RAILWAY STATION

Opposite: Two portraits by lady photographers and several logos showing their involvement in photography. Although many women were employed in photographic businesses, they were rarely at the helm or behind the camera. Their principal labours were as receptionists, or as photo finishers and retouchers. Their nimble fingers and attention to fine detail made them ideal for the latter job, but the pay was poor.

There are many instances of photographers' wives assisting their husbands in a managerial capacity and, in smaller studios, also working at reception and in the finishing room. Often a widow would pick up the reins to keep the studio afloat, prosper in her own right, and later perhaps take her children into the business.

As the century progressed, it became more acceptable for women of the upper classes to work, and in consequence there was a marked increase in the proportion of lady photographers. At the beginning of the *cartes-de-visite* era in 1861 they accounted for 7.7 percent of photographers, but by 1891 their share had risen to 23.6 percent.

On this and the following pages are examples of the work of John Moffat. Born in Aberdeen in 1819, he first set up in business as an engraver in Princes Street, Edinburgh, but was quick to take up photography after the advent of the wet collodion process. He established his studio in 1853, and in 1864 was the first man in Scotland to use magnesium to illuminate his subjects artificially. At the first such sitting he photographed Henry Fox Talbot and Sir David Brewster.

Moffat's business prospered; after his death in 1894 it was continued by his eldest son Frank, a keen experimenter with the autochrome process – the earliest form of colour photography. Frank died in 1912 and his eldest son Pelham took charge of the business. When Pelham left for the trenches in the First World War, younger brother Teddy stepped in as manager. Pelham was invalided out of the war when he lost an arm. The business survived the Depression and the Second World War before finally closing its doors in the mid-1950s.

Above: As well as being an excellent photographer, John Moffat was an accomplished watercolourist. 'A glimpse of St Catherine's Bay, Jersey' is one of the very few of his paintings that survive.

Left: John Moffat in his studio, *c.*1860. Note the bottles of photographic chemicals on the table.
Below: These two cabinet portraits of John Moffat and his wife Sophia were taken in their own studio, *c.*1885. There is more than a touch of sentiment in the photograph of John, who is holding the portrait of Sophia in his hand.

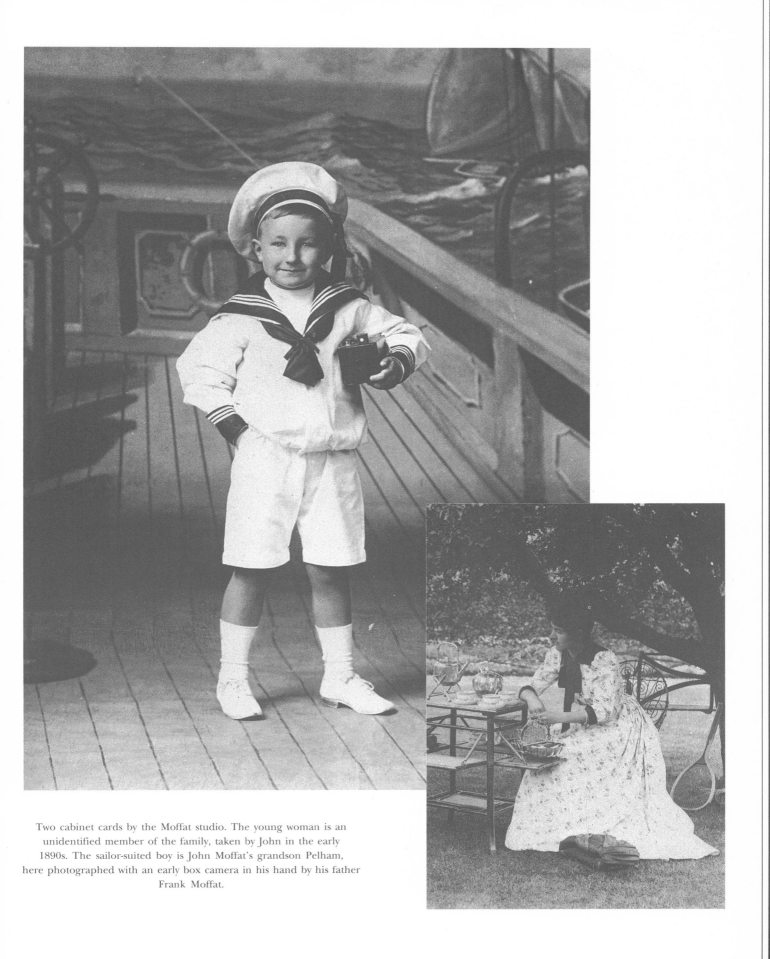

Two cabinet cards by the Moffat studio. The young woman is an
unidentified member of the family, taken by John in the early
1890s. The sailor-suited boy is John Moffat's grandson Pelham,
here photographed with an early box camera in his hand by his father
Frank Moffat.

Wye Cliff – Hay-on-Wye. Home of Crichtons.

The prosperous Victorian upper classes had a great deal of leisure time which they filled with all manner of diversions. Many talented women wiled away rainy days or long winter evenings by embellishing the family photograph albums.

The basis for the designs was a collection of unmounted *cartes-de-visite* which could be trimmed and pasted in a multitude of artistic arrangements. The four examples on these pages are from the Dillwyn albums, presently in the care of Richard Morris, a descendent of the Dillwyn family. Amy Dillwyn, shown seated playing cards with her brother Harry *(above right)*, became a novelist and literary critic for *The Spectator* – giving the first rave review of *Treasure Island*. This *carte-de-visite* was taken in June 1866 by Andrews of Swansea. Amy wrote in her diary, 'I am sick of the popular varieties in photos of smirk, lounge, stiffness, studiousness, frown, simper, idiocy, etc. on the various faces and therefore we were done playing cards together which is, I think, a quite original attitude to be photographed in.'

CHRONOLOGY

1827	Joesph Nicéphore Niépce uses camera obscura to make a view from his study window. The exposure takes eight hours and this is the first permanently fixed image.
1832	Sir Charles Wheatstone's first experiments with the stereoscope.
7/1/1839	Announcement in France of Louis Jacques Mandé Daguerre's discovery
31/1/1839	William Henry Fox Talbot reads a paper concerning details of his photogenic drawings to the Royal Institution.
19/8/1839	Daguerre publishes details of his invention, known as the daguerreotype process.
3/1840	First photographic studio in the world opened in New York by Alexander Wolcott and John Johnson.
1840	Josef Petzval of Vienna designs the first lenses specifically for photography.
2/3/1841	Richard Beard opens the first professional portrait studio in Great Britain at the Royal Polytechnic Institution, London.
6/1841	Antoine François Jean Claudet opens his Adelaide Gallery in London.
1841	William Henry Fox Talbot publishes and patents calotype or talbotype process.
1843-7	Partnership of David Octavius Hill and Robert Adamson.
1844	Mathew B. Brady opens his first studio in New York.
1848	Abel Niépce de Saint Victor introduces albumen on glass process.
1850	The albumen print introduced by L.D. Blanquart-Evrard.
3/1851	Frederick Scott Archer describes his wet collodion process in *The Chemist*.
1851	Queen Victoria is impressed by the improved stereoscope at the Great Exhibition. The stereo craze follows.
1853	Inauguration of the Photographic Society of London – later to become the Royal Photographic Society.
1853	French photographer Adolphe Martin first describes ferrotype (collodion positive on black enamelled tinplate).
1853	Nadar (real name Gaspard Félix Tournachon) opens his first studio in Paris.
27/11/1854	André Adolphe Eugène Disdéri patents the *carte-de-visite*.
1855	Alphonse Louis Poitevin introduces the carbon print process, which is not perfected until 1864.
1857	'The Two Ways of Life' (made up from over thirty different negatives) exhibited at Manchester by Oscar Gustav Rejlander.
1858	Nadar takes first aerial photographs from a balloon over Paris.
5/1859	Emperor Napoleon III sits for his *carte-de-visite* at Disdéri's studio. The birth of cartomania. .
1860	John Jabez Edwin Mayall's first series of royal *cartes-de-visite* popularizes the format in Great Britain.
1861-5	American Civil War well documented photographically – particularly by Mathew B. Brady, Alexander Gardner and Timothy H. O'Sullivan.
1866	Alexander Gardner publishes his *Photographic Sketch Book of the War* in America.
3/1864	John Moffat of Edinburgh uses magnesium for the first time when he photographs Fox Talbot and Sir David Brewster.
7/1864	Diamond cameo portrait patented by Window & Bridge, London.

23/9/1864	Walter Bentley Woodbury takes out patent for his woodburytype.
1864	Sir Joseph Wilson Swan perfects carbon print process.
18/5/1866	First suggestion of the cabinet format by F.R. Window (Window & Bridge, London) in *The Photographic News*.
1868	'Pictorial Effect in Photography' by Henry Peach Robinson published in instalments in *Photographic News*.
8/9/1871	Dr Richard Leach Maddox publishes details of gelatin dry plate process in *The British Journal of Photography*.
1872	Eadweard Muybridge begins his photographic series of human and animal movement.
1873	The platinotype patented by William Willis.
1877	*Street Life in London* published by John Thompson (illustrated with thirty-six woodburytypes).
1879	Introduction of photogravure by Karl Klic.
3/1888	George Eastman patents his first 'Kodak' camera – 'You press the button, we do the rest'.
4/10/1889	Disdéri dies in Paris at the age of seventy in an institution for indigents, alcoholics and the mentally ill.
1889	*Naturalistic Photography for Students of the Art* by Peter Henry Emerson first published.
1890	George Davison takes the first impressionistic photograph, 'The Onion Field'.
1890s	Jacob A. Riis, America's first photojournalist, began documenting poverty in the slums of New York.
1892	Founding of the Linked Ring brotherhood.
1898	Eugèen Atget takes up photography in France.

COLLECTING VICTORIAN PHOTOGRAPHS

The photographs in this book are drawn mainly from the work of the countless high street photographers who plied their trade from day to day in towns and cities all over the world. The great majority remain unknown today and often quite deservedly so. The Victorian era, like all others, had its cowboy operators and get-rich-quick merchants too. However, there were a select few who were clearly skilled and inspired artists. Renowned studios made higher charges for their services, and thus their work tends to appear in albums compiled by wealthier families. Even so, it should be remembered that a famous photographer's name on the back of a photograph rarely guarantees his actual hand at work, since all major studios employed numerous assistants.

The pleasure derived from collecting Victorian portraiture is purely subjective and I would not presume to inflict personal prejudices, but I can offer a few guidelines to those embarking upon a collection. The primary problem is how and where to find photographs. Antique and flea markets are a most fruitful source and car boot sales, where there is fun in the haggling, can yield real bargains. Antique shops tend to overprice photographs and especially albums, but the more downmarket 'junktique' shops and house-clearance companies are well worth a visit. Some antiquarian bookshops also deal in photographs. When buying from dealers or other collectors, you will find that prices are usually fair but reflect the desirability of particular photographers' work or unusual subjects. The most obvious and economical way to collect photographs, however, is by asking relatives and friends. There is something extra special about images of one's own family. The main criterion for acquisition should in any case always be enjoyment.

Of course, the condition of photographs is paramount. Excessively faded or damaged images are usually of little interest or value. Once you have built up a collection, therefore, it is important to house it in a stable environment. Major archives employ extremely exhaustive measures to ensure the preservation of their contents for posterity, but the layman collector can observe a few basic rules. Where possible, images should be stored in acid-free envelopes at a constant humidity and temperature 18°C(65°F) or below and preferably in subdued light or even darkness. Great care should be exercised during handling as fingerprints leave residues on photographs which will cause deterioration. Even though many *cartes-de-visite* and cabinet portraits were produced in large quantities, it should be remembered that by now most copies will have disappeared and the negatives are long gone. This means that any collection will contain many unique images. Treasure them.

Archie Miles

PICTURE CREDITS

CHAPTER ONE

1 – John Hall, London 1864/5. **3** – Typical albums for *cartes-de-visite* and cabinet portraits. **4** – Jabez Hughes, Ryde, Isle of Wight, *c.*1870. **8** – James Valentine, Dundee, *c.*1865. **9** – John Leech, *Punch*, 1862. **10a** Anon., *c.*1855. **10b** – Anson New York, *c.*1855. **11** – A. Robertson, Glasgow, *c.*1860. **13a** – Burgwitz & Co., London, *c.*1865. **13b** – Anon., *c.*1865. **13c** – Ashford Brothers, London, *c.*1865. **13d** – Leopold F. Manley, London, c. 1865. **14** – André Adolphe Eugène Disdéri, Paris, *c* 1860. **15** – Chancellor, Dublin, 1878. **16** – M. Boak, Bridlington, Driffield and Malton, *c.*1885. **17** – Anon., *c.*1880. **18** – Alfred Hughes, London, *c.*1895. **19** – William Elliott Debenham, London, *c.*1895. **21** – Anon., 1873. **22/3** – Archie Miles. **24** – Edward Reeves, Lewes, *c.*1858. **25** – Edward Reeves, Lewes, *c.*1865. **26a** – Archie Miles. **26b** – Archie Miles. **27** – Archie Miles. **28a** – Edward Reeves, Lewes, *c.*1865. **28b** – Edward Reeves, Lewes, *c.*1865. **28c** – Edward Reeves, Lewes, *c.*1865. **29** – Edward Reeves, Lewes, *c.*1860.

CHAPTER TWO

31 – George A. Dean Jr., Douglas, Isle of Man, *c.*1865. **32** Anon., *c.*1895. **33** – Elliott & Fry, London, *c.*1870. **34** – Anon. (USA), 1879. **35** – Alexander J. Grossman, Dover, *c.*1885. **36** – Anon., *c.*1865. **37a** – Anon. 1870. **37b** – Liddiard, Portsea, 1870. **38a** – Negretti & Zambra, London, *c.*1865. **38b** – M. Horner, Settle, 1868. **39** – Negretti & Zambra, London, *c.*1865. **40** – Arthur Western, London, *c.*1885. **41** – Anon. (Brighton), *c.*1870. **42a** G. & J. Hall, Wakefeild, *c.*1885. **42b** – A. Arnell, Scarborough, *c.*1880. **43** – Montague, Ipswich, *c.*1870. **44a** – Anon., 1867. **44b** – Arthur Nicholls, Cambridge, *c.*1867. **45** – Hills & Saunders, Oxford, 1863. **46** – W. Eskett, York, *c.*1885. **47** – Adolph Naudin, London, *c.*1867.

CHAPTER THREE

49 – Anon., *c.*1890. **50** Drawing by Spy, 1882. **51** – Maull & Polyblank, London, *c.*1865. **52** – **53a** – **53b** – **54** – **55** – Probably London Stereo & Photo Co., *c.*1865. **56a** – Thomas John Barnes & Son, London, *c.* 1874. **56b** – Thomas John Barnes & Son, London, *c.*1874. **57** – E.I. Baker, Hailsham, *c.*1880. **59** – Anon. (Eire), *c.*1870. **60/1** – W.&D. Downey, Newcastle, *c.*1865. **62a** – Metropolitan Police, London, *c.*1900. **62b** – Metropolitan Police, London, *c.*1900. **63** – Charles Thomas Newcombe, London, *c.*1869. **64a** – Glusburn, Crosshills, Yorks hire, c. 1890. **64b** – Edward Reeves, Lewes, *c.*1875 **64c** – **65** – Arthur Deenham, Ryde, Isle of Wight, c.1880. **66** – Thomas Buist, Elie, Fife, *c.*1865. **67** – R. Dighton, Cheltenham, *c.*1865. **68a** – Archie Miles, **68b** – Farren Bros., Cambridge and Chatteris, *c.*1867. **68b** – Francis R. Elwell, MA, Weston-Super-Mare, 1868. **68d** – The West End Photographic Company, London, *c.*1875. **68e** – Maull & Fox, London 1879. **69a** – William Mayland, Cambridge, *c.*1867. **69b** – Hills & Saunders, Oxford, Eton and Harrow, 1867. **69c** – William Mayland, Cambridge, *c.*1867. **69d** – Bullock Brothers, Royal Leamington, *c.*1867. **70a** – Hills & Saunders, Oxford and Eton, *c.*1866. **70b** – Farren Bros., Cambridge and Chatteris, 1868. **70c** – Farren Bros., Cambridge and Chatteris, 1868.

CHAPTER FOUR

73 – Edward Reeves, Lewes, *c.*1865. **74** – W.& D. Downey, London and Newcastle, *c.*1870. **75a** – Anon. *c.*1880. **75b** – Wilkinson, Huddersfield, *c.*1875. **75c** – A.H. Clarke, Ripon, Yorkshire, *c.*1870. **75d** – Ingham Riley, Richmond, Yorkshire, *c.*1865. **76** – H. Wilkinson, Scarborough *c.*1885. **77** – H. Wilkinson, Scarborough *c.*1885. **78a** – Anon. (USA), *c.*1865. **78b** – Anon. *c.*1880. **79** – Walter Fisher, Filey, *c.*1870. **80a** – D. Macara, Edinburgh, *c.*1875. **80b** – William Marshall, Preston, *c.*1880. **80c** – Frank Walton, Leeds, *c.*1890. **80d** – H. Hutchison, *c.*1885. **81** – Moir & Halkett, Portobello and Haddington (Edinburgh), *c.*1880. **82** – Shaw & Sons, Atlanta, Georgia, *c.*1885. **83** – James Millard, Wigan, *c.*1885. **84a** – Pibworth, Southampton, *c.*1875. **84b** – Anon., *c.*1870. **84c** – C.Henwood, London, *c.*1895. **85** – William Moscrop, Kendal, *c.*1875. **86** – John Pouncy, Dorchester, *c.*1880. **87a** – Anon., *c.*1880. **87b** – Wood & Henry, Keith and Dufftown, *c.*1885. **87c** – Anon., *c.*1875. **87d** – Anon., *c.*1880. **88/9** – E. Williams, Hawkhurst, c.1885. **90** – Underwood & Underwood (USA), 1902. **91** – Underwood & Underwood (USA), 1902.

CHAPTER FIVE

93 – A. Taylor, Chippenham, *c.*1870. **94** – Albert Flint, London, *c.*1885. **95** – Anon, *c.*1895. **97a** – Underwood & Underwood (USA, 1905. **97b** – Anon., *c.*1890. **98** – C. Bierstadt, Niagara Falls, NY, *c.*1890. **99a** – C.S. Allen, Tenby, *c.*1865. **99b** – Mathew B. Brady, New York and Washington, 1863. **99c** – W. & A. H. Fry, Brighton, *c.*1880. **100a** – T. Atkins, London, *c.*1885. **100b** – Anon., 1865. **101a** – W. & D. Downey, London, *c.*1892. **101b** – Napoleon Sarony, New York, *c.*1880. **101c** – José Maria Mora, New York, *c.*1885. **102** – José Maria Mora, New York, *c.*1885. **103** – James Ross, Edinburgh, *c.*1865. **104a** – Elliott & Fry, London, *c.*1880. **104b** – E. T. Gibbs, Stroud, *c.*1885. **105a** – Kelley & Co., Halifax, Nova Scotia, 1889. **105b** – William Gillard, Gloucester, *c.*1880. **105c** – Mrs H. R. Williams, Bath, *c.*1870. **105d** – William Notman, Halifax, Nova Scotia, *c.*1880. **106** – Anon., *c.*1890. **107a** – Anon., *c.*1867. **107b** – Anon., *c.*1870. **108** – George Washington Wilson, Aberdeen, *c.*1860. **109** – George Washington Wilson, Aberdeen, *c.*1865. **110a** – J. Hopwood, Middlesbrough, *c.*1880. **110b** – H. Roland White, Birmingham, *c.*1900. **111** – Davies Brothers, Weston-Super-Mare, *c.*1885. **112a** – Warland Andrew, Abingdon, *c.*1900. **112b** – Fred Proctor, Bolton, *c.*1890. **112c** – William Wright, London, *c.*1890. **112d** – Edmund John Stoneham, London, *c.*1885. **113a** – Thomas Charles Turner, London, *c.*1880. **113b** – Enos Eastham, Eccles, Lancasashire, *c.*1880. **113c** – T. Illingworth, Halifax, *c.*1875. **113d** – Henry Lenthall, London, *c.*1870. **114** – T. Taylor, Scarborough, *c.*1875. **115** – Moorhouse & Co., Morecambe, *c.*1885. **116** – F. Woodcock, Douglas, Isle of Man. *c.*1880.

117 – T.A. Grut, Guernsey, *c.*1885. **118a** – Anon., *c.*1870. **118b** – James Briddon, Ventnor, Isle of Wight, *c.*1870. **119** – Anon., *c.*1870.

CHAPTER SIX

121 – H. Le Lieure, Turin, *c.*1870. **122** – John Jabez Edwin Mayall, The London, 1860. **123** – The London Stereoscopic & Photograpic Co., *c.*1865. **124** – Window & Bridge, London, 1864. **125a** – A. Dobson, Shipley, Yorkshire, *c.*1900. **125b** – J.C.Gray, London *c.*1900. **126** – Adam Diston, Leven, Fife, *c.*1885. **127a** – Elliot & Fry, London, *c.*1865. **127b** – John Hart, London, *c.*1890. **128** – Anon., *c.*1880. **129** – A. & G. Taylor, *c.*1880. **130** – Anon., *c.*1865. **131** – Edward Reeves, Lewes, *c.*1880. **132a** – Alex Jennings, Keighley, Yorkshire. **132b** – W.T. & R. Gowland, York, *c.*1870. **132c** – C.H. Burrows, Bradford, *c.*1890. **132d** – William Elliott Debenham, London, *c.*1880. **133a** – Anon., 1870. **133b** – E. T. Gasson, Rye, Sussex, *c.*1870. **134** – P. Sebah, Constantinople, *c.*1875. **135** – P. Sebah, Constantinople, *c.*1875. **136** – The Crystoleum Company, London, *c.*1885. **137** – The Crystoleum Company, London, *c.*1885. **138** – The Crystoleum Company, London, *c.*1885. **139a** – Anon., *c.*1870. **139b** – Leopold F. Manley, London, *c.*1865. **139c** – John Jabez Edwin Mayall, London, *c.*1865. **139d** – The Photographic Portraiture Company, London, 1863. **140** – Anon., *c.*1865. **141a** – Edward Reeves, Lewes, *c.*1875. **141b** – A. Foster, Waltham Cross, *c.*1885. **141c** – F. M. Ramell, Sittingbourne, *c.*1885.

CHAPTER SEVEN

144a – James Russell & Sons, London and Chichester, *c.*1897. **144b** – John Watkins, London, *c.*1860. **145** – Ashford Brothers & Co., London, *c.*1865. **147** – John Jabez Edwin Mayall, London, 1862. **148** – William Lawrence, Dublin, *c.*1865. **149** – Hills & Saunders, London, *c.*1880. **150a** – Hills & Saunders, Eton, 1865. **150b** – Hills & Saunders, Eton, *c.*1865. **151** – Archie Miles. **152** – Charles Reid, Wishaw, *c.*1885. **153** – T. J. Sands, Harewood, Yorkshire, *c.*1875. **154a** – Anon. **154b** – R. Clennett, West Hartlepool, *c.*1875. **154c** – Hayman Selig Mendelssohn, London, *c.*1885. **154d** – Auty Ltd, Newcastle, *c.*1885. **155** – Anon., *c.*1895. **156a** – M. Le Tourneux, Salford, Lancashire, *c.*1890. **156b** – James Valentine, Dundee, *c.*1870. **157a** – Alexander Bassano, London, 1887. **157b** Ghémar Frères, Brussells, *c.*1865. **158a** – Professor Hall, Adelaide, *c.*1865. **158b** O'donnell & Smith, Halifax; Nova Scofia *c.*1865. **159a/b** – John Jabez Edwin Mayall, London, *c.*1860. **159c/d/e** – Edward Reeves, Lewes, *c.*1870. **160a** – John Leech, *Punch*, 1862. **160b** – Edward Reeves, Lewes, *c.*1865. **161a** – Partington & Kinsey, Auckland, New Zealand, *c.*1885. **161b** – W. & D. Downey, London, *c.*1875. **162a** – Camille Silvy, London, 1859-69. **162b** – Camille Silvy, London, *c.*1865. **162c** – Camille Silvy, London, *c.*1865. **163** – Camille Silvy, London, *c.*1865.

CHAPTER EIGHT

165 – W. E. Town, St Mary Cray, Kent, *c.*1897. **166** – The London Stereoscopic & Photographic Co., *c.*1880. **167a** – William Barraud, London, 1888. **167b** – William Barraud, London, 1888. **168** – Anon. (USA), *c.*1890. **169a** – James Huff, Penrith, *c.*1885. **169b** – J. E. Whitney, St Paul, Minnesota, *c.*1865. **169c** – Underwood & Underwood (USA), 1903. **170a** – Anon., 1862. **170b** – G. Massaoud Frères, Port Said, *c.*1885. **173** – Anon., *c.*1890. **174a** Anon. (Australia), *c.*1880. **174b** – J.W. Lindt, Melbourne, Australia, *c.*1875. **175** – A. Leroux, Algeria, *c.*1890. **176a** – Hartmann, St Pierre, Martinique and Trinidad, *c.*1870. **176b** – Anon., *c.*1865. **176c** – M. Koizumi, Kioto, *c.*1895. **176d** – Anon., *c.*1890. **177** – Schier & Schoefft, Alexandria and Cairo, *c.*1870. **178a** Underwood & Underwood (USA), 1904. – **178b** – Parisian School of Photography, London, *c.*1888. **179a** – André Adolphe Eugène Disdéri, Paris, *c.*1862. **179b** – Asplett & Green, Jersey, *c.*1870. **179c** – Anon. (USA), *c.*1865. **179d** – Edmund John Stoneham, London, *c.*1885. **180a** – Holmes, India, *c.*1890. **180b** – D. Garrick, *c.*1865. **180c** – Anon. (India), *c.*1890 **181a** – Anon. (India), *c.*1890. **181b** – Anon. (India), *c.*1890.

CHAPTER NINE

184 – The London Stereoscopic & Photographic Co., 1892. **185** – John Jabez Edwin Mayall, London, 1861. **186** – Anon., *c.*1865. **187** – W. M. Chaffin & Sons, Sherbourne, Dorset, *c.*1870. **188** – James Valentine, Dundee, *c.*1880. **189** – Frederick Hudson, Ventnor, Isle of Wight, *c.*1865. **190a** – Anon., *c.*1865. **190b** – Anon., *c.*1860. **191** – W. & D. Downey, London, 1893. **192** – Londsdale Abell, Leeds, *c.*1870. **193** – Anon., 1871. **194** – Anon., *c.*1870. **195a** – G. West & Son, Gosport, Hampshire, *c.*1870. **195b** – George Washington Wilson & Co., Aberdeen, *c.*1875.

CHAPTER TEN

197 – Henry Peach Robinson, Leamington, *c.*1863. **198** – Anon., *c.*1870. **199a** – Painting by Lord Leighton. **199b** – W. & D. Downey, London, 1893. **200** – Anon., *c.*1890. **201a** – Henry Joseph Whitlock, Birmingham, *c.*1866. **201b** – William Barraud, London, 1888. **201c** – Cundall, Downes & Co., London, *c.*1865. **201d** – Robert White Thrupp, Birmingham, *c.*1875. **204b** – Frank Meadow Sutcliffe, Whitby, *c.*1885. **204c** – Frank Meadow Sutcliffe, Whitby, *c.*1890. **205b** – Henry Peach Robinson, Leamington, *c.*1863. **205c** – Henry Peach Robinson, 1882. Book first published 1884. **206a** – Mrs H. R. Williams, Bath, *c.*1870. **206b** – Miss Cumber, Guernsey, *c.*1870. **207a** – Painting by John Moffat. **208a** – John Moffat, Edinburgh, *c.*1860. **208b** – John Moffat, Edinburgh, *c.*1885. **208c** – John Moffat, Edinburgh, *c.*1885. **209a** – John Moffat, Edinburgh, *c.*1890. **209b** – Frank Moffat, Edinburgh, *c.*1895. **210** – Dillwyn family album, 1860s. **211** – Dillwyn family album, 1860s.

INDEX

Numbers in italic refer to photographs/captions.